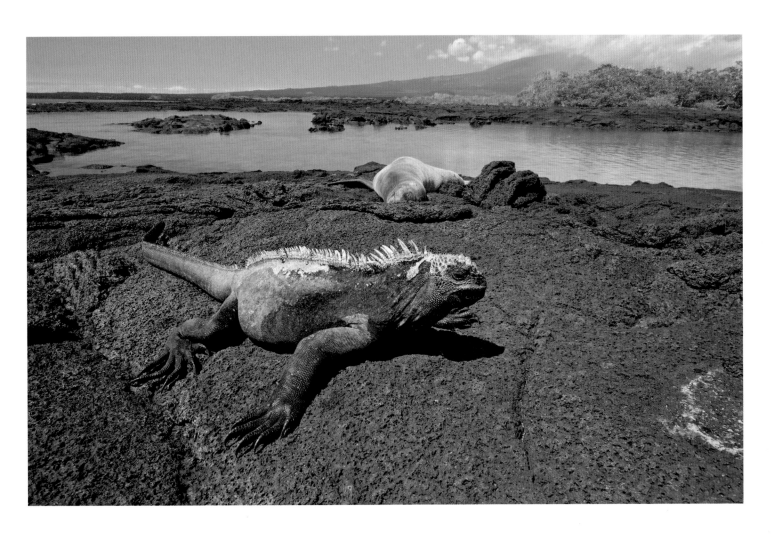

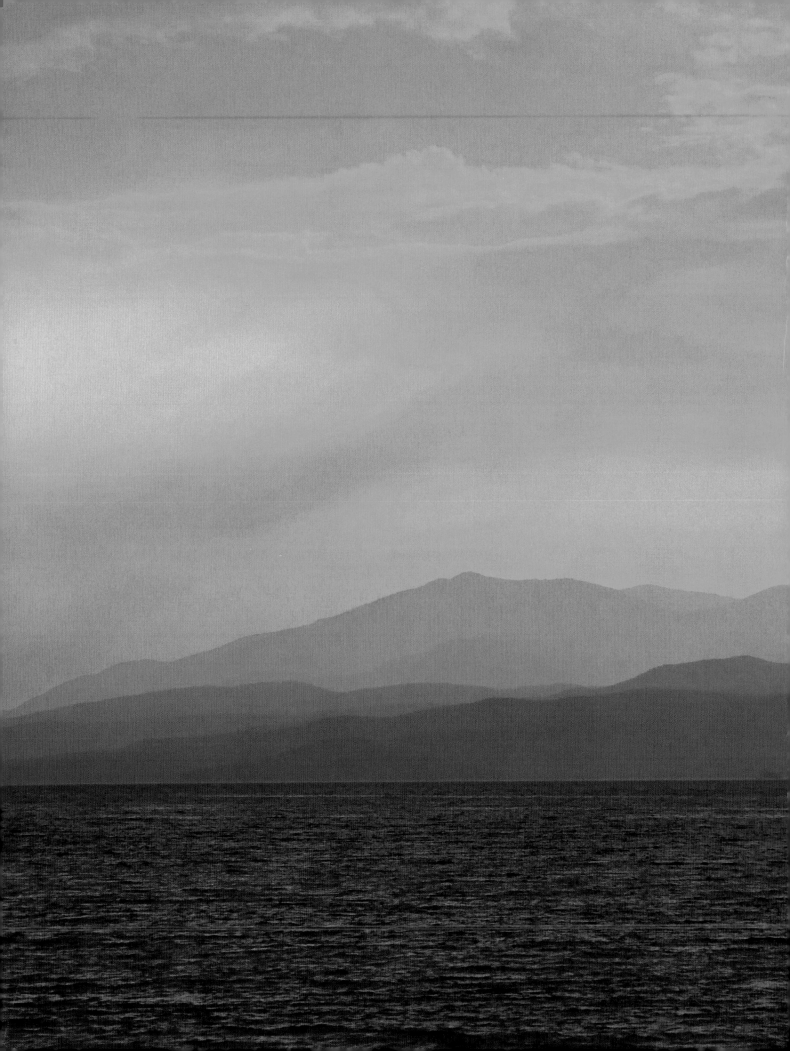

BOYD OUTDOOR
NORTON'S DIGITAL
PHOTOGRAPHY
HANDBOOK

How To Shoot Like a Pro

Voyageur Press

Frontispiece:

Marine iguana and sea lion, Fernandina Island, Galapagos National Park, Ecuador. Shot with a 10–22mm lens.

Title page, main:

Lake Baikal in south-central Siberia, Russia, in misty morning light.

Title page, inset:

Close-up detail of bark and wood of bristlecone pine, Mt. Evans, Colorado. Shot with a 100mm macro lens.

First published in 2010 by Voyageur Press, an imprint of MBI Publishing Company, 400 First Avenue North, Suite 300, Minneapolis, MN 55401 USA

Voyageur Press titles are also available at discounts in bulk quantity for industrial or sales-promotional use. For details write to Special Sales Manager at MBI Publishing Company, 400 First Avenue North, Suite 300, Minneapolis, MN 55401 USA.

To find out more about our books, visit us online at www.voyageurpress.com.

Library of Congress Cataloging-in-Publication Data

Norton, Boyd.
 [Outdoor digital photography handbook]
 Boyd Norton's outdoor digital photography handbook: : how to shoot like a pro / Boyd Norton.
 p. cm.
 Includes bibliographical references and index.
 ISBN 978-0-7603-3298-6 (sb : alk. paper)
 1. Outdoor photography. 2. Nature photography. 3. Photography—Digital techniques. I. Title. II. Title: Outdoor digital photography handbook.
 TR659.5.N655 2010
 778.7'1—dc22

 2009023211

Edited by Danielle Ibister
Designed by Cindy Samargia Laun
Cover designed by Matthew Simmons
Design Manager: LeAnn Kuhlmann

Printed in China

DEDICATION

For Barbara, who has shared in most of my adventures—and survived.

ACKNOWLEDGMENTS

*Voyageur Press has published a number of my books,
and the folks here—Michael Dregni and Danielle Ibister—have been great to work with.*

*I'd like to thank a longtime friend, the very talented photographer Jim Griggs,
for his valuable help in some of the technical parts of the book.*

*And a special thanks to my lovely and patient wife, Barbara, who endured the long days
(and many nights) when I was sequestered in my office writing this and other books.*

CONTENTS

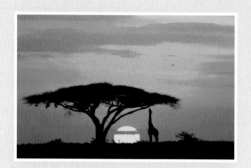 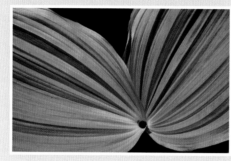

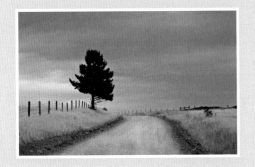 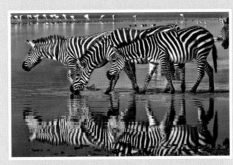

INTRODUCTION

Back in the early 1990s, when digital photography first came to our attention, digital imaging seemed like something that was too far off in the future to be of much use. Early digital cameras were strictly for studio use, tethered by wire to a computer. The sensors weren't all that good, and there were predictions that it would be a very long time before digital photography could match the resolution of film.

We now know that the technology has made some amazing advances. Chief among them are small, high-capacity storage devices—flash memory cards—and high-resolution image sensors. Together, these advances have made digital photography truly portable for use in the field—in other words, outdoor photography.

My own transition to digital photography was slower and later than most, partly because I spend so much time in the boondocks of the world. Why was that important? My major concerns had to do with the electronics and electrical needs for digital. It's not always possible to charge batteries in the rainforests of Borneo or Peru. And storage devices, such as portable hard drives and laptop computers—needed for uploading images from flash

cards—also require electricity. As time went on, these problems were alleviated by the invention of better, longer-lasting camera batteries and storage devices. With such great improvements in such a short period of time, it's obvious that, in the future, things will continue to get better and equipment even more reliable.

I've been publishing my photos in magazines and books for more than forty years, and until a couple of years ago, all of these images were created on film. Old habits die hard. I *think* film. And I love the emulsions that I have tested so thoroughly because they match my way of seeing the natural world around me.

So it wasn't easy for me to take the plunge into digital photography. Or, as an old film-shooting friend calls it, "going over to the Dark Side." (He has, by the way, now switched to digital.)

A couple of factors made me switch. One had to do with the improvements in digital technology. Today's cameras are capable of creating images of very high quality—high enough to suit the demands of picture books and magazines.

This is one of the rarest animals in the world, the Baikal seal called *nerpa*, found only at Lake Baikal in central Siberia. These, the world's only fresh water seals, are extremely shy and difficult to get close to. I had made many trips to Baikal in the past, shooting film, and this was the first time I used digital—allowing me to check the images soon after shooting. Shot on a 10-megapixel DSLR (ISO set at 400) with a 100–400mm IS lens and a 1.4x extender, giving me an effective 900mm lens (with the 1.6 multiplier of the sensor).

A second factor that prompted my switch to digital was the increasing difficulty of traveling overseas carrying lots of film. A lot of my work takes place in faraway places, the boondocks of the world. Airline restrictions (limiting you to one carry-on bag) and increased security have made it more and more difficult to carry all the necessary camera gear *plus* the hundreds of rolls of film necessary for in-depth coverage of a locale. Enough film for a two-week shoot—say two hundred rolls for 7,200 pictures—weighs about 11 pounds (about 5 kilograms) and takes up a large amount of your carry-on space. By comparison, to get the equivalent number of pictures shooting digital (assuming a 10-megapixel camera), your carry-on space is occupied by twenty flash memory cards (4 gigabytes each) for a total of almost 8,000 pictures (about 400 pictures per card), shooting in RAW mode for highest quality; five extra batteries for the camera; one battery charger; and a 160-gigabyte portable hard drive (to store almost 16,000 RAW images) with AC charger. The total weight of all that is about 3 pounds (1.36 kilograms)! And it all takes up less space than those two hundred rolls of film.

Then there are airport x-ray machines to contend with and environmental conditions (high heat and humidity) that have an adverse effect on film. As you can see, with the great improvements in digital storage technology, it is possible to shoot and store many more images with far less weight and space than film requires . . . and with less concern over x-rays or heat or humidity affecting the outcome.

Finally, there is what I call the "Instant Feedback Syndrome." In the past, I didn't care about seeing the images immediately; I had enough experience, derived over years of shooting, to know when I had gotten the right picture. However, there were times, in tricky lighting situations, when I had to do a lot of bracketing of exposures to make sure I got it right on. Or when action was moving quickly and I had to shoot lots of pictures in sequence to make sure one of them captured the best of the action. Or when an interesting new technique occurred to me—something experimental—and the outcome was uncertain. In these situations, the instant feedback of digital is a blessing.

I mentioned earlier that I *think* film; perhaps I should have said I *thought* film. Because now I think digital when I'm shooting in order to get the best possible image. Perhaps the most exciting thing about digital photography is the certainty that it will continue to get better and better and that storage devices will hold more and more in smaller volumes of space.

The future of digital photography is very bright indeed, especially for those of us who shoot in the out of doors.

THE DIGITAL REVOLUTION

When I was a youngster, our family had a Kodak folding vest pocket camera. My father was in charge of all picture-taking because the camera was rather sophisticated. It required knowledge of focus, f-stops, and shutter speeds. And loading was a tricky operation to be undertaken only by those well practiced in such things.

Two or three times a year, on vacations or special occasions, a roll of black-and-white film was purchased and carefully loaded into the camera. The taking of the picture was a mysterious process to the rest of us, involving manipulations we couldn't fathom. I don't think my father fully fathomed them either, for the resulting pictures were occasionally good, but more often they were not. There were problems with exposure and focus. Any time those technical problems were conquered—by luck or design—the picture was deemed good, regardless of content.

High in the Colorado Rockies near the Maroon Bells Wilderness Area, I found these alpine flowers (fleabane) growing out of a rock outcrop. Shooting with my 10-megapixel DSLR and 10–22mm ultrawide zoom and moving in close gave me a perspective that included the flowers and some of the surrounding mountains and forest.

The newest autofocus digital cameras with image-stabilized lenses provide the opportunity to get great wildlife shots. This pronghorn antelope was in Colorado's Wet Mountain Valley. Shot with a 100–400mm IS (image-stabilized) lens at 400mm, which, on my camera with a 1.6 multiplier effect, gave me the equivalent of a 640mm lens! Handheld, braced against a car window.

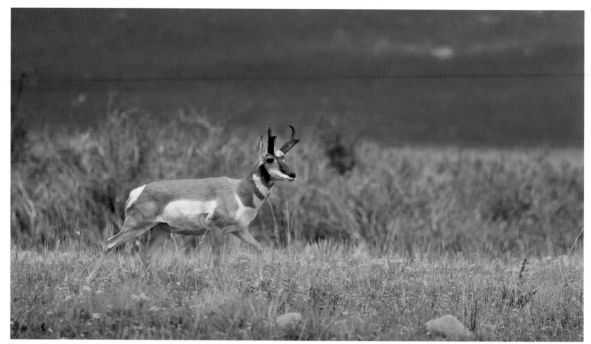

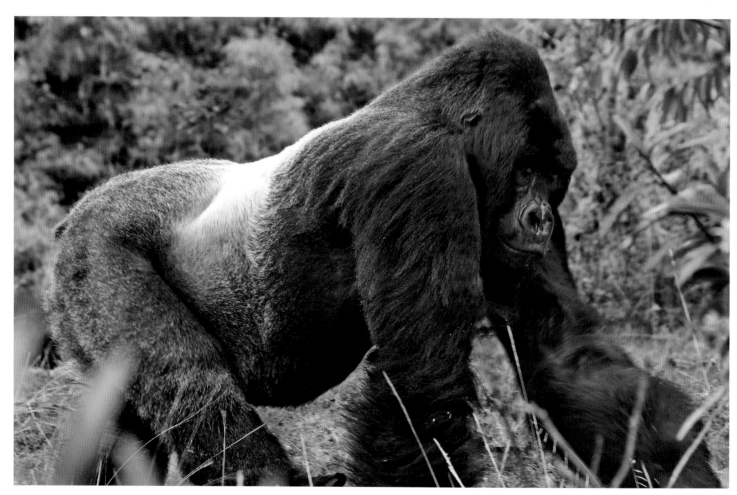

Many years ago when I was working on my book *The Mountain Gorilla*, I had to carry three or more camera bodies, each loaded with a different speed of film, because the rainforest habitat of the gorillas was sometimes overcast and rainy, sometimes bright and sunny. On my recent visits to Volcanoes National Park in Rwanda, instead of carrying all those different types of film, I was able to change the ISO (speed) setting on my digital camera to adjust instantly for changing lighting. Handheld with a 10-megapixel DSLR and 28–135mm IS lens at 135mm (216mm with the 1.6 multiplier), ISO set at 800. My silverback friend Guhonda was keeping an eye on me.

Photography in those days was a chore. It was also something to be endured if you happened to be the subject. ("Hold it! Wait'll I set the focus. Oops, wait a minute. Gotta set the f-stop. There, now let's see . . . ") For most people, good photography involved great dedication to technical manipulations, most often at the sacrifice of meaningful picture content. The subjects were often too far away; horizon lines were not always horizontal.

A revolution has taken place in photography in recent years. Modern technology has freed us from certain technical chores that too often hindered and slowed down the creative process. The result is that we, as photographers, have been liberated to be more creative. This is especially true of digital photography. The technology has given us fluency that expands photography's expressive capabilities. With instant feedback, we learn to be more creative—if we work at it.

But all this fluency and automation won't guarantee great pictures. It is still the person behind the viewfinder who makes photographs exciting and dynamic. The camera, in the final analysis, serves only to complete the picture envisioned in the mind's eye.

TO BE AN OUTDOOR PHOTOGRAPHER

How did I become a photographer? Impatience. And frustration. My earliest efforts at capturing the beauty of the outdoor world involved painting. I wasn't very good at it. Given time, I might have improved as a painter. However, long before the oil or acrylic was dry on a painting, I wanted to move on to something new. I kept discovering so many new things to render on canvas that there simply wasn't enough time to do it all.

So I turned to photography and discovered how much more difficult it is than painting. That's right. Painters really have it pretty easy. Cluttered scenes and less-than-perfect subjects can easily be altered in renditions on canvas. Elements can be added or deleted,

mood and lighting created to fit the subject perfectly. Yeah, yeah, I know—photographers can alter images in Adobe Photoshop, taking out power lines, adding elements that weren't there. But the fact remains: The basic photograph often deals with finding the right angle or the right lens choice to eliminate chaos.

Photographers have to deal with harsh reality. It takes patience to find that right angle or lens choice to isolate a particular scene or subject. Or to come back when the lighting is right. And that ends up being the challenge of good, creative photography.

What I like about photography, though, is its fluency—the ease with which we can make a fine photograph, then change the angle or the perspective to improve on the first or make a different, equally effective photo. Despite the meticulous care that is needed to create an exciting photograph, the fluency allows for lots of experimentation.

I became an outdoor photographer because I wanted to share my vision of the beauty of nature and wildlife with others. My photography developed hand in hand with my environmental work, which began when I moved to the wilds of Idaho in 1960. Idaho was then, and is now, one of the most scenically beautiful states, with more wilderness than any other state outside Alaska. The beauty, the ruggedness, the sheer splendor of it all inspired me.

There are few things in life as exciting as being outdoors, trekking through forest or desert or tundra, absorbing the sights and sounds and smells of places either new or familiar, and being challenged with the awesome task of capturing the essence of a place or subject and doing it in such a way as to evoke in others, even in small measure, a hint of the beauty, mystery, and drama to be found in our world.

My growing interest in photography and conservation coincided with the publication, in the early 1960s, of those wonderful, large,

and lavish picture books from the Sierra Club. The photographs of Eliot Porter, Phil Hyde, Ansel Adams, and Bob Wenkam were an inspiration and an encouragement to me. Here was the perfect blend: photography as art and photography as a powerful form of communication. The art raised our level of sensitivity to the beauty of wilderness; the communication conveyed the message that we need to act, or these beautiful things will be lost.

Along the way, I developed, through trial and error (mostly the latter), my photographic skills in the out of doors.

TRANSCENDING SNAPSHOTS

We make photographs for various reasons. The primary one is to record or document events, places, or people in our lives. Snapshots. Reminders of pleasant experiences or the means to share with others something in our lives—a vacation trip, for example.

For most people, as was the case for my parents, the documentation aspect of photography is adequate and satisfying, so long as the pictures are sharp and properly exposed (and, nowadays, have believable color rendition).

But for a lot of us, we want photography to be more. We want to capture the excitement and beauty we see around us. Photography has the potential to be creative expression, art, powerful communication. And when we arrive at that level of ambition as photographers, the attributes of the snapshot or "record" picture are no longer adequate. Therefore, the casual aim-and-shoot technique of making snapshots needs to be replaced with a more methodical, precise approach to capturing the essence of scene or subject.

But how?

The answer to that question is what this book is all about. I don't pretend to have pat formulas for successful photographic expression. In fact, rules and formulas are, too often, the antithesis of creativity. What I seek to provide here is a blend of information and inspiration that is useful in understanding the mental and mechanical processes necessary to create strong, dynamic pictures. The rest is up to you. But bear in mind that the only way to learn how to create great pictures is to *photograph*. Take the camera off that dusty shelf and shoot, shoot, shoot! Then learn by your mistakes as well as your successes.

In structuring this book, I've tried to follow a logical learning sequence for those who are just getting into digital photography in a serious way. I start with some of the basics—how digital imaging works—and carry on through to practical field techniques. Inevitably, when you get seriously into digital photography, you discover that computer work is an integral part of it—like it or not. This means dealing with details like image storage and filing, image processing and enhancement, and image manipulation. I have included chapters here to cover these topics, but they are not intended to be rigorous treatments on the subjects. Hundreds of books have been written about using Photoshop, and it is not the goal of this book to explain everything you need to know about Photoshop. Instead, I have simply highlighted the techniques and tips that I find particularly useful.

Digital photography is rapidly evolving. By the time you read this book, newer and better products may be on the market, so I've tried to avoid being too specific in terms of equipment. To stay informed about new equipment, techniques, tips, and the latest developments in digital technology, visit my website, www.wildernessphotography.com. It will be updated periodically.

Finally, if you are waiting until the newest and best digital camera comes along before going digital, *don't wait any longer*. Something better is always going to come along, but the equipment nowadays is so good that you don't want to miss out on the benefits of digital. It's time to jump in.

This autumn hillside was in Alaska's Chugach Mountains. Shot with a 100–400mm IS lens handheld (but braced against a tree). ISO was set at 200 to give me a fast enough shutter speed ($^1/_{500}$ second).

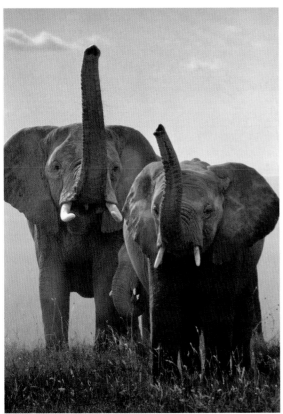

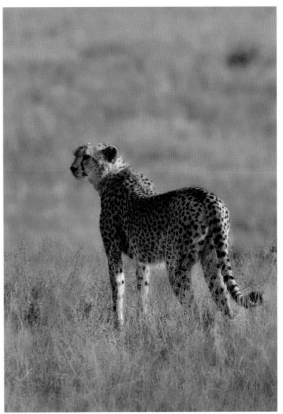

There was a lot of dust in the air that day in Serengeti National Park. These elephants, using their trunks as olfactory periscopes to check our scents for danger, were posed against that light background of swirling dust. It made for some tricky metering for proper exposure. Being able to check the histogram after each shot on my 10-megapixel DSLR allowed me to get it right. When shooting film, I would often bracket such exposures to make sure I had at least one proper exposure. I used a 100–400mm IS lens at 400mm (640mm with multiplier).

This magnificent cheetah was out looking for breakfast and posed nicely in that wonderful early morning light in Serengeti National Park. Shot with a 100–400mm IS lens at 400mm (640mm equivalent with multiplier effect). Using a long telephoto lens allowed us to stay far enough away so as not to interfere with the cheetah's hunt.

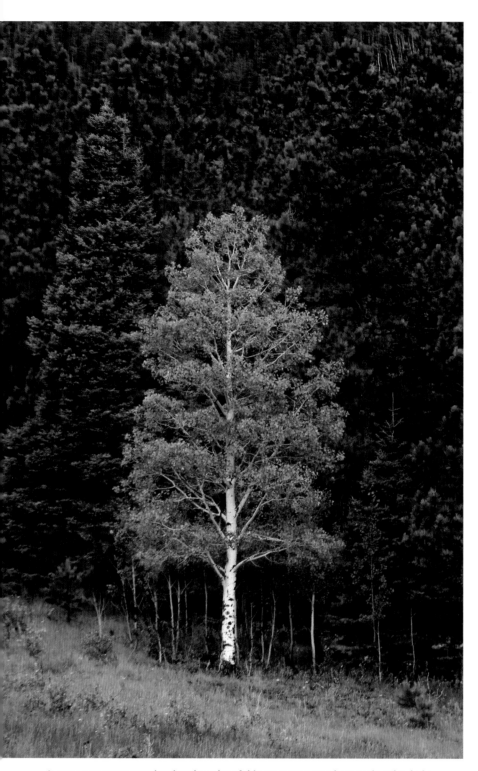

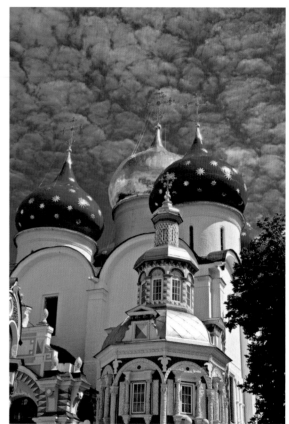

The Russian Orthodox monastery of Zagorsk outside Moscow had been restored since my last visit there many years ago. I used a 28–135mm image-stabilized lens to capture these spires against an interesting sky. ISO was set at 200 to give me enough speed for handholding.

It was an overcast morning, but the color of this aspen tree stood out against the darker green of the spruce and pines behind it. I used my 28–135mm image-stabilized lens at 135mm (equivalent to 216mm with multiplier) and handheld the camera. Later, in Photoshop, I enhanced the aspen's color a bit and darkened the trees behind to make it stand out. (See chapter 10 for some useful tips and tricks in Photoshop.)

Here, I had been photographing some sunset colors at the Paws Up Ranch in Montana. When I finished, I turned and saw this moody scene behind me. Because the light was fading fast, I quickly switched the ISO to 1,600 and got this shot using a 10–22mm ultrawide zoom. Had I been shooting film, I might have missed this shot because I would have needed to switch quickly to a high-speed film.

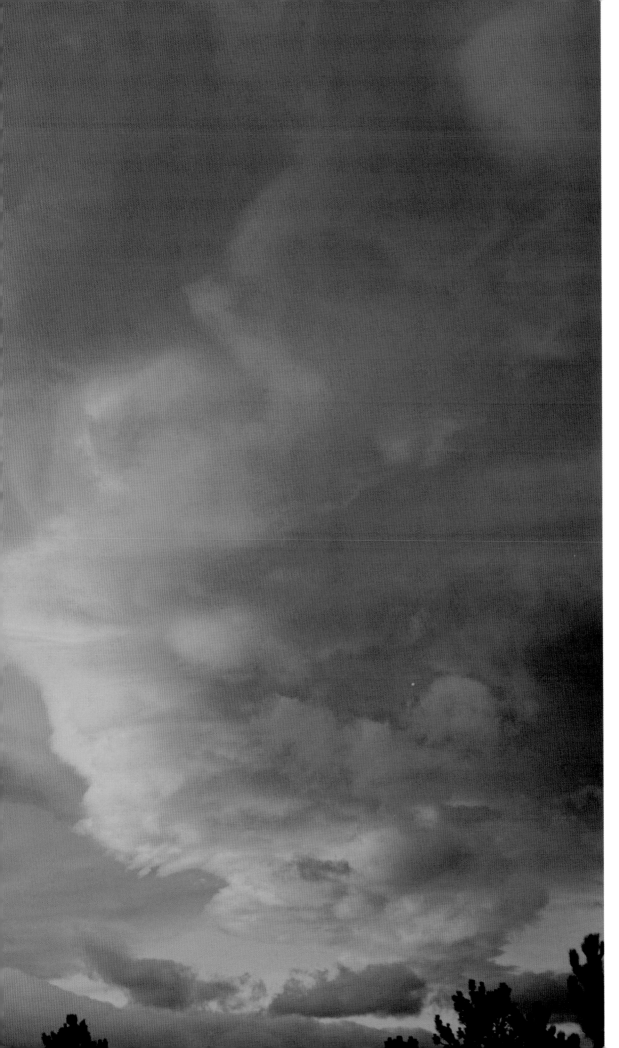

This picture literally was taken in my own backyard in the Front Range of Colorado. I was cooking on the barbecue for some friends who were over for dinner, and we saw these storm clouds moving overhead near sunset. The lighting was dramatic. I grabbed my camera with the 10–22mm ultrawide zoom for this shot. Later, before the friends left, I gave them a print of this shot.

Upper left: Some of the biggest tusked elephants in all of Africa are found in Tanzania's Ngorongoro Crater, saved from the poaching of the 1970s and 1980s by the closed geography of the crater. It makes for great photography, especially when shooting digitally to make sure you got the right pose. I used a 100–400mm image-stabilized lens on a 10-megapixel DSLR.

Upper right: A dentist's-eye view of Guhonda, a silverback mountain gorilla in Rwanda's Volcanoes National Park. Being able to shoot with a digital camera is a big help, not only to check results immediately, but to be able to change ISO settings quickly with changing lighting conditions. Rangers in the park forbid the use of flash when taking pictures (a good idea, since it minimizes human impact on these highly endangered animals), thus it's often necessary to use a higher ISO setting—in this case, 400.

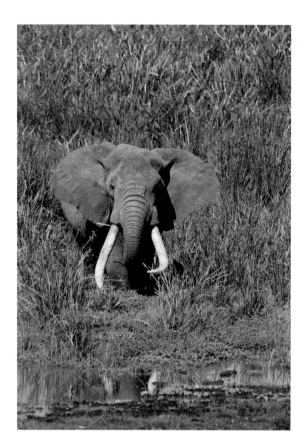

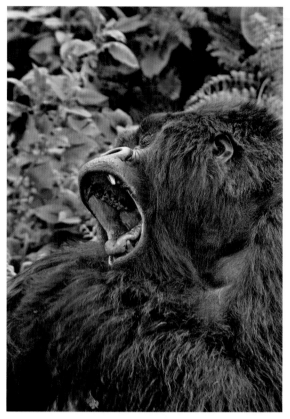

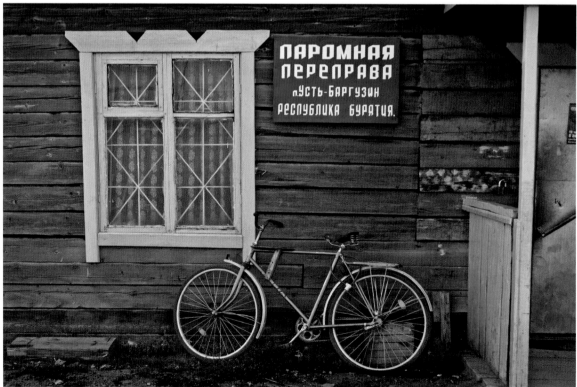

I liked the way the blue bike matched the painted trim outside this building in the village of Ust Baguzin near Siberia's Lake Baikal. It was very gloomy and overcast that morning. I used a 10-megapixel DSLR with 28–135mm IS lens, ISO of 1,600. I can read the sign. Can you?

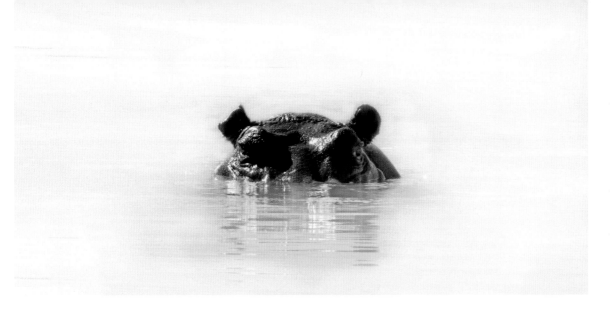

This hippo in Ngorongoro Crater was eying me warily as I made this shot. I used a layer in Photoshop to create this effect, eliminating much of the water surrounding the hippo but keeping the reflection and his eyes. See chapter 10 for more information on this technique. I used a 100–400mm image-stabilized lens at 400mm.

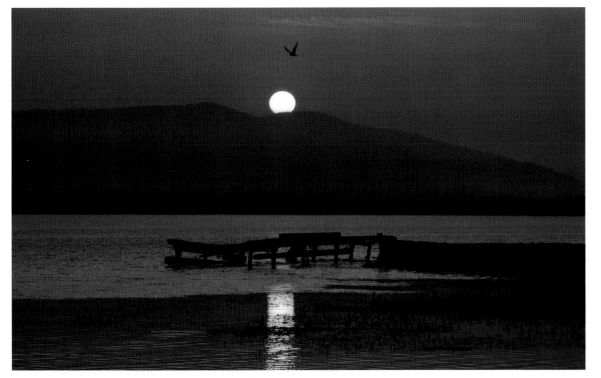

Some terns were diving in the water near this dock at the edge of the Barguzin River near Lake Baikal in Siberia. I was hoping to capture one of the birds in flight as the sun was coming over the distant hills. It was reassuring to be able to check on the LCD screen of the camera to be sure I got it. I used a 28–135mm image-stabilized lens at 135mm (216mm equivalent with 1.6 sensor multiplier effect).

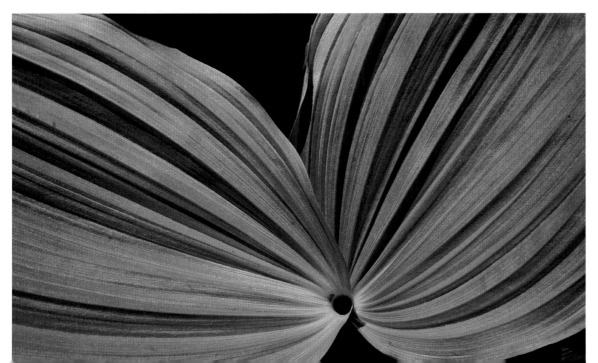

False hellebore is a common sub-alpine plant growing in the Rocky Mountains. I liked the lighting here, which emphasized the color and lines of the leaves. Shot with a 10–22mm ultrawide zoom, handheld.

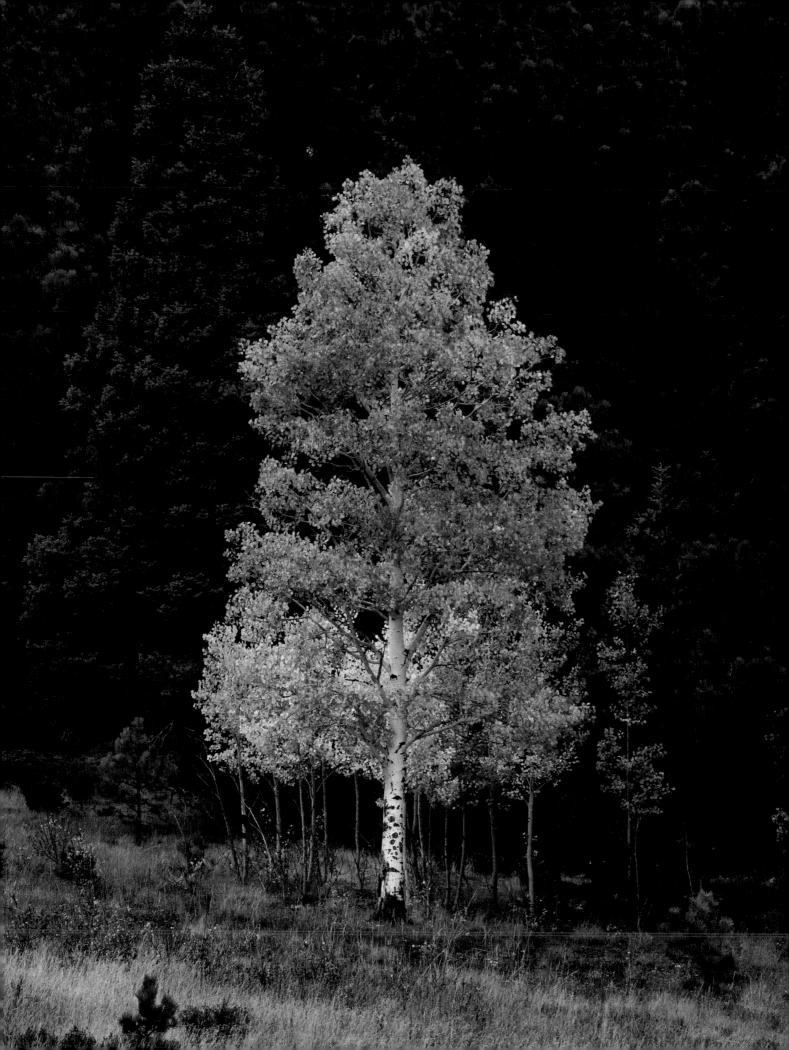

CHAPTER 1
DIGITAL BASICS

Image sensors. Megapixels. Image storage. RAW versus JPEG. Flash memory cards. Portable hard drives. Sensor size and multiplier effect.

Without getting deep into the world of electronics and quantum physics, it is useful to have a basic understanding about how digital technology works. If you are an experienced film shooter and have used some of the newest film cameras, you won't find a significant difference in the basics of the cameras themselves. The digital photographer uses sophisticated metering systems and sets functions, such as aperture priority or shutter priority or fully automatic mode, just as on the newer film cameras. Shutter speeds and f-stops still function in the same way as on film cameras, controlling the amount of light that reaches the recording medium. If you are an advanced photographer, you undoubtedly use a single lens reflex (SLR) film camera; in switching to digital, you'll use a digital single lens reflex (DSLR) camera.

The big difference is NO FILM. Instead, your digital SLR has an electronic image sensor. Rather than producing a physical piece of film, negative, or slide as a final product, you will create a digital file stored on magnetic or optical media. For longtime film shooters (like me), it's a bit scary knowing that your precious image is an ephemeral collection of 0s and 1s represented as binary data instead of something you can hold in your hand like a slide or negative.

But relax. You'll soon discover that you *can* handle it and enjoy the many advantages of digital photography.

HOW MANY MEGAPIXELS?

There are two basic types of image sensors: CCD (charged couple device) and CMOS (complementary metal oxide semiconductor). The latter is the most common. There may very well be some newer devices lurking in the wings. (And that's what makes digital photography pretty exciting nowadays. It just keeps getting better and better.) But for now these are the major devices used to record images. In their simplest forms, a CCD sensor and a CMOS sensor both do the same thing: convert photons of light into electrical pulses. If

Autumn aspen, pines, and spruce, Sangre de Cristo Mountains, Colorado. Shot with a 28–135mm lens.

you were to look at a sensor under a microscope, you'd see that the surface consists of a rectangular grid pattern of thousands of separate, tiny elements, and each element in that pattern is, basically, a pixel.

Pixels are roughly analogous to the light-sensitive grains in film emulsion. In film, a photon of light hitting the light-sensitive grain causes an invisible chemical reaction to take place, later to be made visible by developing the film with proper chemicals. In a digital sensor, the light causes an electrical impulse, a charge that is directly proportionate to the intensity of the light striking it. Moreover, each pixel has its own color filter, and each one captures only red or green or blue light. So the overall sensor is composed of a mosaic of microscopic pixels that record the red, green, or blue information from a full-color image formed by a lens.

But that's not enough. The electrical charges on each pixel have to be processed to be usable, and an internal device in the camera converts it from an analog to a digital impulse in numerical binary form (that's those 0s and 1s) to be further processed and stored. In essence, each digital camera contains its own microprocessor (computer). It's a powerful processor that has to perform numerous tasks:

- **Color interpretation**—is it light red, medium red, dark red, pastel red?
- **Corrections** for tonal ranges and contrast, as well as noise reduction (noise is like film grain)
- **Antialiasing**, or getting rid of artifacts that may appear as wavy lines or moiré patterns
- **Sharpening**

In doing all this, the processor (also known as a converter) creates what are known as RAW image files. These files contain all the basic data about the image and allow for great adjustments to be made later in imaging programs like Photoshop. In addition, the processor may also create JPEG files in which it interprets, to a large degree, what the image should look like and then compresses it. Compared to RAW files, JPEG files have limited editing capability, but they are convenient in not having to be processed further to be usable. As you'll see, if you save your images as RAW files, you have enormous control over how the images are interpreted and rendered later.

The sensor is one factor that helps to create images of good resolution. Say the rectangular sensor grid consists of 4,000 pixels by 2,000 pixels; multiplied out, that gives 8 million pixels, or 8 megapixels. The higher the megapixel count, the better the image—right? Is bigger always better? Sometimes, but not necessarily. There are other factors that enter into the resolution of the final image, including the following:

- Lens quality
- The internal image processing engine in the camera
- The type of image storage (RAW, TIFF, JPEG)

So the pixel count is only a rough measure, and in fact, the quality of the sensor itself varies from manufacturer to manufacturer.

Returning to my film analogy, even the finest-grain film will do you no good if you hang a lens of mediocre quality on the camera. And, further, the image quality may suffer if you choose *el cheapo* drugstore processing for your film over good-quality photo lab processing.

Complicating the digital image situation even more is that there are now programs for processing images, called interpolation programs, that can allow you to take a smaller-sized digital image and blow it up to a very large print size with amazing quality. I'll deal with this in chapter 12.

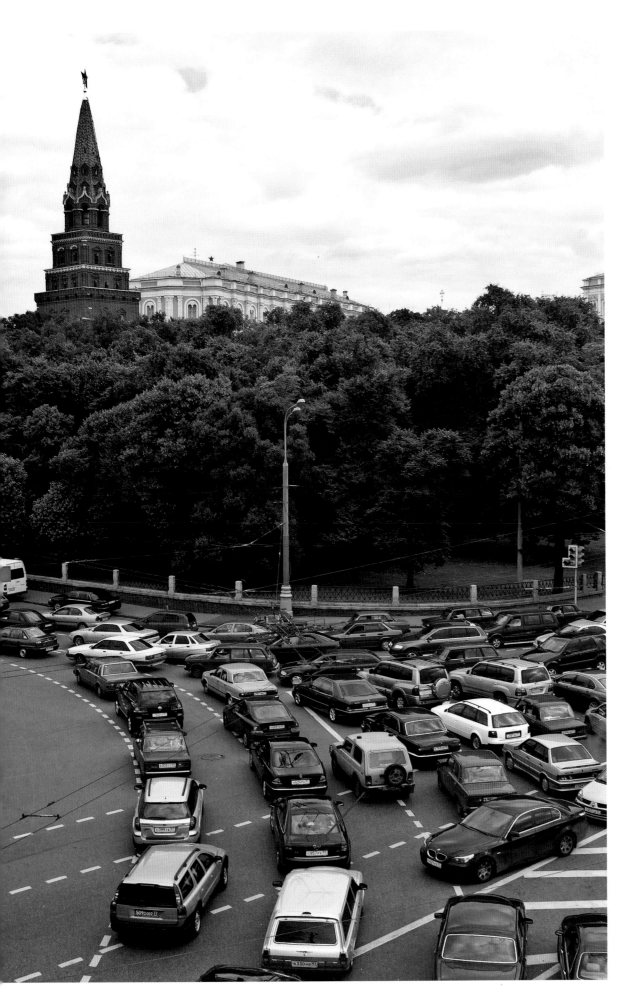

A traffic jam outside
the Kremlin in Moscow.
Note the arrow pointing
to the car's license plate.

Here is the car's plate
blown up 1,600 percent.
Note the pixels that
make up the image.

IMAGE STORAGE

Perhaps the number one factor in making digital photography a portable replacement for film photography was the development of flash memory storage devices. In your computer, data is stored on hard drives—mechanical devices that write those 0s and 1s to a magnetic disk spinning at very high speeds. Even with miniaturization, such storage devices would make a camera excessively big and bulky. In addition, the moving parts—spinning magnetic disks—make these devices vulnerable to shock and possible failure and loss of data. Not good.

Flash memory cards are static devices; that is, they have no moving parts. This makes them more rugged and allows them to be used in environments where hard drives would be too delicate. These media storage cards come in several varieties, depending on the camera system: CompactFlash (CF), Secure Digital (SD), xD, and Memory Stick. More types may well emerge in the future.

In the early years of use, flash memory cards were of rather low capacity—perhaps 256 megabytes (MB). As image sensors increased in megapixel capability, such small storage capacity resulted in photographers sacrificing either quantity or quality. It was necessary

either to purchase a lot of cards or to store image files as compressed JPEGs (more on this below) to maximize the space available. After all, if each picture you took was 10MB, you could only store twenty-five pictures per card. In recent years, the flash storage capacity has increased enormously: 4-gigabyte (GB) cards are common, and capacities up to 64GB are available, with possible higher capacities in the offing.

I should mention one other type of storage card: micro drives. These are miniaturized hard drives made almost as small and portable as some of the flash memory cards mentioned above. These can achieve storage capacities equivalent to the flash memory cards, and some (but not all) DSLRs can accept them. There is debate in the digital photography community about the reliability of these micro drive cards. They are mechanical, with moving parts, and may not be as rugged and reliable as flash memory cards.

So how many pictures can you store on a flash card? The answer depends on three factors: the camera's sensor, the camera's internal processor, and how you choose to store the images (RAW, JPEG, or RAW+JPEG). For example, on one of my camera bodies, a Canon Digital Rebel xTi (a 10-megapixel camera), saving the images as a RAW plus medium JPEG simultaneously allows me to store about two hundred images on a 4GB card. If I were to choose to store the images as high-resolution, low-compression JPEGs, I could get almost two thousand pictures on that 4GB card. So why wouldn't I always store my images as JPEGs? As you'll see later, there is a good reason that I store my images in RAW format.

Compact flash memory cards keep coming in larger and larger capacities that allow more pictures to be stored.

FLASH MEMORY CARD PRECAUTIONS

As good and as reliable as they are, flash memory cards are not 100 percent reliable yet. If you peruse internet photo forums, you will discover lots of discussion of card problems and failures, some of which are due to user mistakes, some of which are not. Here are some tips for avoiding user mistakes.

Don't try to work the card when it doesn't have battery power. Letting the batteries die in the middle of taking pictures may corrupt not only the picture you are currently taking but all of the pictures on the card. Always carry spare, fully charged batteries, and change them well before the battery in the camera becomes fully discharged.

Don't overwork the card. Never remove the card from the camera while it is being written to (right after you have taken a picture), or you risk losing all of your photos. Turn the camera off before you remove the card. And if you shoot in continuous shooting mode to follow fast action, let the internal processor finish its task before taking another set of pictures. Otherwise your camera may freeze up and, again, you could lose all of your pictures. Most DSLRs have an indicator, usually a red light, that tells you it's processing.

Beware of physical harm to your card. Store the card in the protective case it came in. Along the same lines, keep your card protected from excessive heat, cold, and moisture. This is just common sense. Flash storage cards have held up well in all sorts of conditions, but why push your luck?

Avoid magnetic fields and electric shock. Magnetic fields could cause loss or corruption of data on the card. Did you know that many sound speakers have magnets in them? Might not be a good idea to set either camera or storage cards on a speaker enclosure. And in dry climates, be careful of static electricity; even a tiny spark might have some effect.

Regarding x-rays: I travel extensively, and I have never had problems with airport security scanners affecting flash memory cards. In fact, there is no physical reason why they should, unless you subject them to very high-intensity x-rays—which would not likely be used at normal airport security gates.

Since flash cards can fail (with subsequent loss of valuable images), I take some special precautions. While it may seem nice to have a very large-capacity card, say 8GB or 16GB, remember that if something happens to that card, you will lose a *lot* of pictures. For most of my shooting, I use a 4GB card (holding about two hundred pictures as RAW+JPEG files or nearly four hundred pictures as just RAW files). That way, if I have a card failure, I haven't lost *that* many images.

Play it safe!

byte (B)	A unit of computer memory or data storage.
kilobyte (KB)	One thousand bytes. A small file used for email or Internet is in the kilobyte range.
megabyte (MB)	One million bytes. A high-resolution photo file is in the megabyte range, perhaps 20 to 30MB.
gigabyte (GB)	One billion bytes. A standard hard drive is in the gigabyte range.
terabyte (TB)	One trillion bytes. A huge hard drive is in the terabyte range.

MORE STORAGE

What happens when you fill up a flash memory card?

Obviously you can carry around a lot of cards and continue shooting, but eventually when all those cards are filled you will want to transfer the image files on those cards to something relatively permanent. If you've brought along enough flash cards in the field, you can wait until you get home to upload the files into your computer. If you are on an extended trip, you have a couple of options: Bring along your laptop computer or use one or more portable hard drives to upload those images. Both options have advantages and drawbacks:

- **Laptop.** I try to avoid bringing a laptop on photo trips simply because of the bulk and weight (even though some are quite small and light nowadays). However, the laptop *is* nice because not only can you upload and store the image files on the hard drive, you can edit, sort, and arrange those shots in an orderly filing system (we'll discuss this in detail in chapter 9).

- **Portable hard drive.** This is an alternative to carrying a computer. These devices come in various capacities, the most common being 40GB, 60GB, 80GB, and 160GB.

(There may well be even larger capacities soon.) Most of these have viewing screens allowing you to preview images and do some preliminary editing (e.g., deleting obviously bad shots). Portable hard drives have card slots for the most common types of flash memory cards, making it fast and easy to upload images.

In carrying and using portable hard drives, it is important to remember that they *are* hard drives, which are generally sensitive devices. Even though the portable versions have been built to withstand use in the field, they can fail—especially if dropped or subjected to really rough treatment. Also, bear in mind that once you've uploaded images from your flash memory cards and erased and reformatted those cards, all your precious images now reside on that single portable hard drive. If there is one cardinal rule in digital photography, it is this: BACK UP, BACK UP, BACK UP! In order to protect those image files, some photographers carry both a laptop AND a portable hard drive. In my case, I carry two Epson P-7000 portable hard drives of 160GB capacity each. Both together weigh less than the lightest laptop, and I upload the same flash memory cards into each so that I have identical storage.

The viewing screen of the Epson P-7000 portable hard drive. You can zoom in to examine images carefully for sharpness. I usually carry two P-7000s for backup. Over several years of using Epson drives, I've found them to be reliable and rugged enough to withstand a lot of usage in remote locales.

FILE FORMATS

The most common file formats for images are JPEG, TIFF, and RAW.

- **JPEG** stands for Joint Photographic Experts Group, which sets the standard for the compression of image files. JPEG images are often referred to as "lossy" (as opposed to "lossless") because, in compression, some image data is discarded and lost. The degree of compression affects the image quality; highly compressed image files are smaller in size but cannot be printed as large as files that have low compression. In addition, each time a JPEG file is opened and *any change is made to the image, such as sharpening*, when saved again, the file is recompressed and more data lost. Over time, with frequent changes and recompressions, image quality suffers.

- **TIFF** stands for "tagged image file format," and it is a "lossless" file, meaning that no matter how many times it is opened, manipulated, and resaved, no data is lost. However, TIFFs are generally very large files. For this reason, not as many cameras offer the option of storing image files as TIFFs.

- **RAW**, which is not an acronym, is a file format created in the camera after exposure and processing by the camera's internal processor. It is, as the name implies, raw data that needs to be further processed by Photoshop or the manufacturer's software to fine-tune the image for color balance, sharpness, saturation, and more. Each camera manufacturer has its own proprietary RAW file format, different from others. (There is a movement afoot to set one standard RAW file format, called DNG, for all cameras, but thus far it hasn't been adopted.)

 You should think of a RAW file as a format that gives the most options for improving and fine-tuning the final image through later processing. It can be likened to shooting a negative on film where, through adjusting, processing, and printing, the best possible image can be produced.

 RAW files do require more storage space, though not as much as TIFFs. Thus, if you shoot RAW, you will need lots of storage space in the form of memory cards and external hard drive space.

JPEG VERSUS RAW FILES

When you open the box containing your shiny new DSLR camera, you need to make an important decision right off, before you begin shooting: How should you store the images? JPEG or RAW?

JPEG is an abbreviation for Joint Photographic Experts Group, which, back in 1992, issued the standard for compressing data in an image file. A JPEG image is compressed—that is, it uses complicated algorithms to compress the data in such a way as to make a small data file for easier storage and transmission. In order to compress an image, certain information is discarded by the processor. JPEGs also have limited tonal range compared to RAW files. The amount of compression varies; a small amount of compression yields an image file of higher quality (less information is discarded) than a file that has a high degree of compression.

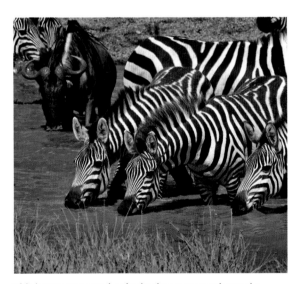

This image was saved as both a low-compression and a high-compression JPEG. Note that when we examine the circled area of the low-compression JPEG (*above right*) at 500 percent, there is some detail in the hairs of the zebra's ear. However, in the image saved with high compression (*below right*), notice the "blockiness" and loss of detail.

27

File Type	Advantages	Disadvantages
JPEG (.jpg)	■ Smaller file. ■ Allows more images to be stored on memory cards or hard drives. ■ Easy to email.	■ Lesser quality. ■ Quality suffers each time image is tweaked and resaved.
RAW (.raw)	■ Allows more control over image quality through processing in computer. ■ Allows fine-tuning of color balance, sharpness, and saturation.	■ Requires processing in computer to store as a usable TIFF or JPEG file, a time-consuming process.
TIFF (.tif)	■ Can be opened and tweaked and resaved with no quality loss. ■ High-quality image file.	■ Large file sizes take up a lot of space on memory cards and hard drives. ■ Not many digital cameras are capable of creating and storing TIFFs.

Should you store your in-camera images as JPEGs? If you don't want to be bothered with post-processing of the image files, JPEGs are a reasonable choice. If you choose this option, be sure to store your photos at the highest quality (lowest compression) so that you can make larger prints later.

However, if you want the best possible image quality through fine-tuning later, choose RAW. Many, if not most, digital camera systems allow you to do both: You can store a RAW image file simultaneously with a high-quality, medium-quality, or low-quality JPEG. The advantage of this is that you have a JPEG image ready for immediate use on a website or emailing without further processing *and* you still have the later option of tweaking the RAW image for best quality.

COLOR SPACE

In addition to choosing how you save your images (RAW, JPEG), you can choose the color space for those saved images. The usual in-camera choices are sRGB and Adobe RGB. A color space is defined as a range of colors that your camera sensor sees and your computer monitor displays and your printer prints. To simplify the differences between the two types here, the Adobe RGB has a wider gamut or range than sRGB. If your primary use of images is for the web or monitor display (including LCD projected slide shows), sRGB is a reasonable choice. For printing or publication, Adobe RGB with its wider gamut is preferable. These can be set as your camera capture choices as a menu item.

SENSOR SIZE AND MULTIPLIER EFFECT

In a standard 35mm film camera, the film frame size is 36mm (millimeters) wide by 24mm high. Early on, it was decided that the "normal" lens for that format is the same focal length as the diagonal of that film frame—about 43mm. For convenience, this was rounded up to 50mm in focal length. Wide-angle lenses are 35mm, 28mm, and 24mm, and ultrawide-angle lenses are 20mm or less. Conversely, telephoto lenses are anything longer than 50mm in focal length.

Some high-end DSLRs have sensors the same size as a 35mm film frame. Because of the increased cost of manufacture, these full-frame DSLRs are higher priced. They are generally capable of taking 12-megapixel or larger digital photos. Examples are the Canon EOS 5D Mark II (21.1 megapixels), the Canon EOS 1DS

Mark III (21.1 megapixels), and the Nikon D3X (24.5 megapixels). As with film cameras, a 50mm lens creates "normal" photos, not wide-angle or telephoto.

In midrange digital cameras, the image sensor is typically smaller than the equivalent 35mm film frame. A common size is 22mm by 15mm (although these dimensions vary by camera manufacturer. When using a "standard" 50mm lens, then, the sensor looks at a smaller image area—effectively cropping part of the image. This gives rise to a multiplier effect. The magnification is generally about 1.5 or 1.6 times (although this, again, varies by camera). Thus on a Canon 50D camera body with its 1.6x multiplier, a "normal" 50mm lens becomes effectively an 80mm lens. A 100mm lens becomes effectively a 160mm lens, and so on.

For the outdoor photographer, this multiplier can be an added benefit when trying to shoot wildlife from a great distance—since it boosts a 400mm telephoto lens to a super-telephoto 640mm! But this "benefit" acts to your disadvantage when trying to shoot a landscape scene, since it makes your 20mm ultrawide-angle lens a not-so-ultrawide 32mm.

To counter this effect, most camera manufacturers have designed special wide- and ultrawide-angle lenses to be used exclusively with midrange DSLRs that have smaller sensors. Most of these are zoom lenses of excellent quality, giving a great range of focal lengths— 10mm to 22mm, for example (the equivalent of a 16–35mm focal length in full frame).

Are the smaller image sensors of lesser quality? The answer is no. Even though smaller than a full 35mm frame, these imaging devices can produce very high-quality pictures— certainly of a caliber for professional use. Moreover, these cameras tend to be smaller and lighter than the full-frame versions—in some cases less than half the weight of the bigger frame camera bodies.

The full image area represents what would be captured on 35mm film or with a full-frame sensor in a DSLR using a 400mm lens. The white rectangular area shows what is captured using the same 400mm lens on a DSLR with a smaller sensor giving a 1.6 multiplier effect.

CARE AND MAINTENANCE

Despite being packed with sensitive electronics, DSLRs hold up reasonably well outdoors. The major things to avoid are physical shock and extreme weather conditions:

■ **Shock.** Physical trauma was something to avoid even with film cameras, although I recall some of my earlier film cameras getting some pretty rough treatment on certain backpacking and mountain-climbing trips. I once fell off a cliff in Siberia, sliding and bouncing thirty feet down some rocks. My Leica R4 hit the granite several times, yet it continued to function for the rest of the trip with no problems. (Later-model Leicas were nowhere near as rugged.) And my old Nikon F was often described as being built like a hockey puck.

My personal experience has shown that modern DSLRs need a little more babying. It's not just the camera body that needs protection against bumps. One of my Canon lenses, an autofocus zoom with image stabilization, rolled off a coffee table in a Moscow hotel onto a heavily carpeted floor. The drop was no more than 18 inches (46cm), but it rendered the autofocus, manual focus, and image stabilization useless. The lens was shot. (It was later repaired and now functions again.) Since then, I have taken great pains to coddle my digital equipment.

■ **Extreme Weather.** Excessive cold, heat, or humidity can cause problems. For one of my digital cameras, the operating temperature range is listed as 32 to 104 degrees Fahrenheit (0–40°C) with a relative humidity of 85 percent or less. Now, if you live in Phoenix, Arizona, you may be pushing the envelope on the high end of the temperature range. In Colorado during the winter, on some days 32 degrees Fahrenheit (0°C) may be the *high*. And in the rainforests of Peru or Borneo, the humidity hovers around 100 percent. So how do you deal with this?

▶ **Cold.** When working outside in low-temperature environments, keep the camera inside a coat or parka. And have lots of extra batteries because the cold drains them. The operating temperature ranges listed in the manual are probably conservative. I suspect that working in winter down to 0 degrees Fahrenheit (-18°C), at least for short periods of time, would not have any adverse effect. Some photographers have reported working in well-below-zero temperatures without problems, though they made sure to keep the batteries warm inside a parka.

▶ **Heat.** The high end of the operating temperature range can possibly be a problem, but again, from my experience, using digital cameras in daytime temperatures over 100 degrees Fahrenheit (38°C) doesn't have any adverse impact. I was photographing in Serengeti one day when the temperature hit 108 degrees Fahrenheit (42°C); even working all day in those conditions didn't have an adverse effect on the camera. However, the relative humidity was low—less than 40 percent.

▶ **Humidity.** High humidity may be the one weather condition that presents real problems for digital cameras, especially when combined with very high heat. Moisture affects electronics, and digital cameras are packed with electronics: circuit boards, sensors, battery contacts, autofocusing mechanisms, image stabilization mechanisms, and more.

With care, you can prevent many problems that might occur. I spent many days in the high-altitude rainforests in Rwanda photographing mountain gorillas—sometimes in a downpour. I carried a lot of plastic bags and made sure I kept the cameras covered as much as possible when shooting. Each evening, I put the cameras and lenses in sealed plastic bags with silica-gel drying agent packets to pull out any moisture that may have accumulated in the innards. I had no problems and came away with great mountain gorilla shots.

A word of caution: Be sure that you bring an adequate supply of silica-gel packets and keep them sealed in their own plastic bags. If you need to reuse some, they should be baked in a moderately hot oven (300°F; 149°C) to drive off absorbed moisture. Or just bring plenty of them and discard after a few uses.

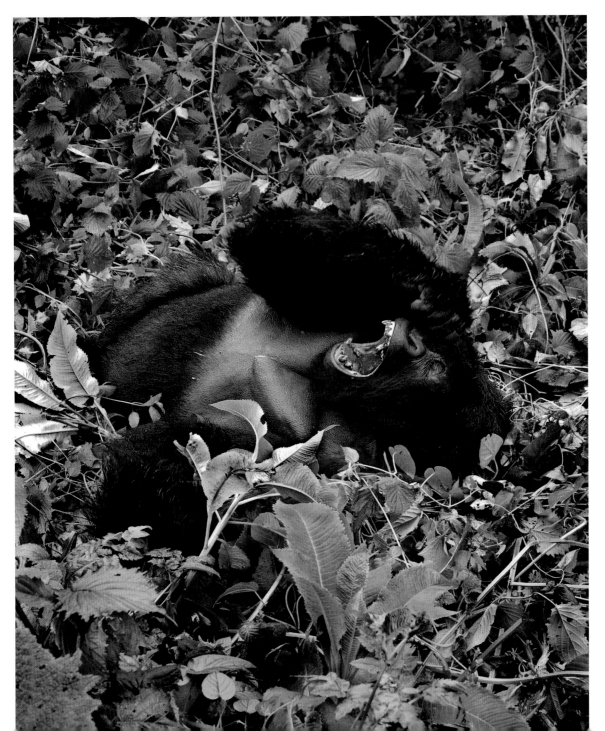

A silverback mountain gorilla takes a nap in the rainforest of Volcanoes National Park, Rwanda. Plastic bags and silica-gel drying agent packets kept my camera and lens dry and in good working condition during the rainy trip.

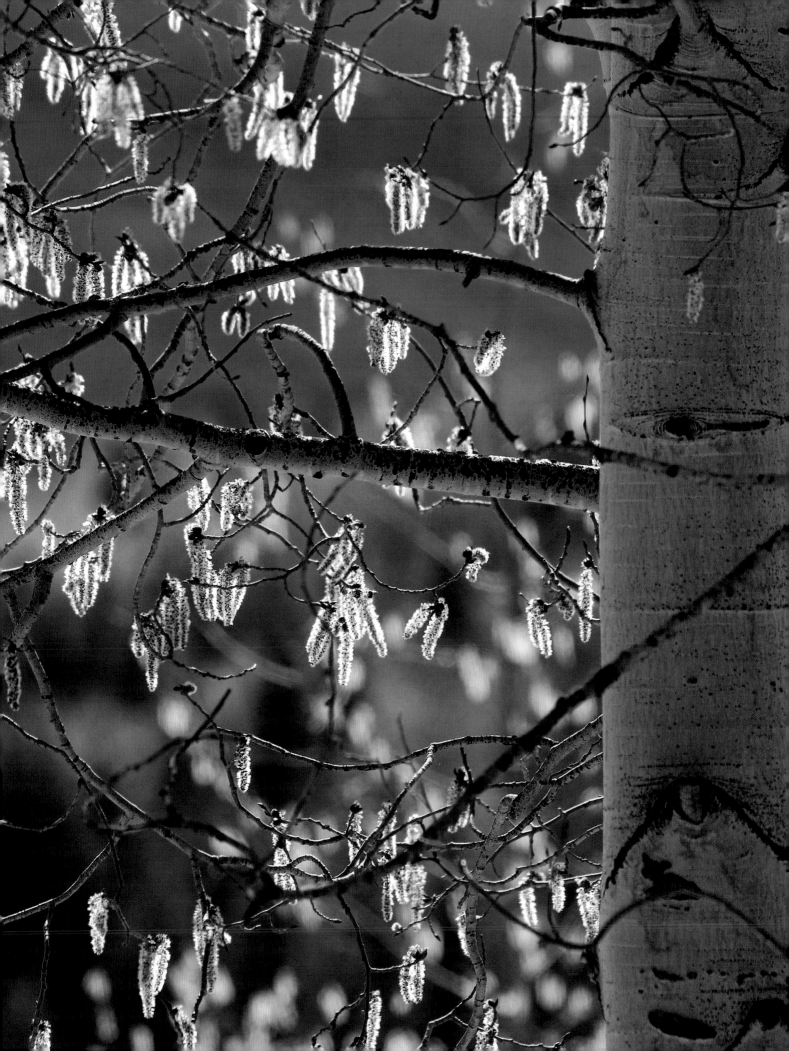

CHAPTER 2
IT'S ALL ABOUT LIGHT

ight is the essence of photography. The very word is derived from two ancient Greek words: *photos*, meaning "light," and *graphos*, or "write." Literally, it means writing with light. To become good writers of light, we must understand two attributes of light: quantity and quality.

Quantity of light determines exposure. Specifically, understanding the intensity of illumination will lead to the proper exposure of the image.

However, there's much more to mastering light than just proper exposure. Quality of light is important in the overall mood and impact of a photograph. Quality is determined by direction of light, such as front light or backlight or side light; by certain intangibles like mood, warmth, or coolness; and by the softness or the harshness of light.

By achieving mastery of the quantity of light and by having good knowledge of the attributes of the quality of light, we can "write with light" very fluently.

QUANTITY OF LIGHT AND THE HISTOGRAM

No, this is not Calculus 101. Don't let the word *histogram* frighten you off.

Back in the olden days (not so long ago), before cameras had built-in metering systems, film photographers carried handheld light meters to determine proper exposure. These were tricky to use, and exposure could vary depending on where you pointed the meter. In time, in-camera metering systems were developed. These, too, were tricky to use. In further time, in-camera metering systems evolved into complex, highly accurate, and versatile mechanisms that made it easy to get proper exposure.

That's true today in DSLRs. These light-measuring devices, through the lens meters, can be relied upon to produce proper exposure for 95 percent of all picture-taking situations. (We'll talk about the other 5 percent later.) However, the term *proper exposure* is open to interpretation, for some pictures may be improved by under- or overexposure.

Spring catkins on aspen tree near Hoback, Wyoming. Shot with a 100–400mm lens.

Low-key lighting produces dark tones and muted colors in a photograph, creating a somber, forbidding mood.

High-key lighting produces light tones and bright colors, creating a lighthearted, upbeat mood.

33

Modern DSLRs have an LCD screen for viewing images—that is, checking pictures just made and any others stored on the flash memory card in the camera. While these LCD screens have improved and gotten larger, it is still difficult to judge from that view whether the exposure is correct or needs fine-tuning. That's where the histogram comes into play—a very useful device.

REFLECTING LIGHT

Let's go back to basics. (For advanced photographers, you can skip this section if you wish, though it may serve as a useful reminder of some of these principles.) First, it's necessary to understand that metering systems measure how much light is being *reflected* from a scene. All metering systems are based on the reflectance of an 18 percent gray card. Why?

ANALYSIS OF A HISTOGRAM

Examine this photograph and corresponding histogram carefully because it will help you gain a better understanding of what a histogram is doing for you:

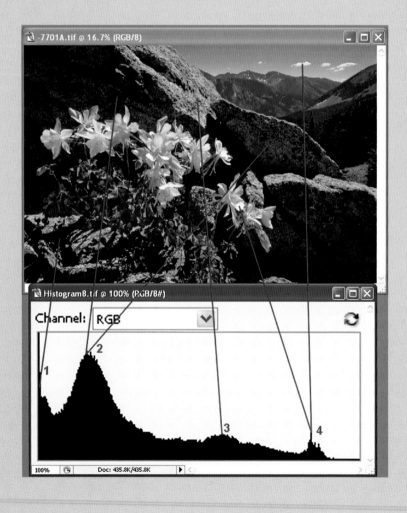

1. Starting at the left, spike 1 indicates that some parts of the photo are nearly pure black with no recoverable image data. In this case, the spike corresponds to those deep shadows and crevices in the rocks. It really doesn't matter, though, because you don't need—or want—detail in those places anyway.

2. Spike 2 indicates that the largest amount of image data is in the dark middle tone area, corresponding to the shadow side of the rocks. If desired, more detail can be brought out in these areas later.

3. Spike 3 is a small peak in the middle tone area of the graph that corresponds to the sunlit portion of the rocks and possibly portions of the sunlit green leaves.

4. Finally, spike 4 corresponds to the white petals and white clouds. But notice that this peak is well away from the far right edge of the histogram, indicating that there *is* recoverable image data. In other words, the highlights are not blown out.

Overall, the histogram tells you that this image is slightly underexposed but that it can later be adjusted in Photoshop for an outstanding print.

Because an average outdoor scene is made up of many objects and elements reflecting light, ranging in brightness from white or near-white to black or near-black. If it were possible to make very precise spot measurements of the reflectance of a great many of these elements, you could average them all and come up with an approximate exposure determination that would appropriately light a reasonably wide range of those different elements. It's also possible to arrive at a good approximation of exposure by using a single gray card with a reflectance of 18 percent—often referred to as "middle gray." This simply means that most objects in an average scene have a reflectance not greatly different from that 18 percent gray. Keep in mind that this has nothing to do with the *color* of these objects, only the *amount of light* reflected from them.

Second, you should understand that image sensors in digital cameras, like film, have a limited range of light values that they can capture and record, though the dynamic range of the newer sensors is actually better than slide film. Slide films have a dynamic range of about five f-stops; the dynamic range of some digital sensors is about seven f-stops. Dynamic range is that range of reflected light from an object that is capable of being recorded with any detail by the film or sensor. That is why scenes in bright sunlight may have very bright objects and very dark areas that have no detail: They lie outside the dynamic range of the film or sensor. In other words, highlights may be totally washed out and shadows become inky black. See chapter 8 for a discussion of a digital technique called HDR, or high dynamic range, which extends the dynamic range of a picture.

Think of a histogram as one more tool to help expose a picture properly for the best possible image. Looking back, think about how you evaluated images shot on film.

After the film was processed, you evaluated the slide for exposure, and from this you gained knowledge to be used in photographic situations later that had similar kinds of lighting. Often, when shooting slide film, I bracketed exposures by ⅓ or ½ f-stop on either side of the "correct" indicated meter exposure (under- or overexposure). It was a way of fine-tuning exposure, especially in tricky lighting situations.

Well, now you can do that with a histogram for instant feedback, and you don't have to wait until after the film is processed. In DSLRs, you have the option to display a histogram along with the image on the LCD viewing screen. Keep in mind that this histogram is the average of three color channels: red, green, and blue (RGB). (In Photoshop it is possible to display a histogram that shows these color channels separately.)

The histogram is a graph. The horizontal scale, left to right, represents the brightness range on a scale from 0 to 255 where 0 is pure black with no detail and 255 is pure white, again with no detail. Here's a representation of that gradation:

At the very left is 0 (pure black), and at the very right is 255 (pure white).

The vertical axis of the histogram represents the amount of data for a particular range of brightness. A very large spike at the left edge of the picture indicates that a large

part of the picture is very dark. A very large spike at the right edge of the picture indicates a large part of the picture is very bright. Here are some examples:

This is a photo of a pure black object. The histogram to the right shows a black bar at the left edge, indicating that the entire picture is pure black.

This is a photo of a pure white object. If you look carefully at the right edge of the histogram, you'll see a spike on the graph indicating that this entire picture is pure white.

This is a shot of an 18 percent gray card. The histogram shows a spike right in the middle of the graph with no other spikes, indicating that the entire picture consists of a medium-gray object.

The major point to remember in reading histograms is that data spikes at the extreme left (0) or right (255) are problems that you may want to avoid depending on how much of your picture falls within these zones. These points indicate parts of the picture that are either so dark or so light as to be unrecoverable later using techniques in Photoshop.

Now for some real-world examples.

In the histogram of this scenic mountain shot (opposite top), there are large areas that fall into the middle tones and darker middle tones (indicated by the two peaks just to the left of center). These correspond to the green areas, the soil, the rocky portions of the mountains in the background, and the blue sky. There is also a spike farther to the right corresponding to the snow patch and the clouds, which are obviously lighter than middle tones. No portion of the histogram hits the extreme right (brightest) edge, and only a small portion hits the extreme left (darkest) edge. Overall, the picture is slightly underexposed but perfectly usable and able to be further enhanced later in Photoshop for a perfect print. (We'll cover this in chapter 9.)

When you display image data on the LCD screen of most DSLRs, you may also display the histogram at the same time (opposite). In addition, some cameras will show areas of blown-out highlights as blinking regions in the

COMPARING TWO EXPOSURES

The first thing to note in this histogram (opposite left) is the very large spike at the far right edge. Large areas of that snowbank have no detail, and it would be extremely difficult, if not impossible, to adjust this shot in Photoshop for a good print. Note that the large spike near the left edge shows *some* shadow detail, and more might be pulled out. Overall, though, it's a difficult shot to work with.

Now let's look at the same shot slightly underexposed (opposite right). The spike on the right representing the bright areas is away from the extreme right edge and therefore has usable image data—detail, in other words. At the left side, the spike corresponds to the deep shadow area under the snowbank. Some portion of the left-hand spike is at the edge of the histogram—meaning pure black. But part of it has some recoverable detail, if we wish to pull it out later in Photoshop. The remainder of the histogram shows middle tones ranging from dark to lighter. In chapter 9, we'll look at how this image can be enhanced in Photoshop for a good print.

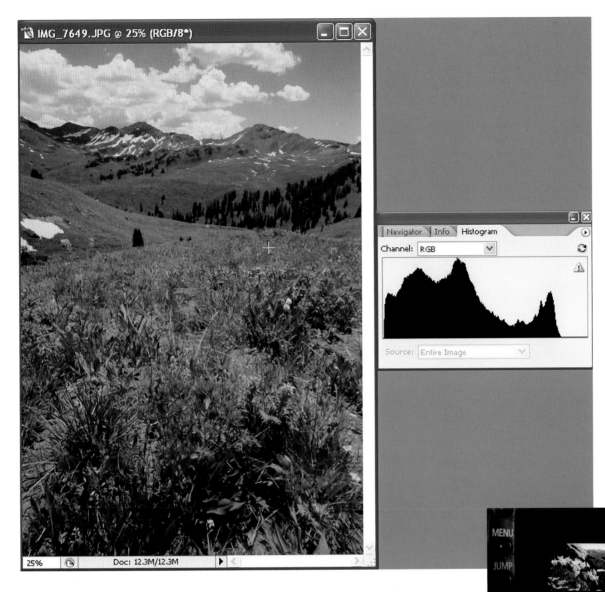

display—giving you a hint that you may need to re-shoot with adjusted exposure. The main point here is to learn how to use all of this information to give you the best possible picture. Otherwise you may be frustrated later in trying to correct images with your computer.

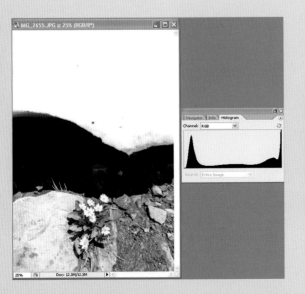

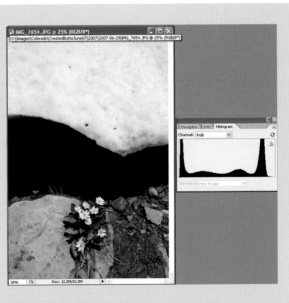

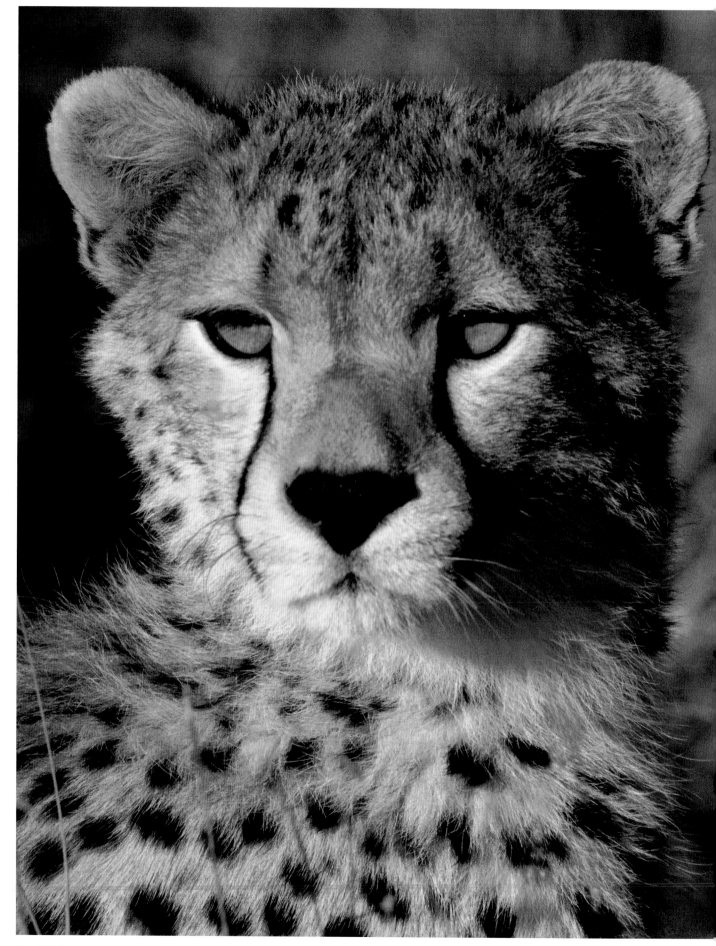

38 Front lighting.

QUALITY OF LIGHT

There is no meter or histogram that can measure the *quality* of light. It is something you must learn to look for, determine, and utilize on your own. One of the most important attributes of light is direction—that is, what direction is the light coming from? It used to be a slavish rule for amateur photographers to take pictures with the light coming over their shoulders. In other words, the subject should always be illuminated by front lighting. This made a certain amount of sense when using simple, non-adjustable cameras to ensure uniform, proper exposure of the subject.

However, as a photographic artist, you want more than decent exposure. You want to think about the directional qualities of light and to use them for creative effect. Let's look at some of these qualities:

- **Front lighting** is often referred to as flat lighting because three-dimensional objects tend to lose their form when illuminated with front lighting. Texture, too, is lost. This type of light can also be harsh, as in the case of on-the-camera flash or direct sunlight. Shadows, which often give a sense of perspective or dimension, are minimized or eliminated with front lighting. So it becomes a challenge to use front lighting to create drama and dimension in pictures—but not impossible. The most dramatic use of front lighting occurs when a main subject is lighter or darker than the surroundings or background (*opposite*). Contrast between colors or contrast between reflective qualities can also keep the picture from being flat and uninteresting.

- **Side lighting** is the kind of light that gives dimension to things. Shapes gain form and textures crackle when side lighting is used effectively (*above top*). Shadows are most prominent with side lighting and help to give a sense of perspective and dimension

Side lighting.

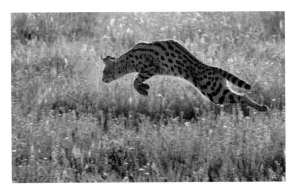

Backlighting.

to landscapes. One of the pitfalls is contrast, especially with harsh side lighting. One side of an object may be brightly lit, while the opposite side is in deep shadow. Unless you want the drama from such stark contrast, be cautious.

- **Backlighting** is the trickiest kind of lighting to utilize, but it can also be the most dramatic (*above bottom*). Two problems: exposure determination and lens flare. Since you're aiming the camera *at* the light source, the meter can be tricked into giving the wrong exposure. In fact, what *is* the right exposure? Because of the dramatic nature of the light in a backlit scene, there actually may be several "correct" exposures, depending upon the degree of contrast and the emphasis you wish to achieve between subject and background. Lens flare is created when direct sunlight hits the front of the lens, making very light, distracting patterns. A lens shade can help eliminate some flare, or you may need to change your position and angle of view to eliminate it entirely. It's most often a

39

Expodisc.

problem when using wide- or ultrawide-angle lenses.

Backlighting also dramatizes the translucency of things like flowers and foliage. When photographing brilliant autumn foliage, try moving around the tree so that sunlight is shining through the leaves toward you. The color becomes much more intense. The same applies to flowers. Use backlighting to bring out the intense colors or delicate variations in whites.

When considering quality of light, you also need to consider such attributes as harshness or softness:

- **Bright, direct sunlight** is harsh, with the tendency to wash out color and negate subtle differences in hue and tone. It also creates the most contrast of all types of natural light, straining the limits of what most color films can handle.

- **Overcast light** has a lovely, soft quality to it that enhances the photographic rendition of many subjects. Overcast light is perfect for subjects where I want to portray subtle hues and tones, as in forest scenes or flower shots (*opposite*). It's also flattering light for people portraits.

- **Open shade** is similar in quality to overcast light in that it is soft, diffused lighting, but there's another attribute of open shade that you need to consider: It often has a cooler quality.

COLOR TEMPERATURE

The coolness or warmth of the lighting in a photograph is referred to as the color temperature and is measured on the kelvin temperature scale. Midday sunlight is about 5500 kelvin. The higher the color temperature, the cooler (bluer) the light. The lower the color temperature, the warmer (redder) the light.

In the open shade of a bright, sunny day, the clear blue sky is above 6500 kelvin and adds a strong element of blue. In open shade at higher elevations, such as my domain in Colorado, there's also a distinct blue component in the light. This color temperature gives an unnatural cool cast to photographs and often requires white balance adjustment. In film cameras, this requires use of a warming filter, such as an 81A or skylight, or the use of a warm-toned film. In DSLR cameras, you can adjust the white balance digitally; however, this can get a little tricky.

One of the best devices to help you achieve a good white balance is the Expodisc. It looks like a strange filter that you slip over the front of your lens (*left*). Aim it in the direction of your primary light source, then take a picture. Because the Expodisc records a perfect 18 percent (neutral) gray, you can then use this stored image file to set your camera's white balance. (Go into the menu, select custom white balance, and select the image you just made on your media card.) Every time you encounter different lighting conditions, you should use the Expodisc and set the white balance accordingly.

You can also adjust color temperature later in the computer using Photoshop or Adobe Lightroom. However, this, too, can get a little tricky, and you may have difficulty achieving the desired results if your monitor isn't calibrated properly.

There are times of day when outdoor light has a warm quality to it. Very early morning and late afternoon sunlight is warm, which is flattering for many subjects and scenes. In landscape photography, midday light is deadly—harsh and full of contrast. This is true for film shooting and also for digital. In early morning, with long shadows and the warmth of the dawn sun, landscapes take on an intensity of color and a dimension that can't be equaled at midday. Late afternoon light is similarly warm, though in many locations it tends to

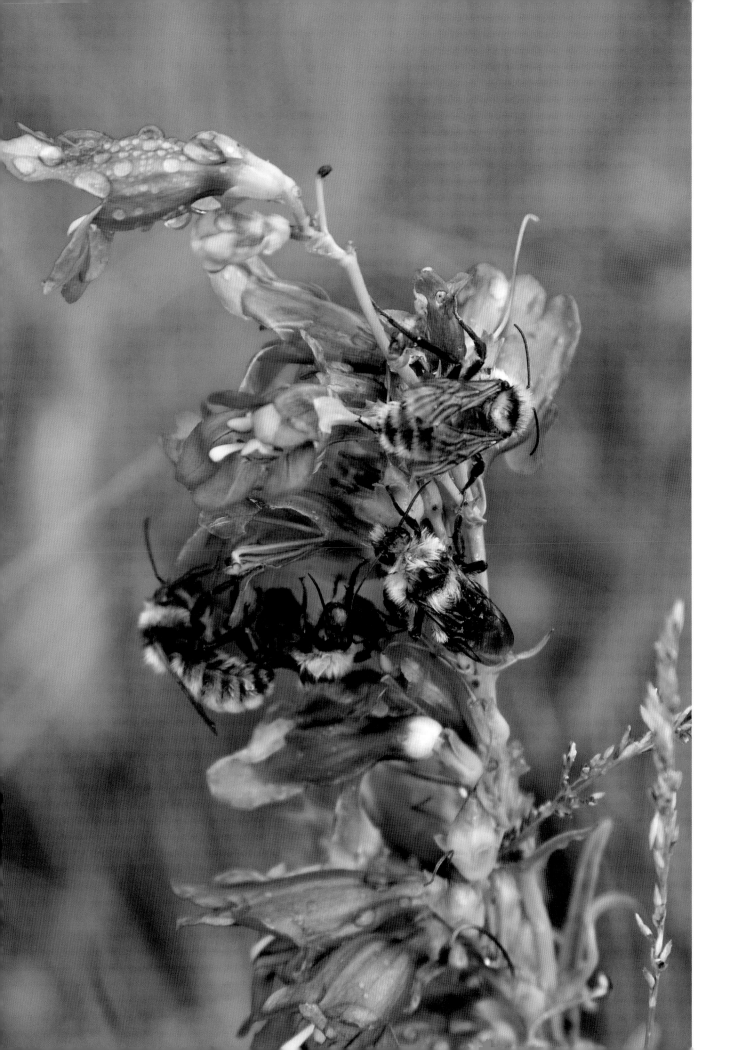

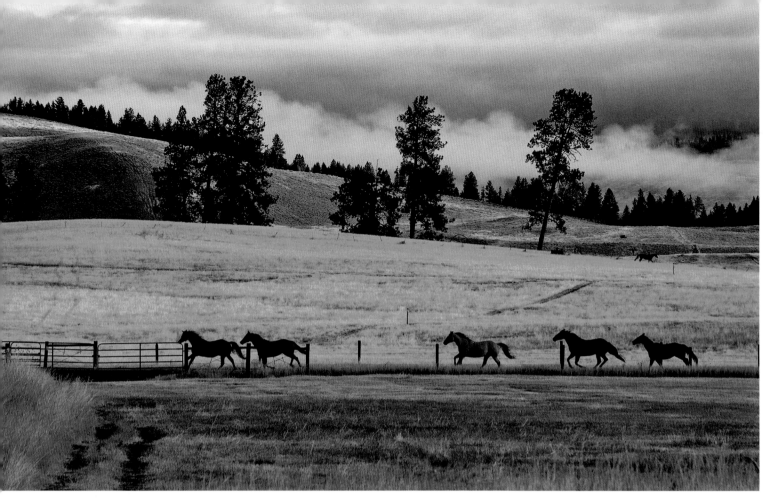

Warm, late-afternoon light.

Opposite: Misty lighting.

FILL FLASH

The term *fill flash* means using flash—either the on-camera flash or a separate flash unit—to fill in shadows or darker areas in a scene that has a brighter background. Often it's needed in a situation where the camera's metering system has been influenced largely by the brighter background or surroundings and the subject is too dark or has deep shadows obscuring detail.

Before the advent of modern electronics in cameras, using flash for fill light was a little tricky and required some experimentation and practice. Today's DSLRs make it very easy and, in some cases, automatic. The first thing to do is check your camera's manual. For the cameras I use, if I simply choose the P or "program" setting, the fill flash works very nicely—automatically. The main idea here is to keep the overall background exposure normal while providing a little light to fill in shadow details. Keep in mind that in most DSLRs, you can change the output of the built-in flash by going into the menu and setting it for more or less light output. You may have to do that to fine-tune the fill light.

The beauty of shooting digital is that you can check your results immediately and make any necessary corrections.

be softer in intensity (*above*). The softening is caused by dust and moisture in the air. Dust is picked up by daytime breezes, and moisture occurs from evaporative heating during midday. These factors, subtle as they are, both contribute to diffuse the sunlight a little. I notice the difference between dawn light and late afternoon light most in places like Africa and the American Southwest. The air is crisper in the morning, perhaps because nights are cool and settle the dust. At dusk, the air is not so crisp, and the quality of light is often softer. The two effects can render landscape shots of the same scene different in subtle ways.

Finally, there are those times when you just *know* the quality of light is something special. Such was the case one morning in Ngorongoro Crater in Tanzania (*opposite*). We were descending from the rim down to the floor of the crater, and the sun has just risen over a misty scene below.

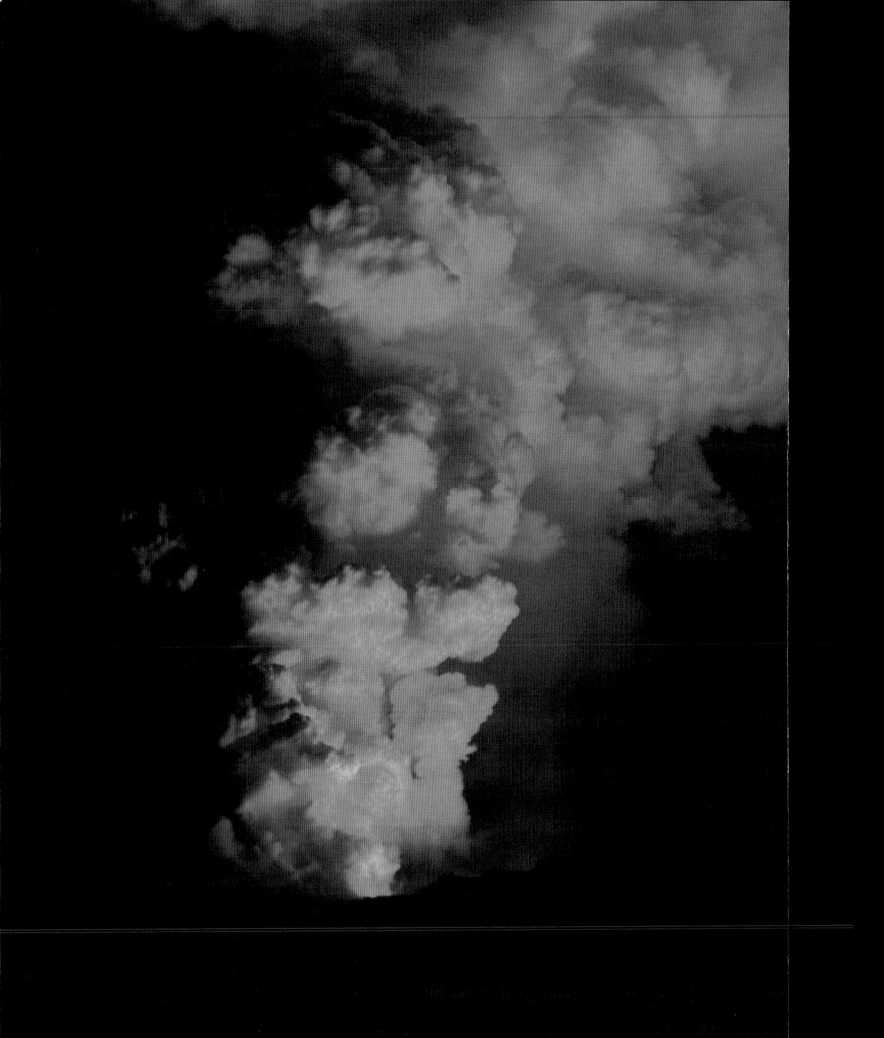

CHAPTER 3
DYNAMICS OF PICTURES

The world is a great place to photograph. It's too bad it's so full of chaos. And I don't mean the political kind. The world of nature has visual confusion everywhere you turn. And it is your job, as a photographer, to bring order to this chaos.

A great sculptor, noted for creating perfect likenesses in marble, was once asked the secret to sculpting an elephant. He said, "Oh, it's really very easy. I simply get a block of marble and then chip away everything that doesn't look like an elephant."

Great photos are created in a similar way: You must eliminate the unnecessary elements.

First, consider that the camera and the eye do not necessarily register images in the same way. When we look at a scene, our eyes continually scan, flitting from nearby objects to distant objects and back again. Moreover, although the eye has a lens not unlike that of a camera, when we look at a particular object in a complex scene, we use a psychological "cone of concentration" akin to a mental zoom lens. This cone functions like selective focus, allowing us to concentrate on a single object in a scene. While our peripheral vision still gives a complete view of the surroundings, it becomes subliminal as the mind processes the selective image, effectively filtering out some of that chaos.

The camera, on the other hand, does not eliminate information as our minds do. It only records it. And sometimes with brutal frankness. You take a photo of some beautiful flowers, only to notice later the trash cans in the background. This visual clutter was filtered out when you looked at the scene with your eyes, but it's the only thing you can see in the photograph. Or, more subtly, you shoot what to you is a beautiful garden scene. Later, the image seems busy and ordinary, not the gorgeous sight you had experienced. And anyone who views the picture will find it difficult to sort out the visual clutter and appreciate the beauty of the scene as you experienced it.

The point here is that you must keep the picture from becoming too chaotic or complex. To do that, you must be selective about what the camera records. This is done by a conscious and deliberate process of discrete steps.

A steam column from lava flows into the ocean during a volcanic eruption on Fernandina Island, Galapagos National Park, Ecuador. Shot with a 28–135mm lens.

This is a nice scene, but it is full of visual clutter. There are some photographic possibilities, however, if we isolate the elements.

We often have a psychological "cone of concentration," causing us to look at that more pleasing composition of waterfall and rocks while mentally filtering out the clutter.

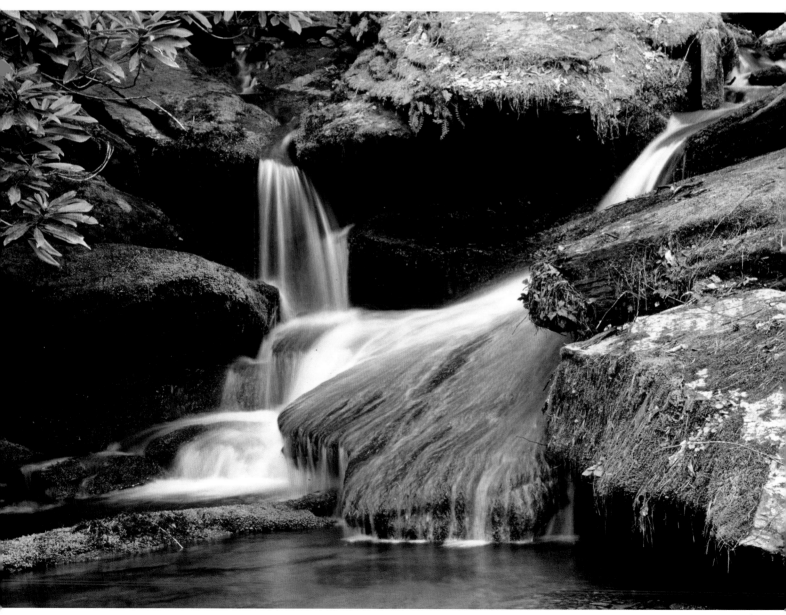

Zooming in with a longer focal length, or moving physically closer, we can isolate the more pleasing composition and eliminate all the chaos in the photograph.

HOW TO MAKE
A GREAT PHOTOGRAPH

■ **See.** This isn't as easy as it sounds. There's more to seeing than looking. Begin concentrating on the objects before you. See how light strikes those objects. See color. See quality and direction of light. See contrast. See texture. See lines. See forms and shapes. See details like leaves or rocks or patterns in the grass or the clarity of water in a mountain stream. It is especially important to look for—and *see*—the things that give a special distinction to a place. The strength of a photograph is directly related to how well—and how carefully—you see things around you.

■ **Feel.** This one is tougher to define. Feeling has to do with the emotions generated by a place or subject. Sometimes you need to just sit and *absorb* your surroundings. Listen to the wind and the birds. Smell the flowers and the pines. Feel the rough texture of the granite you sit on. If you are photographing an animal, watch its movement and behavior. If you are photographing people, listen to their words, understand their feelings, and watch their movements and interactions with the surroundings or other people.

Use this sensual input to guide your emotions in capturing the essence of the place or person on film. True, you can't photograph the smell of flowers, the sound of birds, or the feelings of a person, but the emotions generated by this sensual input can subtly guide you in finding important attributes of the scene or subject.

■ **Think.** This is the most important step in the process. Strong composition begins in the mind, not in the camera. Before you begin blazing away with the camera, think about how to utilize that sensual input and couple it with the realities (and limitations) of the camera, the lens, the medium, the lighting, the physical dimensions, the mood.

Is the lighting the best? Is the amount of contrast beyond the range of the camera's sensor? Would soft, overcast light work better? Or a different time of day? What about angle of view? High angle? Low angle? Lens choice—should you use a wide or ultrawide angle that has a great depth of field and expanded perspective? Or maybe a telephoto to compress perspective and reduce the depth of field? And shutter speed—is it adequately fast to allow handholding, or should you use a tripod? Or what about a slow shutter speed for deliberate blur?

■ **Isolate.** Now we get down to the nitty-gritty of composition. Get rid of those extraneous, chaotic objects in the picture. Simplify. In scenic photographs, it's not necessary to include every tree, rock, flower, and mountain. Isolate only those elements that convey a strong sense of place. Emphasize the strong lines or shapes or patterns or textures or colors of things—but not all of them at once. Be bold and decisive. Think you need to frame the scene with foliage? Ask yourself why. What does it contribute, other than visual garbage, to the picture? Try it clean and uncluttered.

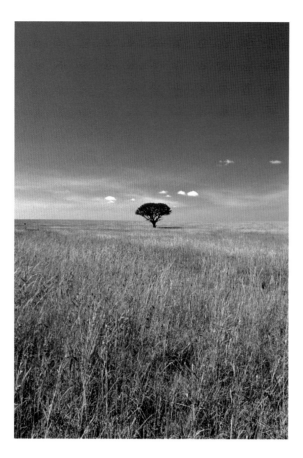

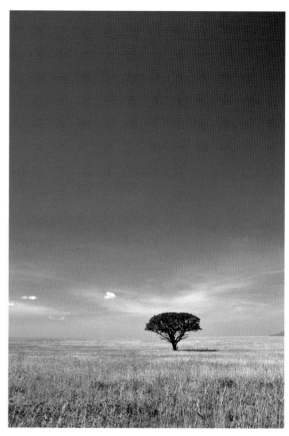

Left: Placing the horizon line exactly in the center divides the picture equally in half and creates a static arrangement. This is especially true with the focal point of the tree also in the center.

Right: Placing the horizon line lower in the picture gives a more dynamic arrangement. Here, it gives emphasis to the sky, conveying a sense of spaciousness—which is what the Serengeti Plains are all about.

Opposite: Here's the same shot of that lonely Serengeti tree but done as a horizontal and with the horizon line low in the picture. Note how there's an even stronger feeling of openness with the horizontal format giving a wider view.

If necessary, move in closer to the subject (unless it's a grizzly bear or a rhino). Or use a telephoto lens to isolate things optically. Nowadays, most of us use zoom lenses, and this gives us great optical versatility to isolate. I love watching distracting elements disappear from the viewfinder as I zoom in. Examine the viewfinder carefully before you take the picture. Is what you see in there the best you can do to isolate the elements of a picture? Can you make it stronger by isolating even more? Would that viewfinder image make a good magazine cover? Would you hang that picture on your wall? If not, why not?

Organize. Having isolated carefully, you now need to organize or arrange the elements in the strongest possible way. Traditionally, this is the part of the process called "composition." Where should you place the subject in the frame? In the center?

If so, why? It may be too boring or static of an arrangement. On the other hand, it may convey a sense of peacefulness. Or should you put the subject near the edge of the frame? Or one-third in and one-third up (or down) from the edges of the frame?

And what about the horizon line? Should it divide the picture evenly in half (*above left*)? Or would the picture be more dramatic and dynamic if the horizon line were higher or lower in the frame (*above right*)?

And, finally, what about the picture orientation itself? You have a choice of creating a vertical or a horizontal picture. Which is best for the subject? Vertical orientation tends to emphasize vertical lines or the height of things. Horizontal orientation can give emphasis to sweeping panoramas or the movement of subjects (*opposite*). But again, be careful. These guidelines are not chiseled in stone.

Experiment. Look for new ways to portray familiar subjects. Don't always photograph the same kinds of scenes in the same ways. Try different lenses or compositions or angles of view. Experiment with different orientations in scenes. Do you shoot landscapes mostly as horizontals? Try some as verticals, paying special attention to the impact created by that orientation. And what about action shots? More often than not, we shoot action as horizontals—partly because that's the quickest and easiest way to hold a camera, partly because we need to give room for the action in the picture if it's moving past us parallel to the film plane.

Digital photography makes it easy to experiment because you have instant feedback on the LCD screen. If the technique doesn't work, you simply erase the image and try again. On a recent trip to the summit of Mt. Evans near my home, I was using my favorite ultrawide zoom, the 10mm to 22mm, to capture the grandeur of the rock structure near the summit. When I looked at my shots on the LCD screen, I discovered something I hadn't noticed before: fantastic cloud formations floating overhead. The wide view of that lens made them prominent, and I re-composed the scene to make those clouds a major part of the picture (*pages 50–51*).

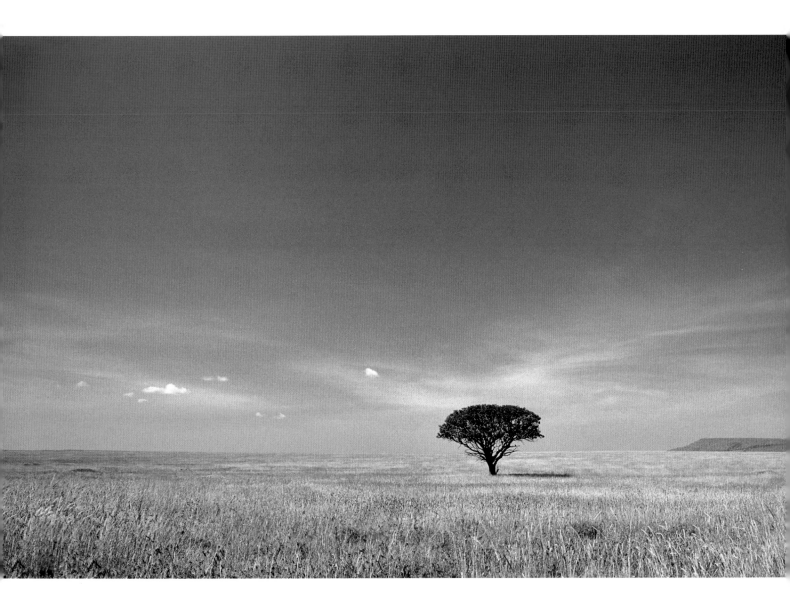

On the summit of 14,230-foot Mt. Evans in Colorado, I was composing a scenic shot when I discovered that my 10–22mm ultrawide zoom lens was giving me an interesting portrayal of some clouds overhead. I recomposed the scene to make this more of a skyscape than a landscape.

THE ELEMENTS OF COMPOSITION

The basic design elements that go into each picture are the same. We can categorize those elements as *shape*, *form*, *lines*, *texture*, and *color*, plus the composite element *pattern*. These are the components of design, and we seek harmonious use of them in our pictures.

We must also consider our subjective response, which is our emotional reaction to a subject (as opposed to our objective reaction to the design elements). For example, a photograph of an event or a person or even an animal may have discordant design elements, creating a "bad" composition, yet we react to the picture emotionally, based on feelings of empathy, fear, abhorrence, humor, or remembrance. Many news photos, capturing some sense of human drama, fall into this category.

While we strive for visual impact using the strength of simple design, many striking photographs are complex, even bordering on discordant, yet they appeal to us by reason of emotional response. So we need to add another element to our list: *mood.*

Let's analyze these elements individually.

SHAPE

Shape in photos is two-dimensional, the outline of familiar things. As a part of growing from infancy to adulthood, you acquire a visual database of things in your world, allowing you to instantly recognize objects by shape alone: trees, cars, airplanes, violins, hammers, cameras, ad infinitum. When you think about it, you realize that this is true. How many computer icons use graphic representations of familiar shapes to convey a function—printer, camera, and so on?

As artists, how do we *use* shape in our photographs? We can use shape as a strong visual design element, emphasizing the familiar aspect of a particular object's shape. Sometimes we use recognizable shapes to establish a sense of place: the distinctive skyline of New York, for example, or of the Grand Tetons. More often than not, we need to ask how we *misuse* shape. For example, if we photograph the silhouette of a familiar object—such as an airplane or a bird—and don't pay attention to the orientation, the shape may end up a meaningless blob.

Left:

Shape

Through our learning processes, we begin to associate shapes with certain things. Here this silhouette of the onion dome spires of St. Basil's Cathedral in Moscow tells us that this is probably Russia. The picture itself, being a pure shape, has no feeling of dimension.

Right:

Form

These same spires of St. Basil's now take on a more three-dimensional feeling by virtue of lighting that reveals form and color.

FORM

Shape becomes form when we use light to sculpt objects into three dimensions. While the image remains two-dimensional, we create the illusion of three dimensions with careful use of lighting.

It's easy to overlook the importance of form when we're busy arranging a composition in the viewfinder. Later, in viewing our efforts, the picture appears flat and lifeless—and puzzling. What had been a dramatic *form* in person is merely a meaningless *shape* in the photo because we didn't pay enough attention to the lighting.

In photographing a particular object, we need to decide whether it is the form or the shape that is the key design element in our picture (leaving aside, for the moment, other elements like texture and color). A flower, for example, may be photographed at such an angle as to emphasize the beauty of its shape—either as a silhouette or a translucent, backlit object—or at another angle that emphasizes its three-dimensional form.

Form

Here, my shot of river-polished boulders on the bank of Idaho's Salmon River was made under soft lighting, but with the subtle shading, these rocks feel three-dimensional.

Vertical lines

Composing this shot as a vertical orientation helps emphasize the tallness and stateliness of the aspen trees.

Opposite:

Diagonal lines

In this shot of wildebeest fighting in Tanzania's Ngorongoro Crater, there's a strong sense of action. Why? First, there is a strong diagonal slope of the back of each animal. Without that, the sense of action would be diminished. In addition, I composed the two off center, giving a more dynamic arrangement. Being silhouetted helps as well because there's no distracting detail. More subtly, that dust being kicked up is emphasized by the backlighting.

LINES

When I scrutinize my viewfinder, perhaps more than anything else, I look closely at lines and how they interact, since lines can have a strong impact on composition and on the feeling you wish to create in a picture:

- **Bold vertical lines** convey a sense of great height (*opposite*). They can also connote a sense of stability and strength, as might be associated with the vertical lines of a building.

- **Horizontal lines** also convey stability, in terms of breadth or expansiveness. They subtly reinforce a feeling of peacefulness—probably because we associate horizontal lines with the horizon and good, solid earth.

- **Diagonal lines** connote instability, movement, something dynamic (*below*). The more oblique we make diagonals in a picture—that is, the farther from vertical or horizontal—the stronger the sense of movement or instability.

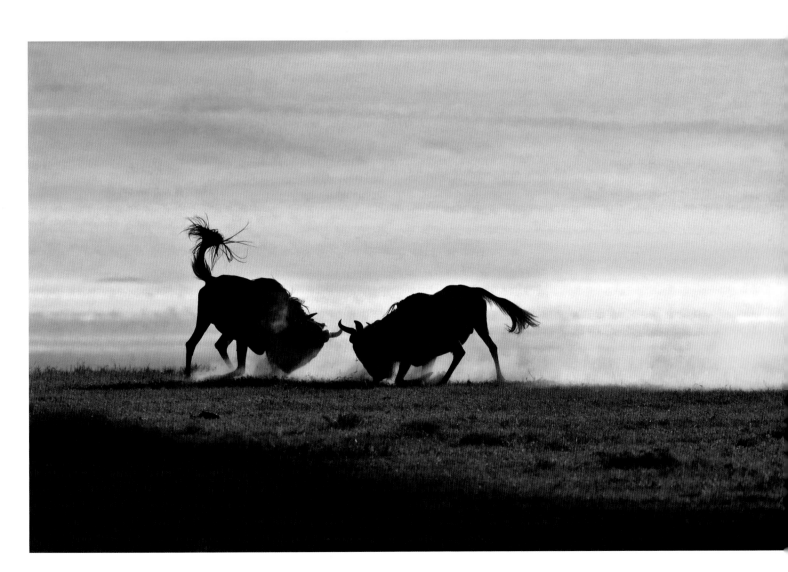

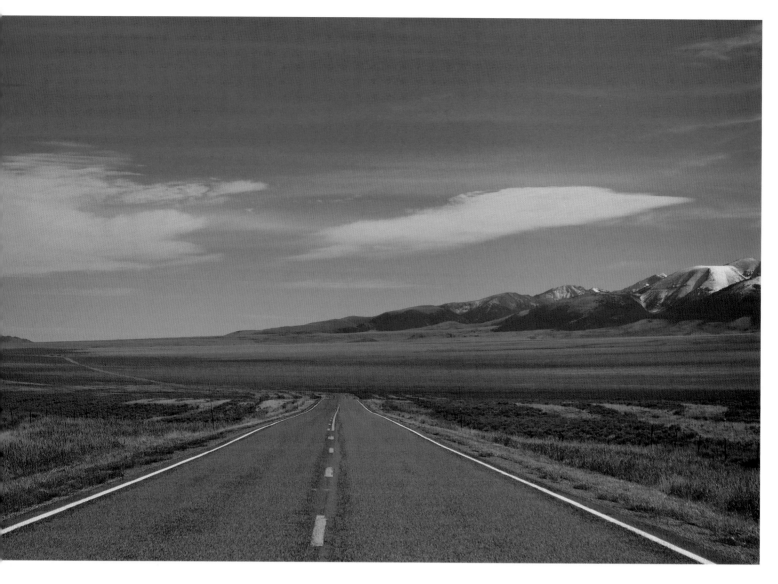

Above:

Receding lines

The remote and sparsely populated Lemhi Valley hasn't changed much since the days when I used to live in Idaho. I wanted to convey a sense of vast space and loneliness. Just a straightforward shot of the grass and sagebrush valley with the mountains didn't quite do it. So I used the highway. Framed with my ultrawide 10–22mm lens at 10mm, those strongly receding lines of the highway helped to convey that feeling of spaciousness.

Right:

Zig-zag or jagged lines

While visiting the Laguna Atascosa National Wildlife Refuge near South Padre Island in Texas, I discovered this scene of dense brush growing here—part of the native vegetation. Notice how those zig-zag lines of branches create a feeling of tension and foreboding. Not the kind of place where you want to do any bushwhacking off trail.

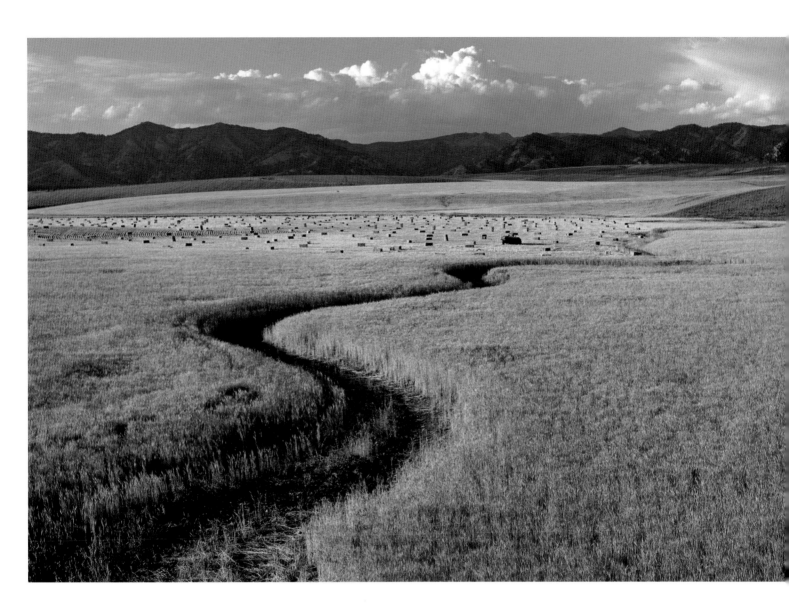

Receding lines are related to diagonal lines. They give a sense of depth to a picture (*above*).

Curved lines can connote something sensuous, peaceful, or graceful when they appear smooth and gentle (*opposite top*). Tight curves and re-curves become a bit sinister, as in the coiled body of a snake.

Zig-zag or jagged lines create feelings of busyness, tension, and sometimes chaos. The same is true of crisscrossing lines, especially lots of them in a random pattern; there's a feeling of something

chaotic. That's great, if your intent is to create a chaotic feeling in your picture (*right*). But sometimes that feeling creeps in by accident because you haven't paid enough attention to the lines in your picture.

In using lines as a design element, you need to think about the vertical or horizontal orientation of your picture format as well. Vertical orientation emphasizes vertical lines, giving a strong sense of the tallness and stateliness of trees, for example. Shooting a horizontal picture of strong vertical lines de-emphasizes those feelings. The tall trees appear stunted, less impressive.

Above:

Curved lines

This peaceful scene in an eastern Idaho hayfield is enhanced by the curving swath through the golden field.

CREATING DIAGONAL LINES

Lines play a strong role in these shots of racing yachts I made on assignment at the Rolex Regatta in the Virgin Islands. Frankly, as a spectator sport, yacht racing is pretty boring—about as exciting as watching the grass grow, someone once said. The challenge was to convey *action* and *movement*. But even when the boats were moving at a good clip, my pictures were all horizontal lines (hulls, booms, horizon) and vertical lines (masts, lines). The effect felt static and motionless. So I stationed myself at a marker buoy where the boats had to make a sharp turn. Notice that in the picture where the mast, sail, deck, and even the people are all in strong diagonal positions (*right*), there's a greater sense of action than in the picture where everything is vertical or horizontal or nearly so (*left*).

Horizontal lines.

Diagonal lines.

Another example is this black rhino I photographed walking toward me in Ngorongoro Crater. It's not exactly an action shot (*left*). But look what happens if, through a little Photoshop magic, I tilt the animal's body in the picture (*right*). It appears that the rhino is running fast, charging me, and making a tight turn. The diagonal line of its body creates that dynamic feeling.

Horizontal lines.

Diagonal lines.

TEXTURE

Texture relates the *feeling* of a surface. We usually tell texture by touching, so to convey it photographically requires special attention. The measure of how successful you are in capturing texture in a photograph is when a viewer feels mentally what that surface is like—without the benefit of actually touching it (*below*).

Lighting plays a key role in conveying textural qualities. Side lighting, in particular, helps to impart a sense of texture by bringing out surface relief and contrast. If the primary element of your composition is the textural quality of the subject, you should pay careful attention to the lighting and use it to heighten the texture.

Texture

Though subtle, there is side lighting here that helps give depth and enhances a feeling of texture. Flat overhead light would have diminished this feeling.

COLOR

We react to color in very emotional ways. Even our vocabulary reflects the ways that color affects us: "seeing red" indicates anger, having "the blues" denotes sadness. Color can have a subtle yet strong impact on the success of a picture. Let's look at the color spectrum and see what psychological implications there may be in photographic compositions:

Blue is associated with coolness or coldness. And, as mentioned above, there's a psychological hint of sadness. To me, blue also seems to be a quiet color—perhaps because, in those predawn moments, things are tinged with blue and usually very, very still. Blue whispers. Blue is tranquil.

There are times when I use a subtle blue filter to enhance the sense of coolness, quietness, or tranquility. A CC05B or CC10B is just right for subtle effect. (CC stands for color correcting; 05, 10, etc., is the density. The higher the density, the deeper the color. "B" stands for blue, "R" for red, etc.)

Green is very close to blue in its emotional connotations. There's still a strong sense of coolness, as in the cool green of evergreens. But green can also be a warm yellow-green, which is less somber, more active psychologically. Also, we strongly associate green with natural, earthy things, giving a subtle sense of stability and also tranquility.

Blue

I used a blue filter to enhance the feeling of coldness and perhaps add a bit of mystery to this floating iceberg in the Scotia Sea, Antarctica.

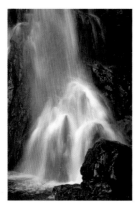 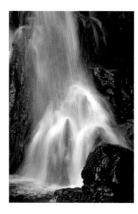

Blue

This shot of a Rocky Mountain waterfall conveys a sense of coldness by virtue of the blue rendition (*left*). Note, however, the different feeling when this same shot was warmed up in Photoshop Camera Raw by changing the white balance setting (*right*). Which one would you rather bathe in?

Green

Green also can be a cool color, though not quite as much as blue. Even though this scene is in the tropical rainforests of the Amazon Basin of Ecuador, where it's hot and steamy, this shot has a quiet coolness to it.

I love color, and I look for scenes or subjects that have impact because of the colors in them. This is a shot of bags of spices at a market in Otavallo, Ecuador. Markets like this offer vivid subjects to photograph.

DYNAMICS OF PICTURES

Red

Red screams. Red is hot in more ways than one, as it is in this shot of red-hot chili peppers at a market in the Andes of Ecuador.

▨ **Yellow** and **orange** move us into the realm of warm colors. We associate these colors with sunlight. (Remember those crayon drawings you made in grade school where the sun was always a big, yellow blob?) The main impact is a feeling of warmth, perhaps joy and action.

▨ **Red** shouts. If blue is quiet, red screams. If you include a red object in your composition and it's *not* intended to be your center of interest, you've screwed up because it will draw the attention from any other subject. Red is hot. Red is excitement. Red is tricky.

There are no neat formulas to guide you in using color in your photographs. A lot of what you do in arranging compositions with strong colors is guided by your own instincts and reactions. Just be aware that wild mixtures of intense colors have a chaotic, kaleidoscopic effect that can be counterproductive if, say, you were hoping to create a feeling of tranquility.

Yellow

The yellow blossom of an opuntia cactus stands out against the darker background of heavy brush in Laguna Atascosa National Wildlife Refuge in southern Texas.

Right:

Pattern

I was fascinated by the pattern of this plant in Volcanoes National Park in Rwanda, a pattern offset by the white flowers.

Below:

Pattern

I love the pattern of these lines of rice paddies in Bali.

PATTERN

With both natural and manmade objects, pattern can be a strong compositional element (*right*). Pattern can range from a ripple in windblown sand dunes to the straight, repeating lines of a fence or of buildings in a city. The appeal is the visual rhythm or order created by such a design (*below*). The major compositional consideration here is how much of a pattern to include in the picture. If you include too little, you do not achieve that sense of visual harmony. But if you include too much, you dilute the impact of the strong graphic design. Use your instinct, and when in doubt, experiment with different compositions of the pattern.

Mood

I've been to Machu Picchu many times when the weather has been clear. But the times when it's overcast and misty are when it gets exciting from a photographic standpoint. The swirling mists give a sense of mystery to these ancient Inca ruins.

MOOD

Mood is another one of those elements that is hard to define precisely. You know it when you've got it, but the process of setting a particular mood in a picture takes careful thought. Often, the subject of your photograph sets the mood (*right*), regardless of the design elements used. Viewers react emotionally to the person, animal, or event depicted. A photograph of a crying child will almost always elicit empathy, no matter what the composition. A man with a gun held to his head will elicit fear. A Ku Klux Klan parade will elicit abhorrence. A kitten hanging from a branch will elicit amusement. A farm at sunset will elicit nostalgia.

Mood can also be set with lighting. High-key lighting, in which things are bright and light in color, sets a mood of lightheartedness, an upbeat feeling. Low-key lighting, in which things are dark and colors muted, creates something somber, forbidding.

In the outdoor world, you can take advantage of weather and time of day to set a mood (*above*). And these can be enhanced by controlling your exposures. For example, dark storm clouds gathering over a landscape

create an ominous sense of foreboding. That mood can be enhanced further by underexposing slightly to create a darker scene. But that ominous feeling is diminished, or lost, if you overexpose the scene.

Mood

It doesn't all have to be serious. I love this humorous shot taken by my daughter Jean Anne on a trip with me to Tanzania. Shade is sometimes sparse out in the Serengeti Plains, so this lion plopped down in the shade of my vehicle, and Jean Anne, in an adjoining vehicle, captured this look of contentment. Not a good time to step out of the Land Rover to stretch.

Jean Anne Norton

63

IMPROVING YOUR PHOTOGRAPHS

Think, for a moment, about photographs that have really excited you, really caught your attention and made you say, "Wow! I wish I had made that picture." Chances are, those photos were clean, simple, and direct, and they emphasized only a few of the fundamental design elements of shape, form, line, texture, color, pattern, or mood. The more elements you add to a picture, the more visual confusion you create. Simplicity and elegance is the goal.

Zero in! Make some element the central subject or center of interest—a line, a form, a color, or a pattern. Don't dilute the impact by including too much.

Use self-assignments to sharpen your compositional skills. Focus on a single color in a whole day's shooting. Or devote a day to other compositional elements: pattern or texture, for example.

Learn to critique your own work. One of the major struggles we all have is to self-critique effectively. In my photography workshops, the critiquing sessions are the most valuable part of the whole workshop. This is done as a group process, with lots of insights from fellow students. It's always easier to critique someone else's work.

But when it comes to our own pictures, we often have too much emotional energy tied up in creating those photos. It's not easy to be objective about our own work.

So, what to do? One tactic that works for me is to let my pictures age a little—easy enough because I often travel to the far corners of the world on various projects, and by the time I return, previous pictures have aged pretty well. The point is to consciously move on to other picture-taking efforts and come back to earlier photos in a few months when your emotional involvement has diminished. Then play the role of picture editor: Would this one make a good magazine cover? Or a lead photo for a story?

Here's something that helps (sometimes) in judging your own work: Reverse the picture. In Photoshop or picture viewers on the computer, you have the capability of flipping the image horizontally from left to right. You often remember a place or a shot as having a certain orientation, and it remains just that way in your memory. By reversing the picture, the familiar becomes unfamiliar. Now judge the composition—the arrangement of elements, the mood, and so on.

Sometimes you come across pictures that are vaguely disturbing. They just don't quite make it. And it's hard to put your finger on why. Most often, I find that the picture is weakened by cramming too much into it. The composition could have been strengthened by eliminating some elements. *Tighten it up.* For some of those problem pictures, try cropping to eliminate certain elements. You might discover a sensational picture within a mediocre one. Next time, do the cropping with the camera!

Practice. You'll never improve the quality of your pictures if your camera sits on a shelf for months gathering dust. You learn as much from your mistakes as from your successes— if you take the time to analyze your pictures.

Finally, study the work of others. In the early 1960s, Dave Brower, then-executive director of the Sierra Club, launched an exciting book-publishing program featuring the work of Ansel Adams, Eliot Porter, Phil Hyde, and others. (A few of them are still in print.) I learned a great deal about photography and composition from these books. I spent hours going through each one, savoring the pictures and analyzing them: the lighting, the compositional elements.

You can do the same. Anytime you see a picture that grabs you, take a moment to analyze it. What makes it such an exciting image? When you are able to answer that question effectively, you can apply that knowledge to your own work.

Opposite: I started this chapter by advising you to avoid chaos in your pictures. Here, I broke that rule because that's exactly what I wanted to convey: chaos and clutter. This shot of a coal-fired electrical generating plant in Wyoming helps carry a strong message about what we are doing to our environment. Global warming, anyone?

Arrange your compositions to enhance any visual statement you may make. I was saddened by little donkey, waiting outside the door for his next burden to carry in the village of Rio Verde in the Ecuadorian Andes. His drooping head reinforced that sad feeling.

THE ART OF SHOOTING

DSLRs make picture dynamics and composition more interactive. The LCD screen allows instant critique in the field. But use it carefully. Most screens are small, so details tend to get lost, but you can still analyze the design elements in a scene. Look at the relationships between elements: lines, form, shape, pattern, and even color to some degree. (Keep in mind that final colors from a processed RAW image will be different from the original, and you have a wide degree of latitude in adjusting final colors.) More often than not it is the *arrangement* of the elements that you are looking for: where the subject is located in the frame, where the horizon line is located, etc. Even though you see those elements in the viewfinder before you take the picture, the nice thing about the LCD view is that it creates a little detachment, a sense of seeing the picture a little differently. As I said before, it is always difficult to critique your own work, so I try to use whatever objectivity I can in viewing my pictures.

The one thing I wish to emphasize here is the importance of creating the strongest possible picture *in the viewfinder* when you shoot it. There is a terrible tendency in digital photography to think that bad compositions can be cor-

rected in Photoshop later. They can't. Well, they can sometimes, but this attitude makes for very sloppy technique in photography. It is true that Photoshop can do some wondrous things, creating totally new pictures out of combinations of elements from other pictures. That may be fun to play with in your spare time, but I prefer to make the picture as strong as possible at the time I shoot it. Practicing your skills behind the camera is the only way you will truly become a great photographer. Later, I use Photoshop to refine the picture to achieve optimum color balance and tone and sharpness. It's a great tool, but use it carefully.

CHAPTER 4
IN-THE-FIELD WORKFLOW

Since the advent of digital photography, a new term has appeared in the photographer's vocabulary: *workflow*.

In the olden days of film shooting, workflow was simple:

1. Load the camera with film.
2. Shoot.
3. Have the film processed.
4. Edit the subsequent pictures (big wastebasket nearby).
5. File the pictures.

Today, it's a little more complicated. Workflow with digital photography takes more, well, work. Here's a typical workflow I use when shooting in the field with digital photography:

1. Load the camera with a freshly reformatted flash memory card.
2. Shoot.
3. Check the histogram (only for certain pictures); re-shoot if necessary.
4. When card is nearly full, upload image files to a portable hard drive or laptop. When time allows, edit pictures (using Delete).
5. When certain images are secure on a portable hard drive or laptop, erase the memory card and reformat it. If there are enough blank cards, leave image files on card for additional backup. Continue shooting.
6. At home, transfer the image files from the portable drive or laptop to more permanent storage: a desktop computer or external hard drive.

A fallen tree and bluebells in a forest near Lamerton, Devon, England. Shot with a 28–135mm lens.

7. Edit pictures (using Delete).

8. Process the saved RAW image files and store as TIFFs. Processing can be done in batches, with some pictures needing individual attention in processing.

9. Rename pictures (done in batches) with a more logical naming system than the camera's. (Note: Alternatively, you can rename pictures as you are uploading from the camera to a portable hard drive or computer.)

10. File the pictures in a logical way on the hard drive.

11. Back up the hard drive image files (external hard drive, CD, or DVD).

12. Transfer original RAW files to a CD or DVD or to an external hard drive for storage.

13. Delete RAW files from the main hard drive (optional if you have enough space).

Yup, there's a lot of work in workflow. But in the end, it improves your photographs and ensures that they will be filed for easy retrieval and archived in various locations so they won't be lost in the event of a malfunction.

WORKFLOW PRECAUTIONS

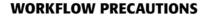

Don't overload the flash memory card. Media cards are sensitive devices. When I see that a card is approaching the limit (i.e., the camera shows I have space for a dozen or less pictures), I make a point of removing it and replacing it with a fresh, blank card. Why? To prevent overshooting and overloading a card's capacity, which could corrupt the files on the card, including the pictures already taken. It might not happen, but it's best to play it safe.

Be patient while the camera processes a file. When removing or replacing media cards, turn off the camera first. Sometimes, just after shooting, the camera needs to process the file internally. If you work too quickly and remove the card

when this processing is taking place, you risk corrupting files. Play it safe and wait a minute.

Protect cards from the elements. Keep the cards in the manufacturer's plastic box as protection from dirt and dust. If you plan to work in a very dusty or wet environment, buy special cases that hold four or more cards and have a tight seal against environmental conditions (*left*).

Separate full cards from empty cards. You don't want to mix up your full and empty cards, so find a method for differentiating them. I keep empty, formatted cards in the case with the manufacturer's label face up (*opposite top*); later, I replace the full card in the case with the label face down (*opposite bottom*).

Reformat cards between each use. When you have securely transferred the files from a full card to a hard drive, the files need to be erased from the card. I usually do this in the camera, rather than in the computer or card reader of the portable hard drive. To guard against any possible file corruption, you should, in addition to erasing files, reformat the card. I prefer to do this in the camera as well—and more specifically, in the camera system in which the cards will be used. This is to safeguard against any possible read/write variations from system to system.

Watch your battery level. When working in the field, it may seem like a good idea to squeeze every last bit of energy from the camera's battery, but this strategy could lead to some problems. In a film camera, when the battery runs down, everything quits working. In a digital camera, the information from the sensor takes a few milliseconds to be processed and

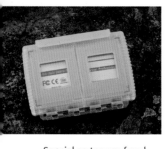

Special waterproof and dustproof cases are available to protect your media cards. When snapped shut, these cases provide excellent protection from water and dust.

written to the media card. During that time, a power failure could corrupt the file being written and possibly other files on the card. You may be all right and lose just the information from that last shot, but don't risk it.

WORKFLOW ADVANTAGES

The digital photography workflow does not always mean more work. One of the great features of a digital camera is the ability to change the ISO to compensate for changing lighting conditions. (ISO stands for International Organization for Standardization, and it is the effective speed or sensitivity of the sensor, equivalent to the speed or sensitivity of film. A higher ISO will let you shoot in lower light conditions.) In my film-shooting days, I used to carry one camera body loaded with 100-speed film and another loaded with 400-speed for those times when low light dictated the need for higher speed. In digital, you simply turn a dial or push a button to change the sensitivity of the sensor. It's like switching to high-speed film without having to change film or camera bodies.

Most DSLRs have ISO settings of 100, 200, 400, 800, and 1,600. (Some go even higher, to 3,200 and 6,400 and, with special boosting, up to 12,000!) Usually, I shoot at 100 or 200 ISO for maximum quality. Like film, there are some drawbacks to higher speeds. In film, it was increased grain; in digital, it's increased noise, which is much like film grain. The amount of noise varies from camera to camera and from sensor to sensor. It used to be that 1,600 ISO produced objectionable noise, but that noise has since been greatly reduced. Experiment with your own system to see what you can tolerate in terms of image quality. Some noise can also be minimized later in RAW images using such software as Nik Dfine 3.0 or Camera Raw.

Typically, fieldwork using a DSLR is no different from fieldwork using a film camera, except in circumstances where you may be out for a very long time or if you are doing a lot of shooting and may well exceed the storage capabilities of your memory cards. I usually carry ten 4GB memory cards for a total capacity of around 40GB, easily enough for a day's shooting. In my 10-megapixel camera, saving images as RAW + medium JPEG, I can get about two hundred pictures on a 4GB card. With 40GB worth of storage, I can shoot approximately two thousand pictures without need for uploading. (Note: These numbers vary depending on your camera system and its sensor. Use them as a rough guideline only.) This is equivalent to about fifty-five rolls of thirty-six-exposure film—and memory cards take up a lot less room than film rolls. If I think that I might exceed that capacity, I bring an Epson P-7000 portable hard drive so that I can upload images in the field.

PROS AND CONS
OF HIGH-CAPACITY CARDS

With the development of higher capacity flash memory cards, there is serious debate now about the wisdom of using, say, 4GB, 8GB, 16GB, or even 32GB cards in the field. The argument goes like this: If I shoot with a 2GB card and something happens (file corruption, failed card), then I lose only those shots (in my case, about one hundred images on a 2GB card). But if I use an 8GB card, I run the risk of losing up to four hundred pictures if I have a card failure. How likely is a card failure? Most major brands of memory cards are pretty reliable these days. Only once have I had a failure, and actually this was a card brand new right out of the sealed package. Neither the camera nor the computer could "read" or recognize the card. I sent it back, and the replacement worked fine. Still, I limit my cards to 4GB and smaller, just to be safe.

The counterargument goes along these lines: If I have higher-capacity cards, I don't have to switch cards so often—and thus miss important action. My rebuttal? As an

I mark media card cases with an X to determine the top of the case; when a freshly formatted card is placed in it, it's put with the main label face up, denoting that it's empty and ready to use.

Full cards are put back in the case face down to denote the card has images. Also, I keep full cards and empty, formatted cards in separate pockets. Any system you can work out will be vital to help prevent accidental erasure of pictures.

Card Capacity	Pros	Cons
Lower (2–4GB)	■ In the event of card failure, you lose only 100–200 images.	■ Necessary to carry more cards. ■ More frequent card changes. ■ Necessary to switch cards when uploading files to hard drive.
Higher (8–32GB)	■ No need to carry as many cards. ■ Less frequent card changes. ■ No need to switch card when uploading files to hard drive.	■ In the event of card failure, you lose 400–1,600 images.

experienced film shooter, I often was able to anticipate action and, if near the end of a roll, rewind and reload a fresh roll. The same is true with memory cards. When I am approaching the capacity of the card, I replace it—which is a lot quicker than reloading film, by the way.

Of course, in the field, you may run the risk of getting dust or dirt or water in the card slot each time you change, but with care you can avoid most of these problems.

There is one final argument in favor of the high-capacity cards. At the end of the day, when it comes time to upload images into your laptop or portable hard drive, you have to sit there and switch the low-capacity cards several times; with the high-capacity cards, you switch less often or not at all.

CARRYING EQUIPMENT

For my fieldwork, I use a backpack-type camera bag, the LowePro Rolling Computrekker (*left*). With wheels, it's great for rolling around airports. In the field, it holds a lot of equipment (maybe too much!) and is waterproof. The only drawback I've found is it's just a little large for some airline overhead bins, so I always check what kind of aircraft I'll be flying on to make sure it'll fit.

Working in the field with a film camera necessitated carrying extra batteries, and the same is true with digital. Modern DSLRs use rechargeable batteries, and I always carry several extras. The LCD screen, autofocus, and image stabilization lenses all draw their power

from the batteries and add to battery drain. To save battery capacity, you can turn off the LCD—unless you are working in tricky lighting conditions and need to check the histogram frequently (or view the image). Fortunately, the newest DSLRs are quite good in terms of minimizing battery drain. Even with all these features draining the battery, I can take about 350 pictures on my 10-megapixel camera on a single battery charge. With two batteries, I can take about 700 pictures, roughly equivalent to about nineteen rolls of thirty-six-exposure film. This is usually more than enough pictures for a day in the field.

OVERSHOOTING

This brings up another point worth discussing: overshooting. In the days of shooting film, we were all more aware of the limitations—only so many shots per roll and only so many rolls in your pack. If we shot medium- or large-format instead of 35mm, it was even more limiting. My feeling is that these limitations were a *good* thing because they made us concentrate more on getting a good image.

Today, with digital, if we carry enough high-capacity memory cards and spare batteries, we can literally shoot thousands of pictures in a day. But is the *quality* any better? No. When shooting landscapes or close-ups (*opposite top*), we should be concentrating on getting the best possible image, not the most possible images. Digital photography has made us lazy when it comes to good technique in

I use my LowePro camera backpack both in the field and, because it has wheels as well, for trekking through airports and on flights.

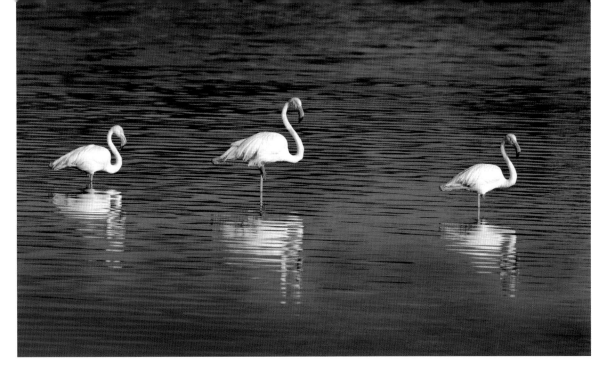

With static or slow-moving subjects, there's little need to blaze away with multiple shots.

creating the perfect photo. In the backs of our minds, we think that if the shot isn't perfect, it can be fixed in Photoshop. I'm of the opinion that we should strive to make each photo as good as we can in the camera and only use Photoshop later for fine-tuning—if necessary.

An exception is when you are photographing fast action, such as wildlife interacting or birds in flight, in which case shooting lots of pictures may help you get the perfect shot (*right*).

SPECIAL TECHNIQUES IN THE FIELD

Of course, post-processing does have its place in outdoor digital photography. Special techniques are available to the digital photographer that are not available to the film photographer—specifically, the opportunity to take multiple shots and then digitally combine them into a single photo. Work in the field entails watching for special picture opportunities: landscape scenics and macro pictures, just to name a few. And, of course, we should all be cognizant of lighting conditions that make for dramatic pictures: approaching storms, the warm light of early morning or late afternoon. But with digital photography, the opportunity for post-processing effects adds a new dimension.

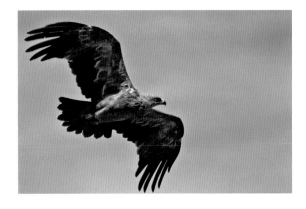

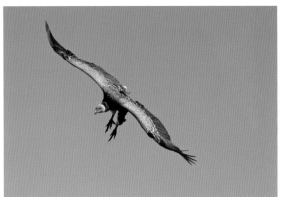

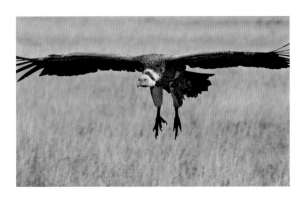

When following action, such as birds in flight, it's often necessary to shoot multiple frames to get just the right one. However, I generally do not use the camera in continuous run, choosing instead to shoot multiple times by pressing the shutter release each time (not holding it down and using it like a machine gun). This is what I did for this tawny eagle (*top*) and these white-backed vultures homing in on a kill in the Serengeti (*middle and bottom*).

71

STITCHING SIDE-BY-SIDE SHOTS

You no longer need to carry a separate, special panorama camera to get those big, wide-view scenics. Instead, by shooting a series of pictures in sequence across the breadth of a scene, you can stitch these together later in Photoshop or in other special stitching programs (see chapter 8). I recommend a tripod (not a bad thing, since it makes you work with more care and deliberation). However, if you are especially careful, you can get by without.

First, plan your shots. Decide on the scope of the final picture. How much do you plan to take in? Consider lighting variations across the width of the scene. You may not want to compensate too much (if at all) for exposure because it can make for vastly different lighting in parts of the final stitched-together image.

Lens choice is also important. Wide-angle, ultrawide-angle (may be too much in some cases), medium-focal-length, telephoto? What usually works best is a wide- (35mm focal length equivalent in 35mm format) or medium-focal-length lens (50mm up to 100mm in 35mm equivalent).

Keep the camera level. If you use a tripod, be sure it is level before swinging the camera for the panoramas.

Check your overlap points. If panning from left to right, check the right edge of the picture for an obvious point of reference (*left*) so that when you move the camera to the right for the next shot, that point of reference is on the left of the frame (*right*). And allow for enough overlap.

So the technique is this: Start from the leftmost part of your scene, find a reference point on the *right* edge of the picture in the viewfinder, and shoot. Swing the camera to the right for the next shot, line up the first reference point on the *left* edge of the frame (not too tightly on the edge, leave some room), find another reference point on the *right* edge of the frame, and shoot. Then swing the camera to the right again and again line up that new reference point on the *left* edge of the frame, find another reference point on the *right* edge of the frame, and shoot. You can repeat this as often as necessary, though I doubt that you'll want to make a 360-degree panorama. The wider the focal length of the lens you're using, the fewer times you'll need to swing the camera (*opposite bottom*). The beauty of this technique is that with long focal lengths, the background elements are more dramatic than when you use a wide-angle lens.

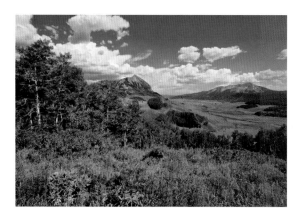

Panoramas can consist of two or more shots, later to be combined in Photoshop. In this case, I made only two shots because I used a very wide-angle lens (Canon 10–22mm) for this scene of Crested Butte, Colorado. Red zones demarcate the rough area of overlapping of each image. Later, in Photoshop, I selected the two images in Bridge, went to Tools>Photoshop>Photomerge, and selected Auto for the layout. Photoshop did a good job of matching and blending.

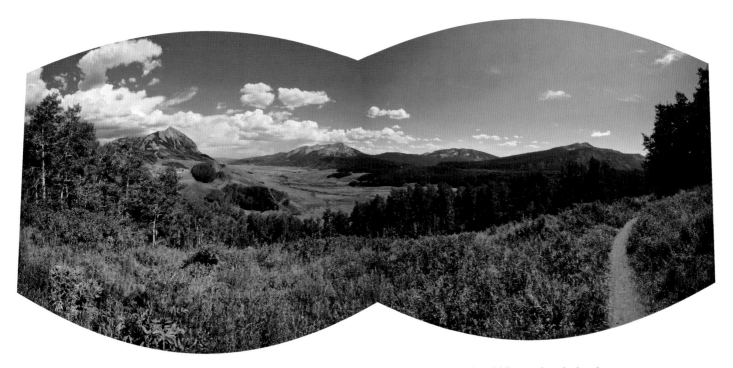

This is the result of Photoshop's blending, before cropping. Some additional blending of the sky in the middle was done by hand.

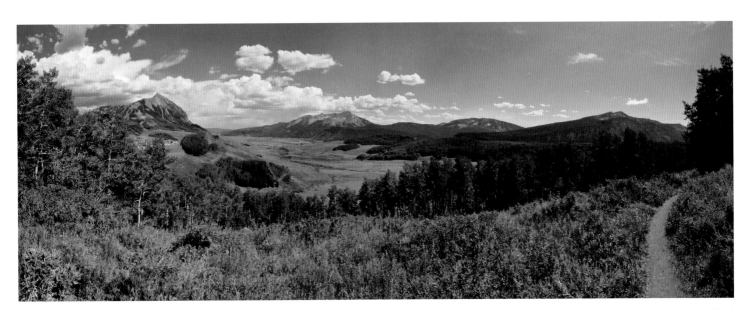

This is the result after cropping and blending the image manually. Because I used a very wide lens (10mm, equivalent to 16mm in 35mm format) when I stitched together the two adjacent images, it gave a panorama equivalent to about a 140-degree angle of view.

STACKING NEAR-TO-FAR SHOTS

This technique increases the depth of field and is great for macro photography as well as static landscape shots. The depth of field is the zone of sharpness in a photograph. This technique requires some detailed image processing and software. Basically, it entails making a series of exposures of a scene and changing the focus slightly for each shot. The subsequent photos are then stacked and arranged in order of focus (i.e., focus from near to far, or vice versa). Then, using special software like Helicon Focus Pro, the images are compared and combined, giving a final picture that has a great depth of field—in fact, a focus range normally impossible to achieve with the camera even by stopping the lens down to its smallest aperture.

Focus stacking is particularly useful in macro work where the depth of field is extremely narrow. You must have a nonmoving subject, and a tripod is mandatory because of the need for precise alignment later.

In this shot, you can see the limited depth of field (*opposite top*). The aperture was f/8, which was not sufficient to keep the insect and most of the flower in focus.

For this picture (*opposite bottom*), I made a series of six shots, changing the focus each time from foreground to background, then processed the image in Helicon Focus Pro. The procedure is given in the instructions for Helicon Pro, and the directions are quite easy to follow.

In addition to improving the depth of field in macro shots, the stacking technique can also be used in scenics. There are times when we wish to convey a great perspective of a scene, such as foreground flowers *and* background mountains—and all in sharp focus. One way to do this is to use an ultrawide-angle lens—say a 20mm or less in 35mm full-frame format (or about 13mm in a DSLR with a 1.5 multiplier effect). By stopping down to minimum aperture and working at a low angle, close to the ground, you can achieve the necessary depth of field to keep everything in sharp focus, from inches in front of the lens to infinity. However, the ultrawide-angle also diminishes those mountains in the background. If you use a longer focal length to make the mountains more dramatic, you can't achieve the depth of field you need to keep everything sharp—even at the smallest aperture of the lens.

Using the focus-stacking technique, you can achieve this. Once again, you must use a tripod. Set up your shot, arranging the composition with the foreground elements and the background elements the way you'd like them. Switch off the autofocus on your lens. Check the lighting. Make sure it will stay uniform during the time it takes to make the separate exposures. Also, be careful that you don't have moving objects in the scene—windblown flowers, for example. Start by focusing on the nearest elements in the picture and make your first shot. In subsequent shots, change the focus slightly to intermediate and then background elements. The smaller the increments of focus change, the more detail will be retained in the final composite image. Shooting eight, nine, or ten separate shots is not unusual. Then let Helicon Focus Pro do its magic.

Focusing closely on this fly with a moderate aperture (f/8) did not give me enough depth of field to keep the entire insect or much of the flower in sharp focus (*top*). With the camera on a tripod, I made six shots, each one with a slight change in focus from front to back—and hoping the subject wouldn't move! Later, in Helicon Pro software, the images were magically combined to give much more focus across the picture (*bottom*).

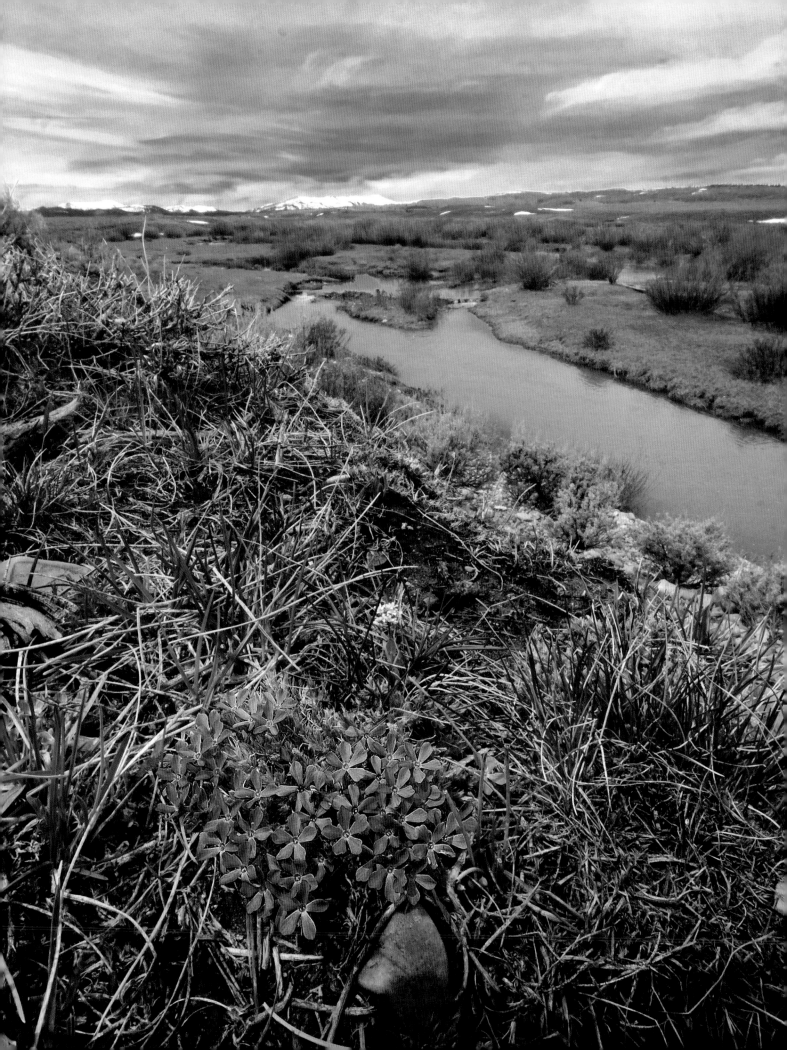

CHAPTER 5
CREATIVE USE OF LENSES

A photograph is a two-dimensional compression of the three-dimensional world. That compression means we need to give careful thought to the spatial relationships formed in the image. And lenses are what form those spatial relationships.

In the real world, our stereoscopic vision makes depth apparent to us when we view a nearby object and one that is farther away. But a photograph, lacking a three-dimensional view, renders the two objects in the same plane. As photographers, we need to give thought to how those objects appear in the picture so that we can create that sense of depth. We can do this by emphasizing their relative sizes (the foreground object being larger than the distant one) or by overlapping their two-dimensional forms, making it apparent that one is in front of the other.

Before the advent of zoom lenses, photographic lenses had a single focal length and were lumped into four broad categories:

- **Telephoto** (longer than 55mm)
- **Normal** (45–55mm)
- **Wide-angle** (24–35mm)
- **Ultrawide-angle** (20mm or less)

We still use these terms, even though zoom lenses typically encompass focal lengths from wide-angle to telephoto, all in one convenient optical unit.

A so-called normal lens in a standard 35mm-format film camera is one with a focal length of about 50mm. This focal length was chosen as normal because it was close to the diagonal measurement of the 35mm frame—about 43mm. (Unfortunately, the term "normal" suggests that this lens creates a normal sense of perspective—that is, close to the way we view things with our eyes. I never believed that. A lens of 80mm to 100mm is closer in perspective rendition to the way I see things.)

A couple of advancements have radically changed the way we think of focal length: the multiplier effect in many DSLRs and the extensive use of zoom lenses. There was a time when a zoom lens was a compromise—the resolution was not as good as a single-focal-length lens. Today, zoom lenses are so good there is no reason *not* to use them. I travel with just three zoom lenses (a 10–22mm, 28–135mm, and 100–400mm) that replace the nine or ten single-focal-length lenses I used to carry.

Spring phlox grow near a tributary of Green River, Pinedale, Wyoming. Shot with a 10–22mm lens.

In the following discussion of lenses, keep in mind that I'm referring to focal length equivalents in *zoom* lenses.

As I explained in the first chapter, the use of smaller-than-35mm-format sensors in most DSLRs effectively gives a multiplication factor to a lens. This means that a 50mm normal lens in 35mm format becomes an 80mm focal length in a DSLR with a 1.6 multiplier effect. And a 35mm lens, a modest wide-angle in 35mm format, becomes close to a 50mm normal lens with that multiplier effect. To achieve the effect of an extreme wide-angle lens in most digital cameras (less than 20mm in 35mm format) requires a very short focal length because of the multiplier effect. Thus you need a 10mm extreme ultrawide lens to get the effect of a 15mm ultrawide on a 35mm-format camera.

Many of these extreme wide lenses are designated strictly for use with DSLRs that have smaller sensors with multiplier effect. In other words, you can't, or shouldn't, use them on a 35mm film camera or on a digital camera with a 35mm full-format sensor.

A wide-angle lens, as the term implies, provides a wider angle of view than a normal lens.

Wide-angle lenses have focal lengths that are shorter than 50mm: 35mm, 28mm, and 24mm (with multiplier effect, these are 24mm, 19mm, and 16mm, respectively). In the realm of ultra-wides, the focal lengths are 20mm, 18mm, and 15mm (with multiplier effect, these are 13mm, 12mm, and 10mm, respectively).

Unfortunately, the term "wide-angle" makes some photographers think the lens is designed to allow them to cram more things into a picture. This is *not* the most effective way of using wide-angles and ultrawides—more on this when we deal with perspective.

A telephoto lens has a focal length significantly greater than that of a normal lens. Telephotos deliver a magnified image, and most often we associate telephoto lenses with wildlife and sports photography, when you need to capture action and detail from a distance. But they can be used for so much more.

As I said, these terms have too often suggested certain ways that we use different focal lengths—normal lens for normal perspective, wide-angles to pack more into a picture, long telephotos exclusively for wildlife. These notions stand in the way of creative expression.

Perspective matters! While photographing in Torres del Paine National Park in Chilean Patagonia, I chose an ultrawide lens (10–22mm zoom) and moved in close so that this red flowering bush was prominent in the foreground. Stopping down to f/22 gave a depth of field sufficient to keep the bush and background sharp. The great perspective here gives a feeling of expansiveness.

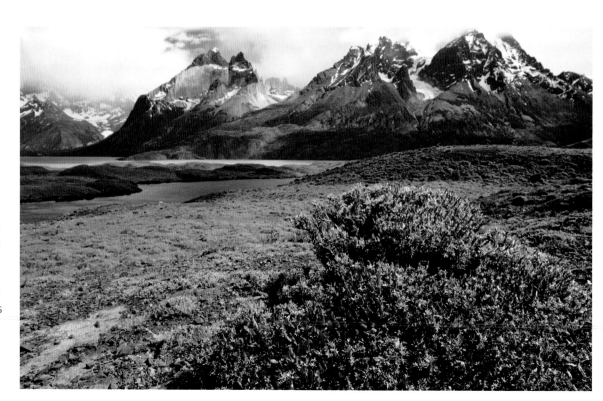

From a creative standpoint, the most important properties of lenses that we need to understand are 1) perspective relationships produced by different focal lengths and 2) depth of field control.

When we approach the task of photographing a scene, we need to think of focal length, especially the relative perspective renditions of different focal lengths and how that will affect the photo. The choice of a particular focal length also dictates how we position ourselves with respect to the subject. We may want to move in closely to the primary foreground subject and use a wide- or ultrawide-angle lens to increase the sense of perspective and show dramatically the relationship of foreground to distant objects (*opposite*). Or we could back off significantly and use a telephoto lens to compress the perspective—that is, make the background elements appear to loom large against our foreground object (*right*).

Using a normal lens of 50mm focal length achieves a compromise between these extremes. But because this perspective is used so often, scenics and landscape photographs made with this lens tend to lack drama and to look pretty much alike. (Unless, of course, there's something else to add drama to the picture like moody lighting or an unusual subject.)

Let's look in detail at some lens characteristics, in particular those lenses representing the extremes of focal length.

WIDE- AND ULTRAWIDE-ANGLE LENSES

As a group, wide-angle—especially ultrawide-angle—lenses may be the most misunderstood, misused, and disappointing lenses for beginning photographers. These are the 20mm, 18mm, and 15mm lenses (with multiplier effect, 13mm, 12mm, and 10mm, respectively).

Take scenics, for example. We're all awed by great panoramic vistas. Whether it's the Grand Canyon or the Grand Tetons, we want to capture that *grandness*. There's a tendency to think that, in order to capture the great scale

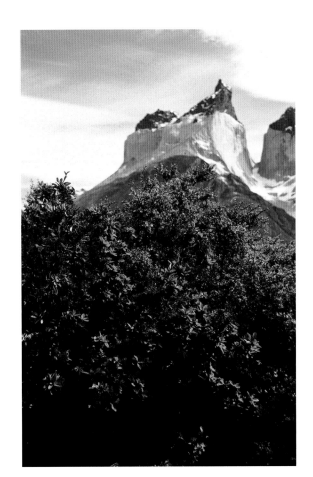

Another red flowering bush, also in Torres del Paine. Here, however, I used my 28–135mm zoom, set at about 100mm (160mm equivalent in 35mm format), to compress the perspective and make the mountains in the background loom more dramatically. I chose an aperture sufficient to keep the bush sharp but not the background mountain.

and scope of it all, we need to use a wide- or ultrawide-angle lens.

The results are inevitably disappointing. Instead of capturing grandeur and greatness, the short focal length diminishes everything. Rather than appearing as towering mountains, majestic peaks appear as little bumps way back there in the far distance. The picture is often further weakened because too much has been included. There's a confusing clutter of elements, with no strong center of interest. And if the picture was made at normal eye level, even foreground foliage and flowers may lack detail because they appear so far away.

After a number of such disappointments, many photographers tend to shy away from wide-angle lenses. But, instead of relegating that lens to the camera bag, learn to use it for its two most important characteristics: the ability to produce exaggerated perspective and the ability to produce a great depth of field.

Don't confuse **ultrawide-angle lenses** and shorter focal lengths with **fisheye lenses**. Fisheyes have a *curvilinear* perspective, rendering straight lines as curves; ultrawides have a *rectilinear* perspective, rendering straight lines as straight.

■ **Exaggerated perspective.** To utilize this effectively, you need to choose an angle that places the foreground subject close to the lens. Most often this type of photo is best taken at a low angle, close to the ground so that the foreground subject looms large in the picture while the middle and background elements remain sharp (*below*). The effect is a heightened sense of distance between foreground and background.

This perspective expansion can also occur in the sky. I was photographing one morning in Tanzania's Ngorongoro Crater, and I noticed a cloud pattern overhead (*pages 82–83*). By tilting my ultrawide lens upward, I got this shot of expansive clouds overhead, at the same time including the expansive floor of the crater. So look up once in a while!

■ **Great depth of field.** This works hand in hand with exaggerated perspective to enhance the impact of your pictures. The depth of field is the zone of sharpness in a photograph. A 20mm lens (13mm with multiplier effect), when stopped down to f/22, creates a depth of field ranging from about 14 inches (36 cm) in front of you to infinity. And a 15mm lens (10mm with multiplier effect), stopped down to the same f/22 aperture, creates a depth of field from 10 inches (25 cm) to infinity! Keep in mind that these figures are measured not from the end of the lens but from the sensor. And since an ultra-wide zoom lens may be 5 inches (13 cm) long, that depth-of-field figure means that something only 5 inches (13 cm) from the front of the lens will be sharp, *along with everything else to infinity.*

By the way, let's dispel the common notion that ultrawide-angle lenses *distort* objects. They don't. Modern rectilinear wide-angle lenses display very little optical distortion. What's thought of as distortion is really perspective exaggeration. It becomes especially apparent when you use an ultrawide lens and tilt it upward or downward. Straight, parallel lines will appear to converge strongly. This can be used for dramatic effect. For example, lying on your back in a grove of trees and pointing the camera upward with an ultrawide lens creates an interesting effect of strong, converging lines of tree trunks (*opposite top*). If you try this, take note of the fact that it really isn't a distortion. As you lie there looking up, you'll see that these lines really do converge. But when seen with the eye, the effect has less impact than when we view it in a photograph.

A surprising characteristic of wide-angle lenses is the fact that you can handhold them at slow shutter speeds. The wider the angle, the slower the shutter speed. You would never dream of handholding a 50mm or a telephoto lens at shutter speed of ¼ of a second. But with practice and a bit of bracing, you can handhold a 20mm at that speed. For example, in shooting interiors in dim light, I can

The Atacama Desert of southern Peru and northern Chile is the driest desert in the world. In order to capture the feeling of extreme aridity, I used my 10–22mm ultrawide zoom at a very low angle to include the sand and rocks in the foreground and emphasize the lack of vegetation. It looks like those photos from the surface of Mars.

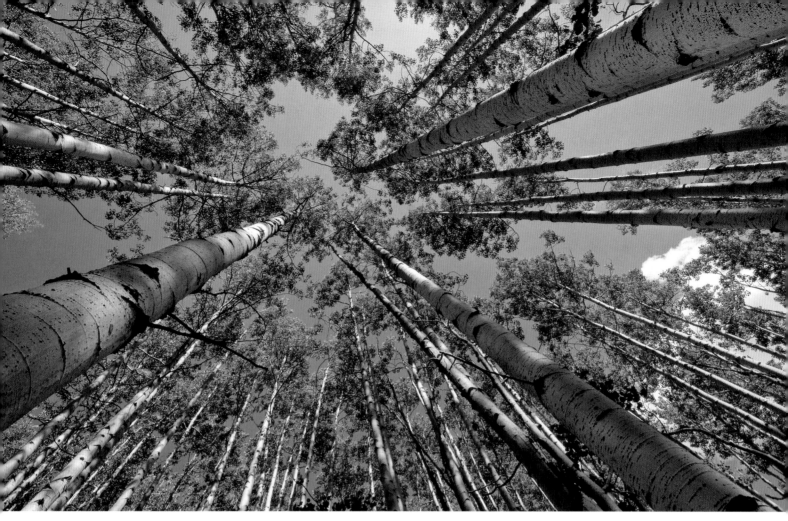

Lying on my back in a grove of aspens (no, not napping), I used my 10–22mm ultrawide zoom at 10mm to get this dramatic effect of converging lines of tree trunks. This is not an optical distortion but rather a perspective exaggeration.

use slow shutter speeds by bracing the camera against a door frame or wall (*below*). Lying down, with elbows braced on the ground, also provides a stable position for such slow speeds.

I particularly like using ultrawides—20mm (13mm with multiplier effect) and 15mm (10mm)—for the dramatic possibilities they offer. They open up a whole new world of photographic seeing. Since many ultrawides focus down to less than one foot, you can even use them for close-ups. Crawling around on a forest floor with an ultrawide lens gives you a whole new perspective. Not only can you get a close shot of a mushroom, you can actually see underneath it—giving you something of a snake's-eye view of the world.

With my 10–22mm ultrawide zoom set at about 20mm, I used an ISO of 800 because this room interior was somewhat dim. But even then my shutter speed was about 1/30 second, and I braced the camera against a door frame. This is the Museum of Wooden Architecture outside of Irkutsk, Siberia, a place noted for its marvelous old buildings of another century in Russia.

Pages 82–83: Ultrawide lenses can also be used, under the right conditions, to include some dramatic skies.

This mountain scene in Torres del Paine National Park in Chile was made more dramatic by using my 28–135mm zoom set at 135mm (about 215mm equivalent in 35mm format with the 1.6 multiplier effect).

TELEPHOTO LENSES

Everyone is awed the first time they use a long telephoto lens or zoom out a tele-zoom lens, like a 100–400mm, to its longest focal length. You can optically reach out and touch things a long way off.

Moving in close to a subject is *not* the same thing as moving back and using a telephoto lens, even though the subject may be kept the same size in the picture. A telephoto lens creates a strong sense of compressed perspective. That is, the separation of elements in a picture is diminished. The longer the focal length, the more dramatic the effect.

Though people normally think of telephotos as useful for wildlife photography, they can be used for much more than that. In fact, medium telephotos are most useful for landscape and scenic photography. Mountain scenes are rendered more dramatically with a longer focal length than with a normal or wide-angle lens (*below*). But be aware that atmospheric conditions may present problems. When shooting over a long distance using a telephoto, haze and dust diminish contrast and sharpness. And on a hot summer's day, shimmering heat waves will create soft images.

Telephotos need to be used with care in order to produce sharp images, particularly when handheld. Every little movement becomes magnified. The longer the lens, the greater the effect. Faster shutter speeds are required in order to minimize image blur from such movement. The shutter speed you choose depends on whether or not you use the image stabilization feature of your DSLR:

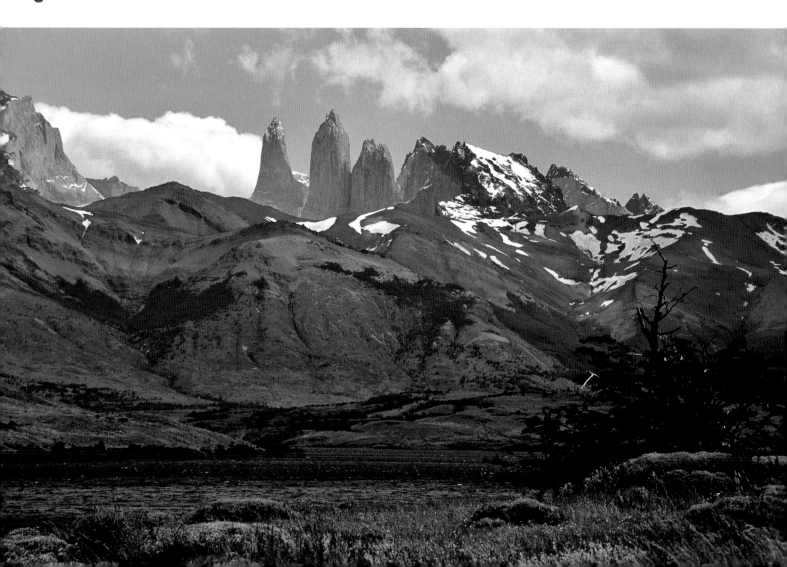

- **Using a telephoto lens *without* image stabilization**. As a rule of thumb, choose the reciprocal of the lens focal length for the *slowest* shutter speed at which you can handhold a particular lens. For example, for a 200mm focal length, use $1/250$ of a second; for a 500mm, $1/500$ of a second. *However*, you still need to brace the camera and lens carefully. If there's not a tree handy, I sometimes hunker down, bushman style, with my elbows braced on my knees. Or, if standing, I hold my arms close to my body, with my elbows pressed against my ribs. In fact, I do this for most non-tripod shooting, regardless of focal length.

- **Using a telephoto lens *with* image stabilization**. The focal length–shutter speed reciprocity only applies to lenses without stabilization. Nowadays, image-stabilized lenses are more common and make it possible to handhold long telephotos at surprisingly slow shutter speeds. For example, I have tested the image stabilization of my 100–400mm zoom lens (160–640mm with multiplier effect) and can create consistently sharp images at $1/60$ of a second shutter speeds at the longest focal length (*right*). However, I still try to use faster shutter speeds and techniques, as described above, to ensure absolute sharpness.

Even with these steadying methods, there comes a time—or focal length—when you should use a tripod. I rarely handhold telephoto lenses longer than about 200mm unless I'm following some fast-moving action—birds in flight, for example. It's just too risky in terms of image quality. The only exception is on a photo-safari in Africa, where I can use a beanbag on an open roof hatch. This method provides an exceptionally stable platform for even the longest telephoto lenses.

DEPTH OF FIELD

When I prepare to take a photograph, one of the most important questions I ask myself is: *What f-stop should I choose—and why?* It's an important consideration because I must know what depth of field I want. I can't overemphasize the importance of this: Determining the depth of field is a vital creative judgment in creating a good photograph.

Depth of field is defined as the zone of acceptable sharpness that extends on either side of—that is, in front of or in back of—the point of focus. The depth of field is a function of 1) lens aperture, 2) lens focal length, and 3) point of focus. For any given lens, the zone of sharpness is increased by stopping down to a smaller aperture. A longer focal-length lens produces an inherently narrower depth of field than a shorter focal-length lens. The depth of field shrinks when the point of focus is very close to the lens.

At first thought, it would seem that the maximum depth of field would be desirable for every picture. You want everything in your picture to be as sharp as possible, right?

Wrong! For creative effect, sometimes you *want* to blur part of the picture. Limiting the depth of field in this way can prevent background or foreground elements from distracting from the focal point. Remember, we are compressing the real world of three dimensions into two dimensions for the image, and manipulating the depth of field is one way to deal with that third dimension. There are times when we want a great zone

Left: This shot of winter grasses was taken with my 100–400mm zoom set at 400mm (equivalent to 640mm in 35mm format with the 1.6 multiplier effect), handheld but braced by hunkering down with my elbows on my knees. Image stabilization was turned off. I thought I was doing a good job of bracing, but at a shutter speed of $1/60$ of a second, there was enough movement to blur the image.

Right: Same shot, same way, same shutter speed, but with image stabilization turned on. The IS really does do a good job, though I would not recommend handholding such a long lens very often at slow shutter speeds.

There's a tendency to think that more depth of field is better. Not necessarily so. This shot of some grass in a mountain meadow *(top)* was done with a small aperture (large depth of field) with a 100mm macro lens. The background, though not sharp, is distracting. By shooting at a large aperture with less depth of field *(bottom)*, the main subject stands out better against the background.

of sharpness, from foreground to background. But there are an equal number of times when the foreground or background should remain unobtrusively out of focus.

The depth of field is not like a no-parking zone that has clearly defined boundaries. When we say that the depth of field is the zone of sharpness, we need to realize that objects just outside the boundaries of that zone still have some level of sharpness. That is, they are not so blurred as to be unobtrusive. It is a problem, pictorially, when a foreground object is outside the depth of field and yet still readily apparent. In most compositions, foreground objects that are partially sharp are *very* distracting, since, in general, foreground objects demand to be razor sharp. You should know, before you take your picture, whether an object is inside or outside the depth of field.

For some photos, I choose a telephoto lens to limit the depth of field in order to spatially isolate the subject from the foreground and background *(right)*. The effect can be dramatic, depending on the focal length of the lens and the aperture chosen.

Instead of trying to get everything sharp, I chose an aperture for my 28–135mm lens to blur the background—but not completely. I wanted to maintain a sense of place, in this case, the ruins of Machu Picchu in Peru. Note how the red-leafed plants stand out against the blurred background.

HOW TO DETERMINE THE DEPTH OF FIELD

■ **Use the depth of field scale on the lens**—*if* your lens has one. Many, if not most, zoom lenses these days do not have depth-of-field scales on them. They were more common on single-focal-length lenses. It's a practical matter because such scales get unduly complicated and difficult to read as you change focal length.

■ **Use the depth of field preview button on the camera.** This feature can be a little challenging. The preview button stops the lens down to the chosen aperture—which means that the viewfinder gets very dark. I find it helpful to shield the viewfinder (and my eye) using my hand. This cuts down on stray light and allows me to see the dim image better. Also, keep your eye at the viewfinder long enough for it to adjust to the dimness.

■ **Use a device called ExpoAperture.** This handy little calculator gives you information on how to choose an aperture for a given depth of field at a given distance.

EXPERIMENT WITH LENSES

Experimentation is a vital aid in learning to use lenses creatively, particularly those that are outside the familiar, medium-focal-length range. Give yourself assignments. Explore the perspective-compressing potential of telephotos for scenic shots (*below left*). Experiment with the perspective-expanding capabilities of wide- and ultrawide-angle lenses (*below right*).

Shoot a series of pictures using the widest-angle lens you own—the wider the better. Then examine the photographs you made. Disappointing? If so, ask yourself why. Was it because you were too timid with the scene? Too far away from the subject?

Repeat the assignment with a telephoto lens. Try using extreme focal lengths in non-traditional ways—for close-ups, for example. I mentioned that you can use an ultrawide for close-up work; a telephoto, too, can be used for such purposes. Because the minimum focusing distance on most telephotos doesn't allow close focusing, you may need to use an extension tube in order to move in close to your subject. An extension tube fits between camera body and lens, moving the lens farther from the film plane and allowing closer focusing. Just remember that telephotos require longer extension tubes for reasonable focusing distances than medium-focal-length lenses do. Experimenting with a shallow depth of field and compressed perspective opens up a whole new world of creative possibilities.

Devote some time to the exclusive use of a particular lens and explore its potential. Make portraits of family members using the longest telephoto setting of your zoom and the widest-angle lens you own. Keep notes during these self-assignments so that you can compare such things as depth-of-field control at various apertures.

The idea is to get comfortable using any lens focal length—and to have a good sense of what each lens can do for you creatively in any shooting situation. To me, it's exciting and creatively challenging to explore a single subject using different focal lengths. And with the great zoom lenses available these days, it's easy to do.

Left: Another example of differing perspectives and depth of field. I wanted to emphasize the intricate stonework at the ruins of Machu Picchu in this shot, but I didn't want the background to be distracting. At the same time, I wanted to maintain a sense of place, so I chose a medium-focal-length telephoto lens (about 100mm) and an aperture sufficient to keep the stonework sharp but blur the background somewhat. Using the depth-of-field button on the camera, I could check to see what I was getting.

Right: In this case, also at Machu Picchu, I wanted great depth of field, so I chose a 20mm ultrawide lens and stopped down to keep everything sharp, from foreground to background.

CHAPTER 6
EXPANDING YOUR CREATIVITY

Photography is a human act and therefore subjective, a selective act and therefore interpretive. This makes it possible for photography to be an art, for photographers to achieve a personal style— and for the camera to lie.
—*Arthur Goldsmith*

Digital photography has brought us new ways to expand our creativity. Perhaps most important is the capability to see photos immediately and to use this instant feedback to make corrections or try something different. I find this especially valuable because in my quest to find new ways to capture images, I can try new and different things and not have to wait until the film is developed to see how the pictures turned out. This immediacy should give us all encouragement to experiment.

We tend to think of photography as being realistic and truthful. From its beginnings, photography was a tool for documenting people, places, and events. The camera, being a mechanical device, was thought of as impeccable and incapable of lying. The photograph came to represent, in our minds, a slice of reality. Therefore we never gave much credit to photographers as being interpreters, only recorders.

But if you think about it for a moment, photographers *are* truly interpreters. In framing a subject and choosing the elements to include (or exclude), the photographer forces the viewer to see only what was chosen and intended. In other words, when I create a photograph, I'm basically saying to the viewer, "Here is what I want you to see. This is my vision of something significant, and I want you to share my vision." Therefore, I become an interpreter, a translator. I can create a photograph of a beautiful scene, but I don't show you the pile of beer cans at my feet because I've chosen to show you only the beauty. (I suppose, in this instance, that also makes me a liar.)

From atop the London Eye, the River Thames, London, England. Shot with a 10–22mm lens.

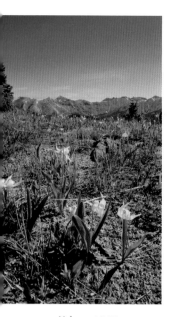

Using a 10-22mm ultrawide zoom on my Canon 20D, I chose a low angle, up close to the flowers, and selected f/22 for depth of field to keep everything sharp, from foreground to background. It's an okay shot, conveying something of the ecosystem near timberline in the Colorado Rockies, but it's nothing really exciting.

Suppose I take a picture of a lovely alpine meadow with wildflowers. And I do it in such a way as to make it as "realistic" as possible—everything sharp from foreground to background (*left*). The photograph may document the place very well, but it doesn't necessarily tell you how I felt about being there. It is a neutral portrayal because we expect all flower-filled alpine meadows to be beautiful. I am not being judgmental, by the way. I am not saying this is a boring way to photograph an alpine meadow. In fact, without departing from a realistic rendition, that scene can be portrayed an infinite number of ways—which makes it challenging from a creative standpoint.

CONVEYING EMOTION

Having satisfied my first impulse to document the scene, I can turn to a more impressionistic rendition. What is there about this place? How does it make me feel? Happy? Reminiscent? Sad? What are the elements that give this place such emotional impact? Color? Sunlight? Wind?

We tend to think of painting as the medium for creating abstractions and impressionistic interpretations, while photographs are thought of as strict interpretations of the real world. But where is it chiseled in stone that all photographs must be strict documentary records?

Let's go back to that alpine meadow. One of the primary things *I* respond to is color. To convey the joy of being amid this field of flowers, I chose, for a different interpretation, a macro 100mm lens (160mm with multiplier effect). With this lens, I could focus closely, and by shooting at maximum aperture (f/2.8), I could create a shallow depth of field. Therefore, objects very close to the lens and objects beyond my focal point—in this case, a yellow flower—were very much out of focus and became merely washes of color (*right*). This is exactly what I wanted—subtle washes of color. I actually lined up my shot in such

a way as to have other flowers or grasses almost touching the front of the lens, and their presence creates those wonderful, subdued, diffused, dreamy colors.

Also, for this particular picture, I chose to focus on the yellow glacier lilies, although there are some red Indian paintbrush in that meadow as well. Why? The bright yellow has a warmth to it that conveys more readily the feeling of a sun-washed field. It's subtle, but it does have an effect on the impact of the final picture.

Impressionistic photographs are interpretive renditions of senses or emotions. Have you ever tried to photograph the wind? Or sounds? Fear? Joy? You can, but it's not easy. You have to switch gears mentally, from a literal way of thinking and seeing to an interpretive one.

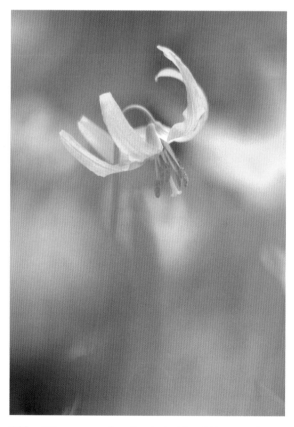

With a 100mm macro lens (equivalent to a 160mm on 35mm format), shooting at maximum aperture of f/2.8, I had a very shallow depth of field and was focused on just parts of the flower. In addition, other flowers close to the lens gave an out-of-focus wash of color to create a more impressionistic rendition of these glacier lilies.

CAPTURING A SENSE OF MOTION

Let's go to a meadow and try photographing the wind. I found a broad, grassy swale not far from Siberia's Lake Baikal where the wind creates ripples of waves through the grass. Obviously, you can't photograph the wind itself. So you need to look for the effect that wind has on things—motion and, in this case, the creation of patterns.

Illustrated here are three interpretive renditions of my windblown grasses:

1. In the first (*top*), I used the pattern of bent grasses, with the curved lines of the blades of grass, to convey a sense of movement. The shutter speed was 1/60 of a second, sufficient to "freeze" the movement and render the grasses sharply.

2. The second rendition (*middle*) utilizes a slow shutter speed—in this case, 1/8 of a second—to allow some blurring from the motion of the grasses. Note that, while some of the grasses are blurred and convey a sense of movement, others are relatively stationary and sharp. The combined effect says "wind." Incidentally, when trying this method of using slow shutter speeds, you should take several pictures because you can never tell with any predictability what the final result will look like.

3. A third technique (*bottom*) uses Photoshop to create the effect of blurred movement. Once upon a time, this technique was accomplished by utilizing multiple exposures on film, but most DSLRs do not allow multiple exposures. In Photoshop, I can create this effect by layering and offsetting slightly the same image. Or, I can first create a duplicate layer, then on that layer select Filter>Blur>Motion Blur and adjust until I get the overall effect. Finally, I add a layer mask and "paint" away the blur in places to reveal the sharp layer underneath.

Technique 1

This grassy meadow was in Siberia, not far from Lake Baikal. I used a 1/60-second shutter speed to freeze any movement of the grasses. The bent blades of grass convey a sense of movement by the wind.

Technique 2

Here, photographed using a 1/8-second shutter speed, some of the grasses are blurred by the wind movement, but some remain sharp. Again, a sense of the wind is conveyed here.

Technique 3

This same blur effect was created in Photoshop (see also the techniques for using Layers and Masks in chapter 10).

Above: This is a straightforward rendition of some aspen leaves in autumn, but I wanted a dreamier effect. On film I would have made multiple exposures on the same frame. Here, I used Photoshop to achieve something similar.

Above left: In Photoshop, I made a duplicate layer, reduced the opacity of that layer to 50 percent, and, using the Move tool, moved the image to offset the leaves.

Above right: I made a layer mask and "painted" away parts of the upper layer to reveal the sharp branches and portions of the leaves in the background layer to create this effect of aspen leaves quaking in the breeze.

In this shot of autumn aspen leaves, most of the leaves are sharp (*left*). What I wanted, however, was something more interpretive. They are called quaking aspen because the leaves move and tremble at the slightest breeze. There wasn't any breeze that day, so I created the effect in Photoshop.

First, I made a duplicate layer and reduced the opacity to about 50 percent (experiment with this). Then, using the Move tool, I moved the image in that layer to offset the leaves slightly (*center*).

Finally, I created a layer mask and, using the brush tool, "painted" away parts of that layer to reveal the sharp branches and a portion of some leaves to give an overall impressionistic rendering of aspen leaves quaking in the breeze (*right*). This technique replaces the simple double-exposure technique you would use on a film camera, where you take one exposure with the subject in focus and the second exposure with the subject out of focus. The effect is a soft, out-of-focus halo that creates a dreamy feeling about the subject.

There are other ways of creating impressionistic photographs—filters, for example. Diffusion filters can soften an image, creating a dreamy look. Other filters create multiple images or far-out color renderings. It's fun to experiment with these, but beware: At times, they can become a little gimmicky.

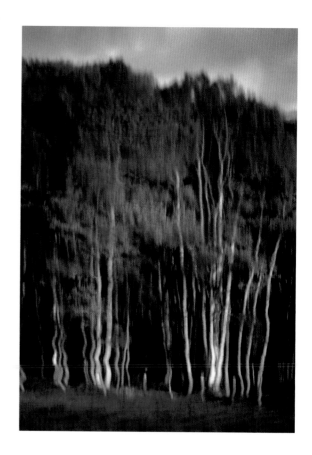

The way this picture is printed here, it's upside down! These aspen trees were reflected in a small pond, but I like the abstract effect. You could, of course, do some similar things in Photoshop, but seeing these things in the field while shooting helps expand your creativity.

ABSTRACT PHOTOGRAPHY

Another realm of interpretive photography is found in abstractions. Abstractions are often created by extreme close-ups of common things. You'll need a macro lens or a close-up adaptor lens that allows close focusing. The emphasis here, as in abstract painting, is on the boldness and power of pure lines, forms, shapes, patterns, or texture without the encumbrance of relating these elements to real objects.

For abstract photography, the choice of subject matter is nearly limitless. But this is the realm where you have to learn to see carefully. In your own household, there are wonderful abstract subjects to be found—fabrics, surfaces, objects ranging from silverware to tools, reflections, bright and bold colors, subtle colors. If you're a cook, as I am, there are wonderful things on the stove. Just one example: the color and texture of simmering spaghetti sauce. (Don't let it splatter the front of your lens, and don't get so caught up in photographing it that you let it burn!)

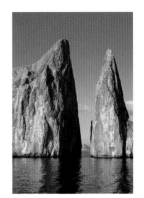

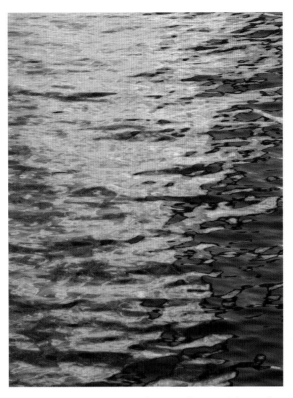

The late afternoon sun painted warm colors on Kicker Rock, a famous landmark in the Galapagos Islands (*right*). But while I was composing this picture, I noticed the gold reflections in the water and realized the water would make an even better picture: an abstraction (*above*). The golden ripples contrasted nicely with the deep-blue sky reflections.

Abstractions are everywhere. This small stream was reflecting the brilliant autumn foliage of a New Hampshire hillside. The blue came from the sky also being reflected. The overall pattern was broken up by the moving water. For even more interesting effects, you could vary the shutter speeds—slower to blur more or faster to freeze some of the movement more.

CAPTURING TIME

The camera is a time machine, and a photograph is a slice of time. In photography, *how* we capture that instant of time determines the drama and impact of the photograph. In addition, that slice of time can convey, in various ways, impressionistic renditions.

Obviously, we have a number of choices for shutter speeds. With modern cameras, the choice is often made for us in the program mode, where a pre-selected speed is used in conjunction with a pre-selected aperture. I'm not particularly fond of using automatic or program mode because I like to make such decisions myself. I admit that for many subjects and circumstances, it's convenient and fast to have the aperture and shutter speed selected for me, allowing me more time to concentrate on picture content—particularly with action shots. But there are times when we should go through the process of selecting the shutter speed manually—because it forces the questions: What effect am I trying to achieve? What slice of time do I want to capture, and what shutter speed should I use to capture it?

Let's say we find a lovely scene with running water, a fast-moving brook with small waterfalls. How can we best capture the feeling of flowing water? One obvious answer is to use a slow shutter speed, allowing the water to become a dreamy blur in the picture. But how slow? This is where experimentation becomes crucial in gaining some knowledge about such situations because the results will vary with the speed of the water. As a starting point, you might use ⅛ of a second (with the camera firmly mounted on a tripod, of course). Then try bracketing shutter speeds (keeping some notes to guide you later when comparing pictures)—¼, ½, 1 second, perhaps even longer (and, of course, choosing the appropriate f-stop for correct exposure).

Of course, such choices will also depend on the lighting. In bright sunlight with a medium speed setting of ISO 100, with the lens stopped down to its smallest aperture of f/22 (assuming the lens' smallest is f/22; some only stop down to f/16), the slowest shutter speed possible is ¹/₆₀ of a second. You can't expect much of a blurring effect at that speed. So you may have to wait for lower light conditions—an overcast day, for example.

Another choice for bright sunlight conditions would be to use a neutral density (ND) filter—that is, one that absorbs a certain amount of light but doesn't change the color rendition of a scene. These filters are designated as ND 0.3, ND 0.6, ND 0.9, etc. A 0.3 ND holds back one f-stop of light, a 0.6 ND holds back two f-stops, and a 0.9 ND holds back three f-stops. If you don't have an ND filter, a polarizing filter makes somewhat of a substitute. Most polarizers soak up about one and a half f-stops of light.

What about using faster shutter speeds for subjects like moving water? This depends on the effect you wish to create, and again some experimentation is called for. I find that very fast shutter speeds—like ¹/₂₅₀ or ¹/₅₀₀—that "freeze" the motion of falling water create a rather unpleasant effect. This is because we view moving water as a blur, rather than an action-stopping impression recorded in the mind. An exception would be when photographing surf and breakers. A shutter speed of ¹/₁₂₅ of a second or shorter "freezes" the curl of a wave or the spray of surf crashing against rocks. It seems natural to capture such action because, as we watch waves crashing against rocks, there is a moment when spray and water drops seem suspended.

Other kinds of water, such as rain and snow, can be effectively captured by choosing a shutter speed that gives a feeling of movement (*opposite*). Experiment a bit with this. Your shutter speed will depend on such factors as how fast the rain or snow is falling and the wind velocity. Start with ¹/₃₀ of a second shutter speed for a good winter snowfall or a summer thundershower. For snow, have a dark background so that the streaks of falling

They don't call it a rainforest for nothing! This shot was made in the shelter of a lodge during a downpour in the upper Amazon Basin of Peru. To capture the rain, I turned off the camera's autofocus, then focused manually on a point between me and the forest across the river so that the rain was really the main focal point, except I used a $1/15$ shutter speed to blur the falling rain. Stay dry!

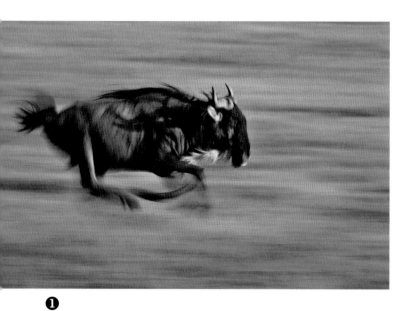

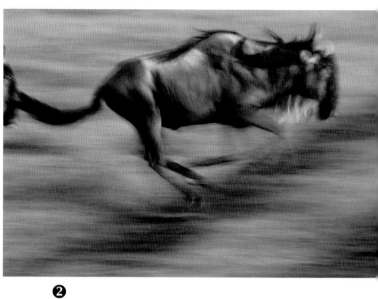

❶

❷

Above: It's called a blur pan: following action with a long lens (in this case, my 100–400mm zoom at 400mm or 640mm equivalent in 35mm) and shooting at a relatively slow shutter speed. In this case, I used $1/15$ second. I followed the animals much like panning a video camera and shooting one frame at a time. (I don't like shooting on continuous.) Sometimes it works, sometimes not—but the beauty of digital is being able to see if you got it right away after shooting.

I used the blur-pan technique again, this time on two Canada geese taking off from a ranch in Wyoming. Shutter speed was $1/15$ of a second.

❸

❹

flakes stand out. Try the same for rain, or, if possible, use some backlighting. Vary shutter speeds—sometimes $1/15$ of a second works best, sometimes $1/8$.

Blur pans are a great technique to use for conveying a sense of speed when photographing running animals, moving vehicles, or certain action in athletics. The trick here is to handhold the camera and follow the action in much the same way you might if shooting video. In this case, however, use a slow shutter speed—say $1/8$ or $1/15$ of a second—to blur the background (*opposite*). The choice of shutter speed will depend on a few things: the focal length of the lens you use, the speed of the subject, and your distance from the subject. I like to use a focal length of 400mm for running animals, and with that lens, I use $1/15$ shutter speed. In the photographs above of the running wildebeest in Serengeti National Park, I used that lens and shutter-speed combination (*1*). Sometimes it's helpful to put the camera on continuous shooting mode—that is, shooting consecutive pictures by holding down the shutter release button. Generally, I don't use that method, preferring to time my shots and shooting quickly in single-shot

mode. Either way, you will discover while using this technique that you must shoot lots of pictures because you never know quite what you are going to get. And that's the beauty of using digital—you can review the pictures right away and delete the ones that obviously didn't work out. I've included here a few that didn't quite make it (*2, 3, 4*).

POST-PROCESSING

Now, having described some of the techniques for creating impressionistic photos in the camera, I must say that nowadays with digital photography you can do similar things in Photoshop. You may not be able to duplicate an effect *exactly*, but the software can do some things that can't be done easily with the camera.

Because there are so many good books on Photoshop techniques, I won't attempt to delve into a rigorous treatment here. However, there are a few simple techniques that you might try, such as the swishing effect (*pages 98–99*). I encourage you to try your hand at abstract or impressionistic photography. The experience, the problem solving, and the thought processes that go into it will benefit your other photography as well.

THE SWISHING EFFECT

A creative method for creating an impressionistic sense of motion in your photograph is to use an ultrawide-angle lens at a slow shutter speed while moving forward or backward. This technique creates a "swishing" effect at the edges of the picture, which gives a feeling of moving rapidly into a scene. This technique can still be done in the camera, but it can also be approximated using Photoshop.

A sharp, motionless picture, shot with a 10–22mm ultrawide zoom at 10mm, 1/250-second shutter speed.

IN CAMERA

This first shot was made looking out the front of a train toward Machu Picchu in Peru (left). The picture was made using a 10–22mm ultrawide zoom lens at 16mm focal length (10mm with multiplier effect). The train was moving slowly, and I used a fast shutter speed (1/250 of a second) so that everything is sharp.

The next shot was made using a 1/4-second shutter speed after the train sped up (below). Note that the center remains relatively sharp but the edges are blurred by the train movement. This is the swishing effect.

IN PHOTOSHOP

Let's duplicate the effect in Photoshop. We'll start with the first image, where everything is sharp. After loading the image to your computer, create a duplicate layer (Ctrl-J on a PC, Cmnd-J on a Mac). Next, with the duplicate layer selected, go to Filter>Blur>Radial Blur (left).

A blurred-motion picture, shot with the same lens, 1/4-second shutter speed.

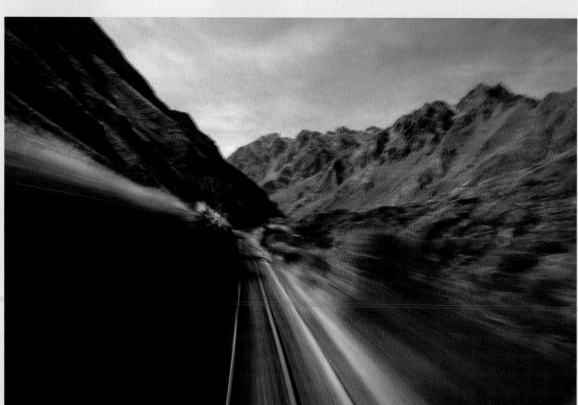

Choose Zoom. Quality: Good or Best. Amount: Start with 20. You can vary this later. Note that in the window Blur Center for the radial blur effect, you can place the cursor and click and drag. Do this so that you move the center (clear part) of the blur to the point where you want it. In this case, I moved it slightly to the left of center. Click OK.

After processing, the image will have an overall blurred effect (*right*).

Not quite what we may want, but that's easily fixed. Next, create a layer mask for that layer (*far right*). Be sure to select the layer mask by clicking on it. What we'll do next is to "paint" away part of the layer, using the layer mask, to reveal the sharp background image. Make sure the Foreground/Background colors are the default Black/White by hitting the "D" key on the keyboard. Select the Brush tool and size it accordingly; you can experiment with this. Set opacity to about 50

The Radial Blur effect.

percent; again, you can experiment. Finally, brush the area of the center of this image where you want it to be sharp (*below*). The remainder of the image will retain the radial blur lines. Again, you can experiment until you get just the effect you want. As you can see here, it is very close to the effect I got when I photographed the scene using the slow shutter speed.

The Radial Blur effect with selective painting.

CHAPTER 7
INTO THE BOONDOCKS

When photography was young, traveling into the wilds of the world to photograph was a major chore, entailing long planning and a large expedition. I marvel at the persistence of such wilderness photographers as William Henry Jackson, who traveled the Rocky Mountain West in the 1870s using the wet-plate process. To make a photograph, Jackson had to set up a portable darkroom in a tent, coat the emulsion on glass plates (some up to 11×14 inches [28×36 cm] in size!), load the plate in the camera, make the exposure before the emulsion dried out, and then develop the negative. Jackson once boasted that he had his equipment pared down to a mere three hundred pounds. This was all carried on pack mules.

Today, in traveling to remote places, it may seem like we need a pack mule: two or more camera bodies (for backup), an assortment of lenses (e.g., 10–22mm, 28–135mm, 100–400mm, 100mm macro), an assortment of memory cards, filters, a sensor cleaning kit, a large supply of plastic bags, a tripod, sometimes a flash, a backpack to carry it all, battery chargers, chargers for a laptop or portable hard drive, plug adapters (for foreign countries), and wires, wires, wires! And, oh yes, camera instruction books because who can remember all the possible functions built into these electronic marvels? (I used to run nuclear reactors that seemed less complicated.)

In chapter 4, I discussed working in the field. The fieldwork described there is what we may encounter near home or traveling to national parks or national forests throughout the United States, where we won't be isolated for long periods of time. In other words, where we have the time and means to upload our images to the computer, charge batteries, and in general keep a reasonable workflow.

But what happens when you get away from civilization entirely—and for long periods of time? For example, flying into a remote camp in the Alaskan bush for a week or two? Or taking a multi-day backpacking trip? Or trekking in the Himalayas? Or spending days in a remote rainforest?

These questions can be answered in three words: *planning, planning, planning.*

These rare green sponges are found in Siberia's Lake Baikal. They were photographed in an underwater exhibit at Baikal Limnological Institute in Listvyanka village near Baikal. Shot with a 28–135mm lens, angled to avoid reflections off aquarium glass.

PLANNING YOUR TRIP

Many years ago, when working on my first Alaska book, I took a thirteen-day backpacking trip into the remote Brooks Range in what is now the Gates of the Arctic National Park. More than any other work I had done before (or after), this trip required extreme planning. The backpacking gear alone weighed almost 50 pounds: pack, sleeping bag, tent, foam pad, cooking gear, food, parka, rain jacket, etc. Added to this gear was the camera equipment. The cameras had mechanical shutters, which meant no batteries were needed to run electronic shutters. Still, the weight of the camera gear alone was 23 pounds, bringing the weight of everything up to more than 70 pounds. Good thing I was young.

With all this heavy equipment and seventy rolls of film, I had the capability to take about 2,500 photographs.

FILM PHOTOGRAPHY TRIP

Gear	Weight
Backpacking gear	50 pounds
Two camera bodies (Nikon F *sans* meter, Nikkormat with meter)	3 pounds
15mm lens	1.5 pounds
20mm lens	0.75 pounds
55mm macro lens	0.6 pounds
105mm f/2.5 lens	1 pound
200 mm f/4 lens	2 pounds
400mm f/6.3 lens	2 pounds
Seventy rolls of film	4 pounds
Tripod	6.5 pounds
Miscellaneous (handheld light meter, filters, lens cases)	2 pounds
Total	**73 pounds**

DIGITAL PHOTOGRAPHY TRIP

Gear	Weight
Backpacking gear	40 pounds
Two camera bodies (both Canon Rebel Xti with a battery each)	2.4 pounds
Ten extra batteries	1 pound
10–22mm lens	0.85 pounds
28–300mm zoom lens	1 pound
Ten flash memory cards (8GB each)	0.3 pounds
Portable hard drive (80GB Epson P-5000 or 160GB Epson P-7000 with two extra batteries)	1.25 pounds
Tripod (carbon fiber with magnesium ball head)	4 pounds
Miscellaneous (filters, lens cases)	1.5 pounds
Total	**55 pounds**

Let's plan the same trip today, using digital equipment. First, let's assume we'll carry some of the lighter backpacking gear available today; improvements have been made in the more than thirty years since I made that trip. Conservatively, maybe a savings of about 5 pounds can be effected, possibly as much as 10 pounds. Let's say the total backpacking gear and supplies now come to about 40 pounds. The digital camera gear weighs only 15 pounds, bringing the weight of everything to about 55 pounds.

Our picture capability this time around is limited not by film or even memory cards but by battery power. Assuming I can take 400 shots per battery charge, I should be able to shoot 4,800 photographs total—nearly twice as many as on the first trip.

This example obviously represents an extreme situation in which you are away from electricity for charging batteries for the total duration of the trip. But, then again, you may find yourself on such a trip—a long trek in isolated circumstances.

Here are some thoughts on the choices for digital equipment:

- **Camera bodies.** The two camera bodies are lightweight: 1.2 pounds each *with battery*. From my experience, the Canon Rebel Xti camera bodies hold up reasonably well in the field. Bring lots of plastic bags to protect them from bad weather.

- **Batteries.** I chose enough batteries (ten extra, plus two in the cameras, for a total of twelve) to cover the entire trip without recharging (or else you need one *very* long extension cord in the Brooks Range). These batteries are quite small and weigh only 1.6 ounces each. Realistically, I may not get as many shots from each fully charged battery because of environmental conditions. Even in August, it can snow in the Brooks Range. (It happened to us on that first trip.) Low temperatures put more strain on batteries, which means you can take fewer pictures. Also, I would turn off the LCD monitor to conserve battery power. You can always turn it on when you need to check the histogram for certain pictures.

- **Lenses.** Notice that I have only two lenses, yet I'm covered from extreme wide angle to long telephoto. With the 1.6 multiplier factor on these cameras, I have, effectively, coverage from 16mm ultrawide to 480mm telephoto in the equivalent 35mm format. What I don't have is good macro coverage, so I might toss in the 100mm macro lens (another 1.5 pounds). Or perhaps a shorter focal-length macro that is lighter.

Places like this remote, unnamed valley in the heart of Alaska's Brooks Range in Gates of the Arctic National Park are accessible only by a multi-day backpacking trip. Careful planning is required for digital shooting; the ability to charge batteries is hundreds of miles away.

Luck sometimes plays a significant role in your photography. This curious cheetah in eastern Serengeti jumped on the hood of our Land Rover to check us out. Shot with a 10-megapixel DSLR and a 10–22mm lens whose wide-angle view helped to include part of the vehicle's interior.

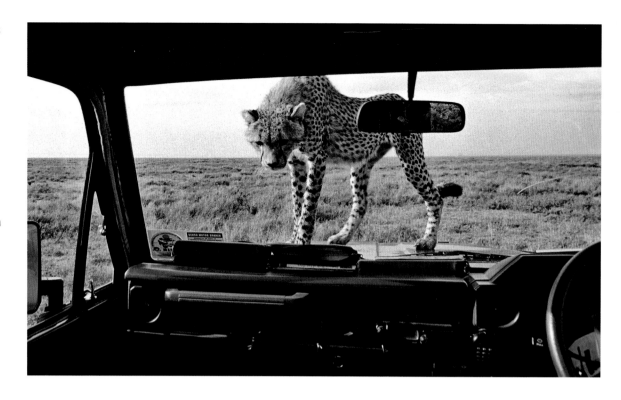

Flash cards. I chose to bring ten compact flash storage cards—which is far more than necessary. But because they are so light (about half an ounce each), it's worth it to carry spares. Again, the main limiting factor here in the number of pictures I can shoot is battery capacity, not storage card space. Still, I try to conserve space by shooting only in RAW mode, rather than RAW plus JPEG. I realize that 8GB cards entail a certain risk; if something should happen to the card, you'd lose far more pictures than you would with smaller capacity. On the other hand, smaller capacity means carrying more of them—a tradeoff.

Portable hard drive. The Epson P-5000 or P-7000 portable hard drive may not be a necessity, but it does give me peace of mind in terms of backup of pictures on the media cards. And, by the way, even when I upload to the Epson in the field, I would *not* erase those cards. It's smart to have your images stored in two places.

Tripod. Finally, the tripod. Is it essential? Only you can decide. In my case, I'd like to have it. However, a tripod is only necessary in bad lighting conditions or when using longer focal-length lenses. With digital, I can dial in a higher ISO (within reason) any time I need to for low-light conditions (*opposite*). (Sure beats having to carry extra rolls of high-speed film as I did on the first trip.) And that 28–300mm zoom lens has image stabilization that works beautifully for handholding shots. Thus, the tripod might be optional—a savings in weight.

Other. What about such things as solar devices to recharge batteries? Solar—in the Brooks Range? You gotta be kidding. Anyway, these devices aren't particularly light in weight. They are at least a couple of pounds. I have used these devices in Serengeti in Tanzania, but there is plenty of sunshine there.

The conditions when traveling into the bookdocks are not always this extreme. But when they are, careful planning allows you to work in the field as you would at home, plus upload and store images in a timely manner.

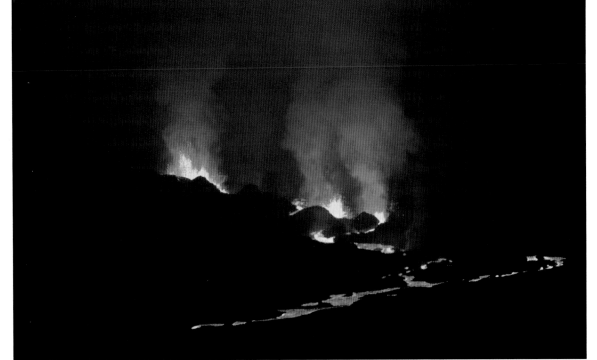

Above: Again, some luck here. On the island of Isabela in the Galapagos, I spotted a marine iguana with a hitchhiker: a lava lizard. I had time to take only a few shots before the iguana tired of his little friend and shook him off. I used a 100–400mm IS zoom lens at 400mm (640mm equivalent in 35mm full-frame format). The image stabilization was a definite help here, since I shot at $1/40$-second shutter speed handheld; I stopped the lens down to about f/16 to have sufficient depth of field for both subjects.

Top: You can't plan ahead for a volcanic eruption, so it was serendipitous that I was in the Galapagos Islands when the volcano on Fernandina erupted. It was two hours before dawn when we arrived at the island, and the only illumination was from the glowing hot lava. Tough photography. Using my 10–22mm wide zoom on a 10-megapixel DSLR, I managed to get a few sharp images shooting at $1/2$- and $1/4$-second exposure times. ISO was 1,600.

Bottom: I used my 100–400mm image-stabilized zoom lens set at 400mm (equivalent to 640mm with the 1.6 multiplier effect) for this picture. Shutter speed was $1/30$ of a second, and the ISO was maxed at 1,600. This shot is testament that image stabilization really does work, though it's not quite as sharp as I'd like. Without IS (and if I had been shooting on film), this shot would have been impossible, unless it were taken on land with a sturdy tripod.

THE CARE AND FEEDING OF ELECTRONS

Like it or not, in the digital world, we are beholden to electrons. In the olden days of film, we might get by with just some spare batteries and lots of film during prolonged periods in the wilderness. But today's digital cameras and processes rely heavily on electrons. When you run out of electrons, you can no longer shoot or store images.

My example above of the backpacking trip is an extreme situation. Trips to far-flung places can involve stays in ecotourism lodges, and these can make life easier for digital shooters. In my experience, it is rare indeed even in remotest Alaska or Peru—that places where you stay do not have electrical generation capabilities, even if only intermittently. One of my favorite rainforest haunts is the Tambopata Research Center on the Tambopata River in the Amazon Basin of Peru. They have electrical generators, but they run them intermittently. Nonetheless, it is possible to schedule battery charging at the appropriate time and keep the workflow flowing. Research and planning can help you choose the places to stay.

ON YOUR OWN OR WITH A GROUP?

Next, you need to determine how you want to travel—on your own or with an organized ecotour. Each has pros and cons. I've done it both ways, and I've been both satisfied and frustrated at times with either option. In my case, I lead photo ecotours, so I spend much of my time helping others get good photos.

SOLO TRAVEL

Going it alone gives you maximum flexibility. You can set your itinerary to match your personal interests, and you can modify your schedule during your trip. In other words, when you find great photographic opportunities in a particular place, you can opt to stay for a while longer. Or shorten your stay and move on elsewhere. On a group tour, you can't do that. You are locked into a preset itinerary.

If you decide to do it on your own, be prepared to pay more (usually) and to spend a lot more time planning. You will need to give careful thought to transportation and lodging and make these arrangements well in advance of your departure. You do not want to be stuck somewhere and waste

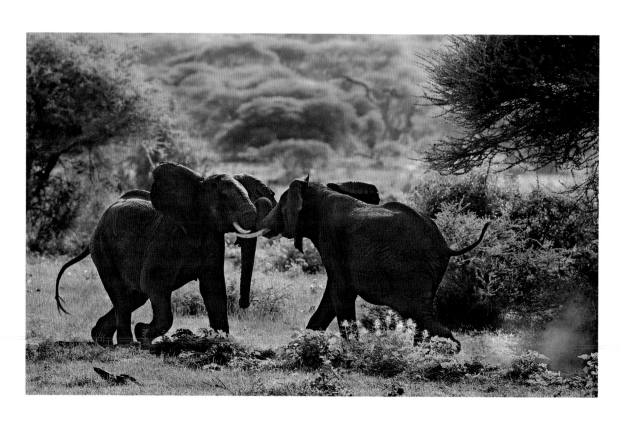

valuable shooting time and money while trying to figure out how to get around. You may find, also, that you have to pay more for airfare, since group travel can often allow you to take advantage of special airline rates.

The internet is a good place to start your planning process. I'm always amazed at how many places these days, no matter how remote and obscure, have a website.

For many destinations, you should hire a local guide, if for no other reason than to have an interpreter. Also, local guides often have a good knowledge of flora and fauna of the region and sometimes know of photo opportunities not found in the guidebooks. In some places, such as East Africa, a good guide is indispensable. I know of many instances of people renting their own vehicles and going on safari, only to return with very few good pictures because they weren't as good at finding game as an experienced guide.

A good local guide can also help to minimize bureaucratic hassles. When traveling in the remote reaches of some countries, you may encounter problems—military roadblocks, for example. It's a little unnerving to stare down the barrel of an AK-47 while its owner asks you why you are there in a language you neither understand nor speak. A local guide helps with this.

Incidentally, under such conditions, it is probably not a good idea to let them know you are a photographer—even an amateur. In many countries, photographing military units and facilities is strictly forbidden, and a lot of camera gear may rouse suspicion. And, depending on the political situation, photojournalists may be regarded with some suspicion. Maintain a low profile, lest you have your camera equipment confiscated.

GROUP TRAVEL

Traveling with an organized ecotour group offers several advantages: time savings, cost savings, camaraderie, support, and security.

You'll save time by having someone else do the bookings for you. By securing group rates for air tickets, lodging, meals, and guide services, ecotour companies can provide you with a trip that is very cost effective.

However, a cautionary note: you should select a tour company that offers special trips for photographers. Otherwise it can be very frustrating. Non-photographers don't have the patience to wait around for the right lighting or the perfect pose.

Camaraderie and support? Well, it is nice to be with others who share your interest in photography. Often there's good exchange of information (and sometimes equipment). The support can be vital at times.

Another important advantage of group travel is security. The old adage about safety in numbers holds true. Individuals traveling alone are much more vulnerable to thieves. A well-coordinated group can watch out for things. Even something as simple as using a restroom is made easier if the group watches your stuff while you are doing your stuff.

In some countries, bribery and corruption are a way of life. A group traveling with a good local guide can avoid some of the bribe hassles, or at least have them minimized. An individual traveling alone might have a tougher time of it. I once spent a couple of frustrating hours at a border crossing in Africa being questioned by the immigration officials who ended up accepting a "gratuity" to smooth the way. A year or so later, I made this same crossing with a group and had no problem because our guide took care of things for us.

This shot of fighting bull elephants in Lake Manyara National Park, Tanzania, was made on one of my photo ecotours. On tours like this, experienced driver-guides know where to go for some of the best photo opportunities.

A TALE OF TWO TOURS

If you decide to travel with a tour group, I strongly recommend spending the time and energy to find one that specializes in photo tours. A couple of good ones are Mondo Verde Expeditions (www.mondove.com) and Strabo Tours (www.phototc.com).

I know a number of photographers who made the mistake of booking an East African safari with a well-known tour company but *not* one specifically designed for photographers. It was a disaster. Seven or eight people were crammed into a safari vehicle. With this many people elbowing for room in the roof hatch, good photography was impossible. Also, the non-photographers (the majority in the group) did not want to leave at dawn—the best time for catching early morning light and animal activity. The group also opted to return to the lodge for cocktail hour, thus missing the good late-day lighting and sunsets.

In contrast, during one of my photo workshop tours in Tanzania, we found just how valuable it can be to travel with other photographers. Not only did we all have the same priority, to spend dawn and dusk photographing outdoors, we also had the same equipment needs. Someone had a camera die. It fell off the roof of the Land Rover and was fatally damaged. The lens, too, was damaged. It was the only camera he had brought with him. Fortunately, another person in the group had the same make camera and was carrying two extra camera bodies, so he loaned one to the person. Someone else had a seldom-used zoom lens for the same camera. Bingo. For one very grateful photographer, the trip was saved from being a total disaster.

The downside to group travel is being locked into a preset itinerary and not being able to change it. To mitigate this somewhat, you should check very carefully the tour itinerary to be sure that enough time is allowed. For example, some tour companies offer seven-day tours to game reserves in East Africa. From a photography standpoint, that is absurd, since even a ten-day tour barely allows enough time. Preferably, you would have twelve to fourteen days for a photo safari.

Keep in mind that even if you travel with a group on a preset itinerary, you can often make arrangements to travel on your own at the end of the tour. This can give you more time to work more carefully, and you may be able to use the same guides you've gotten to know.

Another problem is that you may not be able to find an ecotour group going to the particular region that you are interested in. You'll have to spend some time on the web doing research to find just what you need. An amazing variety of destinations are available. Even if you do find a group tour to your desired area, it may not be designed for photographers. You'll have to decide for yourself whether or not to risk traveling with non-photographers. As I mentioned, it can be a serious problem.

Even if you are with a group of other photographers, there's no guarantee that your interests will coincide with everyone else's. However, in my nearly thirty-five years of leading photo tours, most often it is a very compatible and congenial group when photographers travel together.

PLANNING AND RESEARCH

I emphasize planning and research in regular travel, and it's even more important here. When traveling to very remote areas, you may never have the chance to return there, so you have to do the best job possible the one and only time you visit.

The internet is a valuable resource for planning. Use it. As I said before, there hardly exists a travel destination in the world, no matter how remote or obscure, that doesn't have one or more websites associated with it. In

fact, you may be surprised. For example, a Google search yielded well over a million hits relating to *Borneo travel*. Another search showed more than a million sites for *Lake Baikal* (Siberia). Both of these places hardly qualify as common tourist destinations, and yet a huge amount of information is available about them on the net.

An internet search will yield information both for doing it on your own or for taking organized tours. The next problem is in determining how good the services are. Don't be afraid to ask questions via email or fax. If you are contacting local guides or tour companies in a foreign country, find out how long they've been in business, what services they offer, and exact costs. And try to get references. Chances are, if they've been in business for a while, *someone* from the United States has taken a trip with them and can offer an opinion on the quality of services. Also, if you are part of a social network like Facebook or Twitter, these can be used for references and recommendations. I also assess the quality and the speed of the answers to my questions from the outfitters. If things seem a little vague in responses, there's probably a good reason for it; maybe they haven't had enough experience at running the kind of trip you'd like. And if it takes days and days to get back to you with a response, that can be a tip-off too. I'd be wary of one-person operations or someone doing this part-time.

Screening domestic ecotour companies that you find on the internet can be a bit easier. References are easier to find, and many companies are more than happy to give you names of satisfied clients. (Again, social networking can be a great help.) The problem is, what about the *dis*satisfied ones? You won't get those names. In lieu of that, perhaps the best indicator of the quality of service is from the *number* of happy clients. And if you contact any of these references, find out if they had any problems on the trip.

WEATHER AND CLIMATE

Knowledge about weather and climate when you travel to a remote location is vital. Heavy seasonal rains April through May can make getting around very difficult in Tanzania's Serengeti National Park. The same is true for a great many other places in the boondocks of the world. Keep in mind that normal weather patterns can and do change from time to time. In fact, I've noted in my travels worldwide that a lot of change has taken place in recent years (perhaps due to global warming?). Rainy season in East Africa, for example, doesn't begin and end with the regularity it used to. So I always make it a point to check out recent weather in the region where I will be traveling. Good websites for this include AccuWeather (www.rainorshine.com), which gives five-day forecasts for most countries (and regions or cities within those countries), and CNN's weather page (www.cnn.com/WEATHER). The latter covers a huge variety of regions in every country worldwide, with four-day forecasts.

Here's something else to keep in mind: *In certain places, you may not want to travel there during the driest time of year.* In East Africa, particularly Tanzania, January and February mark the beginning of the rainy season (in normal years). It is probably the best time to see and photograph Serengeti. There are only occasional rain showers, but this rain brings out the fresh, green grasses and, in turn, the migratory animals. Over a million wildebeests and zebras come to the Serengeti Plains because of the fresh food and water during this time of year. It makes for the greatest wildlife spectacle on Earth. During the drier parts of the year, July through November, the big herds have dispersed and moved westward and northward.

If your goal is to photograph rainforest, you may not capture the true feeling and all the diversity if you are there in the dry season. A rainforest is called a rainforest for good reason. On the other hand, it could be pretty tough dealing with long hours of drenching

I time my rainforest trips to coincide with the end of the rainy season. Things are lush, flowers are blooming, and it's better than day after day of rain. However, avoid the very driest part of the year because you'll miss some of that wet greenness that makes the rainforest fascinating.

cloudbursts during the peak of the rainy season. Such conditions not only make photography difficult and uncomfortable but put your equipment at risk as well. For rainforest photography, I like to be there around the end of the rainy season. Everything is green and lush, flowers are blooming, and often the days are merely overcast with occasional light showers rather than continual rain. When you are in thick forest, overcast lighting is more desirable than sunlight because digital sensors simply cannot handle the extremes of mixed sunlight and shadow. And it's a softer quality of light.

Even trickier is trying to time a trip to catch optimal weather conditions in several different regions. A good example is Venezuela. Two major regions of photographic interest here are the Tepui/Gran Sabana rainforests and the Llanos country. The Llanos region has flat plains interlaced with rivers, streams, small lakes, and ponds. The bird life here includes such spectacular species as roseate spoonbills, hoatzins, jabarus, and numerous parrots. Among the larger mammals are jaguars and capybaras. The best time to shoot photos here is in the dry season. The streams and lakes have shrunk, forcing most animals and birds to congregate around the remaining water. And the roads are dry, making access easy. In the rainy season, from April to November, forget about trying to get around here.

For visiting the Tepui region, however, it's best to be there at the beginning or end of the rainy season. In the rainy season, the spectacular waterfalls, such as Angel Falls, are flowing strongly. In the dry season, they hardly flow at all.

CARE OF EQUIPMENT

Being in the boondocks is tough on cameras and lenses. Modern digital cameras, particularly DSLRs, have improved greatly in recent years, but being crammed with a lot of electronics, they still require some care in conditions of wetness and humidity, extreme cold, or dusty environments.

So what's the answer? You should bring, *at the minimum*, one extra camera body. In addition, I would take extra care with the electronic gear. Have lots of jumbo-sized Ziploc or other plastic bags handy. Keep cameras and lenses as shielded from moisture as you possibly can. Dust too. Cushion everything with lots of bubble pack. Treat your equipment in the same way you would a carton of eggs.

For most of my backcountry trips, I prefer to carry camera gear in a good-sized rucksack. Lowepro makes some good rugged models. Their rucksacks and backpacks are designed especially for photo gear. Leave in the interior padded liner, if it has one. To cushion gear, I use foam padding on the bottom and sides of the interior. And for individual items, such as camera bodies and lenses, I make pouches or bags by taping together cutout sheets of bubble-pack material. That way I can just toss stuff in from the top and not worry about it banging around too much. Filters I usually keep in a pocket in my vest or in an outside pocket on the pack.

Photo vests are great. I like having stuff reachable quickly: filters, notebooks, pens, plastic bags, even maps. Sometimes, when I'm working fast, I'll keep extra lenses in the larger pockets to keep them handy. I usually keep my media cards in a fanny pack on my waist, and the full memory cards go into a certain pocket in my vest. The only drawback to photo vests is that they make you rather noticeable, and you may be mistaken for a photojournalist—not necessarily good, as we'll see below. In many remote places, I like to keep a low profile.

MODES OF TRANSPORT

Seems like, at one time or another, I've been on or in just about everything that rolls, floats, flies, or walks. Most have been necessary (the only way of getting from point A to point B). A few have been painful (I don't ever again want to ride in the back of a Russian half-track or on the back of a camel).

If you're just a regular tourist, various ways of getting around can be fun and exciting. As a photographer, however, some modes of transport can present problems:

- **Water Travel.** Many exciting and beautiful boondock destinations are best reached by raft or boat. The interior of Borneo and many parts of the South American rainforest, for example, are accessed by river travel. In fact, in most cases, it's the only access. This, in turn, presents challenges to keeping your equipment safe and dry.

 For such trips, buy a waterproof, neoprene river bag. REI and other outdoor sports stores carry them in various sizes. These have tops that roll down and snap shut, making them very waterproof. In addition, air trapped inside will make them float if you don't have too much heavy gear inside. There are different models available; I like the larger ones that have padded straps on them, allowing them to be carried like a rucksack on your back. Put some foam padding or a couple of T-shirts in the bottom to cushion your equipment. I also use bubble-pack bags to protect lenses and camera bodies from rattling around too much.

In Botswana's Okavango Delta, some travel is only possible by dugout mkoros. To protect cameras and lenses, I keep them in waterproof neoprene bags designed for whitewater rafting trips.

- **Air Travel.** If you've ever spent time in the boondocks of Alaska, you know that the only feasible access to some remote areas is by light plane or helicopter. The same is true in many other places around the world. I love flying (I've always been an aspiring pilot but never had time to get my license), and I spend a great deal of time in small planes and in helicopters. However, there is one major concern for photographers: vibration.

 Vibration can affect your pictures, and it can also affect your camera equipment. Light planes have medium- to high-frequency vibration from the engine. This is transmitted throughout the frame and body of the plane. If you set your camera bag on the floor of the plane—or, even worse, if you set just the camera on the floor to keep it handy—you may discover later that some of those tiny screws in the camera and lenses have vibrated loose (and maybe even fallen out). To prevent that from happening, I keep one or more cameras on my lap (your body absorbs most of the vibration), and I set any camera bags or rucksacks on some bunched-up clothing—a jacket or sweater—to absorb the vibration. You may not notice this phenomenon on the first flight or two, but with enough hours in the air, it will eventually occur. I've even had the retaining ring on the front element of one telephoto lens come loose.

To cover parts of Siberia, I've spent many hours in Russian helicopters like this MI-8. In most instances, it's the only way to get to certain remote places.

In places like Tanzania's Serengeti National Park, a good guide is indispensable. When traveling with a group, be sure it's a trip designed for photographers and that there's plenty of room in the vehicle for moving about and stowing cameras and lenses. I also carry one or more DC inverters with me. Plugged into the cigarette lighter of the vehicle, it can charge batteries during game drives.

■ **Land Travel.** In places like East Africa, the vehicle of choice is a Land Rover with a large, open roof hatch (*above*). This allows you to stand up in the vehicle and shoot comfortably. As I mentioned in chapter 5, the preferred camera support is a beanbag. The best commercially available bag is called a SafariSack, from Kinesis Photo Gear (www.kinesisgear.com). It is large and durable.

SECURITY

You will probably never knowingly make a journey to a place of political unrest. Iraq and Zimbabwe probably don't offer the kind of adventure travel or wildlife you'd like to photograph anyway. But even in seemingly stable countries, unsafe situations may occur unexpectedly. It's best to be prepared for the unforeseen.

I was in Rwanda with a tour group in March 1994 to photograph mountain gorillas. I had been there in 1990 before the civil war broke out, when the political climate was pretty stable. But things weren't quite right in '94, even though there had been a ceasefire and peace settlement. On the highway from Kigali to Ruhengeri, our tour group was stopped at a number of military roadblocks. The atmosphere was tense. Even my driver guide seemed nervous.

So I began to formulate some plans. Should it become necessary, I would bribe our way to the nearest friendly border—Uganda or, preferably, Tanzania. To prepare for that, each night I taped four or five fifty-dollar bills to the soles of each foot with medical adhesive tape. (Robbers usually operate in haste, for fear of being caught, and are not likely to take the time to look in your smelly socks for money.) I also discussed with my driver the best routes to take to get to the nearest border and how to deal with the border crossing.

My careful plans were not required. However, only four weeks after I left, one of the greatest mass genocides in history took place in Rwanda. Nearly 800,000 people died at the hands of Hutu extremists. It could have been disastrous for me and the people traveling with me had we been there at the time. I later learned that some people escaped using essentially the same strategy I had planned.

The best source for current information on travel in any foreign country is the U.S. Department of State website (http://travel.state.gov). Here you will find advisories (warnings) on travel to certain countries or regions, as well as a lot of useful information for all countries, such as problem areas, crime activity, etc. When you read these, remember that the Department of State comes down on the side of being overly cautious. When you stop and think about it, many of the same advisories could be applied to such places as Denver, New York, or Los Angeles—or any other city in the United States.

SECURITY TIPS YOU WON'T FIND IN TRAVEL GUIDES

I *never* argue with a person carrying an automatic weapon—or any weapon, for that matter. You may think that bad encounters with weapon-toting people occur only in developing countries or highly volatile political hot spots. Not so. I once had a Helsinki airport security guard point his Uzi at me and order me to put my film through the x-ray unit. (I wanted a hand inspection and perhaps became a little too insistent. Ultimately, my film went through the x-ray machine, and it survived just fine.)

AERIAL PHOTOGRAPHY

Flying to your destination presents a great opportunity to take some amazing aerial photographs. In order to do so, you need to minimize the effects of vibration and overcome a few other obstacles. Here are some pointers:

- **Stay clear of the plane.** Normally, vibration is not much of a problem if you don't let the camera or lens touch any part of the body of the plane, including the window, while shooting. Also, be sure not to let your hands or arms touch the body of the plane while shooting.

- **Avoid reflections.** The biggest problem is shooting through a window. You may get reflections from light-colored clothing or objects inside. To avoid this, wear a dark-colored shirt. In addition, use a rubber lens hood and hold the lens as close as possible to the window without actually touching it. Sometimes I cup my free hand around the end of the lens hood and press it against the window to form a lightproof shield.

- **Consider a filter.** Haze is a big problem in getting good aerial shots. A polarizing filter helps to minimize haze, but it may also present problems with the Plexiglas used in the plane's window. Check it out by holding the filter in front of your eye and rotating it while looking out the window. If you get strange-colored patterns, forget the filter. If not, use it.

- **Choose the right focal length.** I like a medium-range zoom lens for most aerials: an 18–55mm, a 35–105mm, or perhaps a 28–135mm. Sometimes an ultrawide lens like a 20mm will give you a good perspective and include part of the wing in the picture. But reflections are even more of a problem with wide-angles.

- **Use a low ISO.** For the ISO setting, 100 is often sufficient, though if you use a polarizer, 200 or even 400 might be better.

- **Use a fast shutter speed.** Use the fastest shutter speed possible to minimize any vibration or movement from turbulence. Remember, what you are photographing is infinitely far away, so you'll be focused on infinity and don't need depth of field. Which means you can shoot at maximum aperture if necessary to give you a fast shutter speed.

- **Wash the windows.** Another problem can be scratched or dirty windows. If you know where you will be sitting before takeoff, you may be able to run out and clean the outside of the window with a clean handkerchief. And, obviously, clean the inside as well. When I've had assignments requiring good aerial shots, I've made arrangements for a plane with a window that opens or a door that can be removed. This is the best possible way to do it, but on remote excursions where the plane is a necessary transport, such options are usually not available.

Maintain your cool with any official who is giving you a hard time. Often it's over bureaucratic paperwork or some kind of permit. You can rarely win. So go with the flow. Be patient. Eventually you may find the solution to the perceived problem—perhaps a payment of a small "fee" (but don't offer it until all else fails). If it's serious and there appears to be no resolution, then you may wish to contact the nearest U.S. consulate or embassy. But don't threaten or become abusive.

Incidentally, it's always a good idea to look up the phone, fax, email, and physical address of U.S. consulates and embassies ahead of time in any country where you will be traveling. Keep this information handy in a notebook or on a card in your wallet.

As I mentioned earlier, a good local guide can be of great help in these situations. There have been more than a few times when my guide has smoothed over some bureaucratic hitch. It's well worth a generous tip at the end of the trip.

PROTECT YOUR PASSPORT

Keep your passport with you at *all* times. Be aware that U.S. passports are worth a lot of money on the black market in many countries. They are the basis of forged documents that can be sold for large amounts of money. I keep my passport in a plastic bag in my pocket or, when traveling in a wet climate or by river, in a waterproof bag with my camera gear.

A lost passport is a *real* hassle. If you are in a remote region of a country (that's why you're there, right?), you will have to arrange transport—at your own expense, separate from the tour group—to the nearest U.S. consulate or embassy to get a replacement passport. And don't even think about trying to leave the country without one.

This next topic I bring up not to frighten, but to forewarn. More and more, in certain places of unrest, Americans (and people of other nationalities) have become targets for terrorists. And it's not just in the boondocks. It occurs in popular tourist destinations too.

After a couple of harrowing experiences, I now carry, in addition to my real U.S. passport, a phony passport that declares me a citizen of the West Indies. **Warning:** *Do NOT use a bogus passport for official purposes at government entrance or exit control points. It is only for emergency use where you may be in danger because of your nationality.* Several years ago, a group of tourists was attacked in Uganda, and Americans and citizens of the U.K. were singled out and executed.

My phony passport looks very official, in a burgundy leatherette cover with gold lettering. Inside are stamps from several destinations—all very authentic looking. And I have other documents to back it up. I obtained the passport and papers through an internet service. To find one (there are a great many), do a search using the words "camouflage passport." Be prepared to spend upward of two hundred dollars, depending upon how much documentation you want.

If you opt out of a camouflage passport and find yourself in a bad situation where Americans are being singled out, as in the situation in Uganda, the thing to do is to *get rid of your real passport. Hide it, bury it, but don't have it on you during a search.* You can always claim the passport got lost or stolen or that you are a citizen of the West Indies or some other English-speaking country. The chances are slim that such a situation will occur, but it's best to have a plan of action thought out ahead of time.

On the same note, avoid demonstrations. Think you're an aspiring photojournalist and might get some good photos? Unless you are a street-smart photojournalist with lots of experience in foreign countries, *forget it.* Photojournalists—or anyone carrying a camera—often become targets because some demonstrators or police don't want their activities documented. Keep a low profile, or you may have your cameras confiscated—or worse.

HEALTH AND MEDICAL CONSIDERATIONS

Every boondock traveler's nightmare is having a serious accident or getting sick and needing emergency medical treatment in the middle of nowhere. There are a few things you can do before you leave home that will help you rest more easily:

- **Purchase travel/medical evacuation insurance.** In case of a serious emergency, you'll want to get home to proper medical care quickly. Access America (www.accessamerica.com) and MedJet (www.medjetassistance.com) are two good services. With Access America, you sign up for each separate trip. With MedJet, there's an annual fee covering any and all trips. Both provide rapid air transportation back to your home in the case of a medical emergency anywhere in the world.

- **Check on medical advisories and health recommendations** for the region where you will be traveling. Travel Health Online (www.tripprep.com) and the Centers for Disease Control (www.cdc.gov) are the two best sources for recommendations of shots and medications to take and for awareness of diseases prevalent to the region. In many parts of the world, you will definitely want to bring malaria prophylaxes—in Africa, especially. You'll want to discuss these recommendations with your own doctor.

- **Filter the water.** Even traveling in the wilds of North America, you may encounter health problems. Giardiasis is one of them. The microscopic parasite *Giardia* lives in water supplies in remote places—even in those pristine-looking mountain streams. The parasite causes an intestinal infection. I've had giardiasis three times, and it ain't fun. I don't want it again. I now carry with me, on certain trips, a small water filter/pump. Get one that has a pore size of 5 microns or smaller to filter out *Giardia* and even certain bacteria. In the more remote parts of Siberia, where bottled water is not available, I use the water filter because local water supplies can carry *Giardia* and other nasty stuff.

- **Drink bottled water—or beer.** In planning your trip, determine whether *safe* bottled water is available throughout the journey. In a great many remote places, you can purchase bottled water. Just be sure to check that it is properly sealed and that the seal hasn't been tampered with. Also check for any particulate matter or turbidity or off-color. If in doubt, skip it. My philosophy is, *when in doubt, drink beer.* (Though it takes a while to get used to brushing your teeth with it.)

- **Bring antiseptic hand-washing fluid,** and wash your hands often. Even when traveling in places where things seem relatively clean, you may pick up someone else's germs. A sick photographer doesn't get to be very creative.

- **Bring sunscreen.** You may not find many stores at your destination that sell it, and in most places, you'll need it—even rainforests. (The sun does shine once in a while, and it's hot, tropical sunlight.)

PACKING FOR THE AIRPORT

Traveling by air can be tough these days—and how else can you get to Borneo or Africa? For photographers, airline regulations and security make it especially difficult. The key thing to remember here is this: Have all your essential equipment in *one* carry-on bag. I know, that ain't easy, but it is vital.

Some airlines may say that they allow two carry-ons, but don't count on it when you go

When trekking in the cloud forests on the eastern slopes of the Andes, I almost left my 100–400mm IS zoom lens behind to save weight. Glad I didn't. This rare bird (the national bird of Peru) is called the cock-of-the-rock, and in all my time in the rainforest, I had never before seen one. Handheld at a $^1/_{250}$-second shutter speed, ISO of 800.

to check in. The main point is that your check-through bags may be lost or delayed, and you don't want to have vital equipment in them.

The best way to carry your essential photography gear is in a rolling backpack (a backpack with wheels for rolling around airports). I like the Lowepro packs for their durability, light weight, and good design for space. Make sure you pick a model that fits the airline requirements for carry-on bags. By the time you get all your equipment stuffed in, your bag may have the density of a black hole, and you may be pushing or exceeding the weight limitations. To get around that problem, I recommend wearing a photo vest as well. You can stuff a lot of items into all the pockets, and you won't get hassled because it's part of your clothing.

So what goes into the carry-on? Two camera bodies. All the lenses you definite-

ly want to use. (If you insist on bringing a monstrous telephoto lens, like the 600mm f/4, you will have to have your own strategy for dealing with it because it will take up most of the space in your carry-on. I'd suggest packing it in a special, high-impact plastic case like the Pelican, which is lined with foam and designed for rough handling, insure it, and take your chances on checking it through.) All the memory cards you plan to use. Any portable hard drives or a laptop computer. Camera batteries. Battery charger.

So what goes into your check-through bags? Any additional camera equipment that you deem nonessential if the bags get delayed or lost. Items like extra batteries, extra chargers, any spare lenses you can live without (wrapped carefully in bubble pack), and your tripod. Also, if you are pushing the limit on space in the carry-on, put things like lens hoods in the check-through baggage.

Incidentally, it's always a good idea to use a hard-sided suitcase to protect your equipment.

What else should you pack in your check-through bags? Well, clothing for one. Bring clothes that are appropriate to the climate, such as rain gear or a warm parka. Along the same lines, you'll want insect repellant, depending on where you are going. Repellant may not be necessary if your destination is Antarctica, but it is definitely needed in the Arctic tundra. Remember, too, that you'll need adaptor plugs for foreign sockets. Visit the website World Standards (http://users. telenet.be/worldstandards) for specific electrical information on the countries you intend to visit. Also, bring a small flashlight, just in case. An LED flashlight packs a lot of power for its weight. And always load up on plastic bags: medium-sized bags for cameras and large trash bags to slip over camera bags or packs.

CARRY-ON BAG CHECKLIST

Two camera bodies
Essential lenses
Essential filters
Batteries
Battery charger
Portable hard drives or laptop
Charger for hard drives or laptop
All memory cards
Passport, driver's license, travel documents, tickets
Prescription medications
Stomach medications (antacids, anti-diarrhea pills)
Extra prescription glasses or contact lenses
Photo vest (worn)

CHECK-THROUGH BAG CHECKLIST

Clothing
Personal toiletry kit
First-aid kit (Band-Aids, antiseptic, ointments, aspirin, tweezers)
Sunscreen
Insect repellant
Flashlight
Binoculars
Pre-moistened towels and antiseptic hand wash
Adapter plugs
Guidebooks (bird, mammal, travel guides)
Plastic bags in assorted sizes
Sheets of bubble pack
Extra footwear (tennis shoes or hiking boots)
Nonessential camera gear
Sensor cleaning kit
Camera instruction book
Flash unit
Tripod (optional)

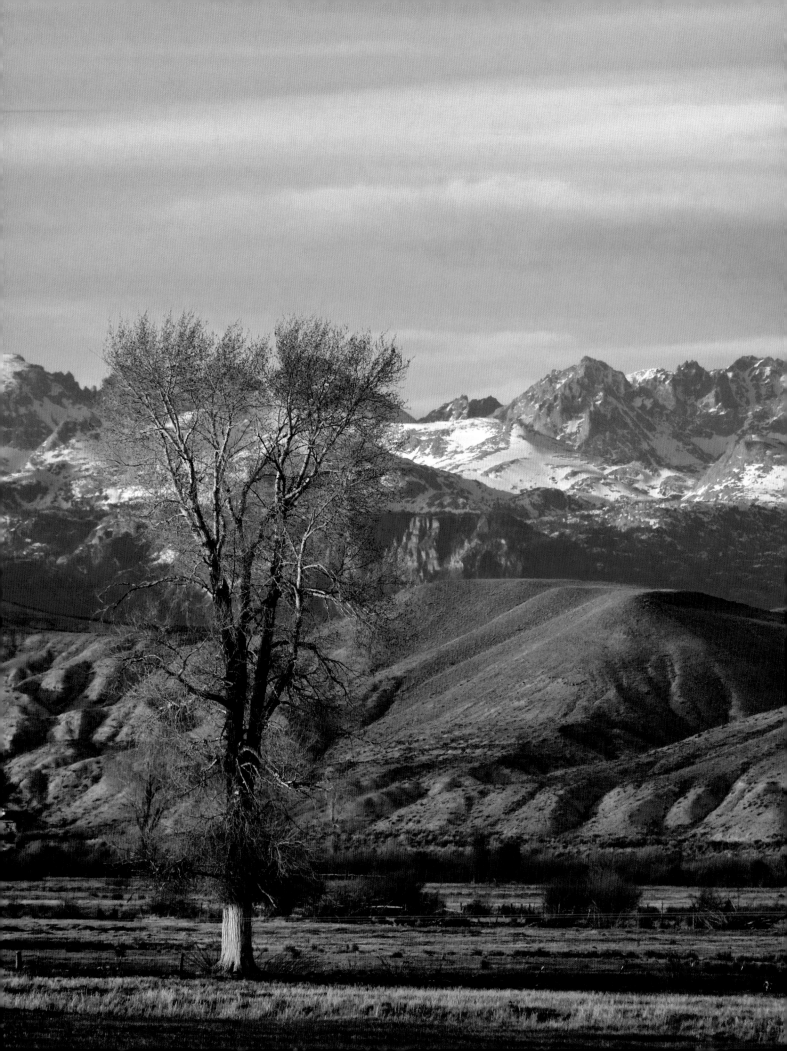

CHAPTER 8
LANDSCAPE AND SCENIC PHOTOGRAPHY

Many of photography's first practitioners were landscape and scenic photographers. Part of the reason for this was practical. The wet-plate emulsions were so insensitive to light that they required bright sunlight to form an image. But part of the reason was aesthetic. There was a movement in the art world toward a romantic portrayal of nature. European and American artists were painting pristine forests and mountains and lakes evocative of the Garden of Eden. The wilderness, heretofore considered a fearsome enemy to be conquered, was suddenly glorified as uplifting to the human spirit.

Photographic advancements coincided with westward expansion. By the 1870s, when field photography had become a feasible if cumbersome art form, large parts of the eastern and southern United States had been settled. What wilderness remained was in the West. Thus there emerged several pioneering photographers who roamed the untracked deserts and canyon country of the Southwest and the rugged mountains of the Rockies and Sierra Nevada.

The tradition began with William Henry Jackson. He was born in 1843, during the time of the daguerreotype. His first job, at age eighteen, was that of photographer's assistant, retouching prints. There he learned the skills of the wet-plate process: part art, part chemistry, part physics.

After the Civil War, Jackson traveled west, eventually ending up broke in Omaha. He took another job as a photographer's assistant and, in short time, bought out his employer with a small down payment. A great lover of the outdoors, Jackson formed contracts with the westward-expanding railroads to photograph scenery along their routes. Soon he established a reputation as one of the finest landscape photographers.

In 1870, Jackson was contacted by Dr. Ferdinand Hayden, one of the directors of the Geological and Geographical Surveys of the Territories, established by Congress. Hayden was leading a series of expeditions to survey regions of the Rocky Mountains, and he wanted Jackson to serve as official photographer. The young man eagerly accepted.

A cottonwood tree on a ranch in the Wind River Range, near Pinedale, Wyoming. Shot with a 100–400mm lens.

Left: The pioneer wilderness photographer William Henry Jackson took the first photos of the Teton Range and Yellowstone country in 1872. This shot in the western Tetons shows his dark tent and equipment for coating his glass-plate emulsions.

Right: Were Jackson alive today, I have an idea that this famous photo would look like this. Always an innovator, Jackson was born in 1843, when daguerreotypes were the only form of photography. He lived to shoot Kodachrome and would have probably embraced digital photography.

Thus, at the age of twenty-eight, Jackson found himself in the mystical region called Yellowstone. It was still largely *terra incognita*. Even though fur trappers had long ago described smoking hills and boiling geysers, few believed it. Jackson portrayed to the world, for the first time, the wonders of Yellowstone. And the following winter, Jackson's prints helped to convince an indifferent Congress to establish Yellowstone as the world's first national park.

Jackson went on to photograph Yosemite, the Grand Tetons, Mesa Verde (including the Anasazi cliff dwellings), Chaco Canyon, and what is now Rocky Mountain National Park. He continued his photography for many decades, traveling around the world. At the age of ninety-six, on another trip to his beloved West, Jackson tried a wondrous new film: Kodachrome! ("Oh, I wish I could do it all over again in color," he remarked.) He died at age ninety-nine, one of the most remarkable landscape photographers of all time. One wonders what he would think of digital photography. I suspect he would be excited about it.

It's difficult to appreciate the work required by Jackson to make a photograph. Today we zip into Yellowstone by car, carry a couple of digital cameras and lenses, shoot hundreds of color pictures, zip home again to work on our digital images, then print on an inkjet printer our glorious color images for friends to see.

For Jackson, it was a major expedition, first by horse-drawn wagon for weeks, then by pack mule into the deep wilderness. Jackson's basic camera was an 8×10-inch (20×25-cm) format. On occasion, he used an 11×14-inch (28×36-cm) format. Some photographers, such as Timothy O'Sullivan, used cameras as large as 20×24-inch (51×61-cm) format! When Jackson found a scene he liked, it meant unloading all the gear from the mules and setting up the dark tent. Then he disappeared into the tent to sensitize a plate. Yellow muslin lined the tent to allow a dim light to filter through, acting like a safelight. The emulsions were sensitive primarily to the blue end of the spectrum and thus not affected by the yellow-orange light.

Jackson would extract a piece of glass from a specially padded and slotted leather case. The glass had to be cleaned carefully before the next step, the coating of one side with a layer of collodion—cellulose nitrate dissolved in ether—in which potassium iodide had been dissolved. The thin collodion layer served as a medium to hold the light-sensitive emulsion in much the same way that gelatin does in film. Next, the plate was dipped into a solution of silver nitrate and left for several minutes while a light-sensitive precipitate of silver iodide formed on the surface of the collodion. The plate was then loaded into a light-tight holder and ready for exposure in the camera.

There was one catch. The exposure and development of the image had to be carried out before the plate dried. Otherwise, the emulsion lost its sensitivity and was rendered useless. After exposure, the film was developed, fixed, and dried.

Only after long experience did photographers acquire the necessary "feel" for the working medium. They also faced many other problems, such as water supplies that ranged from the mineral-laden waters of Yellowstone to pure mountain streams.

Then there was exposure. Compared to modern ISO speed settings, the wet plates of Jackson's era were incredibly insensitive to light, corresponding roughly to an ISO of 0.1. By comparison, a common ISO setting of 100 on a digital camera is one hundred times faster.

Despite the difficulties and the seeming crudeness of the equipment, Jackson and others were able to create photographs of exquisite beauty.

So I don't want to hear any complaints about equipment.

SEE THE SCENERY

I became a landscape and scenic photographer in the early 1960s when I began my career as a nuclear physicist at the National Reactor Testing Station in Idaho. We used to ride a bus from Idaho Falls fifty miles to the vast desert where the project was located. To many people, this desert, part of the Snake River Plain and a northern extension of the Great Basin Desert, appeared bleak and barren. I found it incredibly beautiful. There were frigid January mornings, with the temperature well below zero, when the land was blanketed with snow, blue and cold, and the dawn sun painted the snow-covered peaks of the Lost River and Lemhi ranges a brilliant orange. It was like a depiction of the end of planet Earth, the sun a dying white dwarf and the world frozen and lifeless. In spring, cactus blossoms, Indian paintbrush, evening primrose,

bitterroot, globemallow, and scores of other wildflowers splashed vivid color amid the gray-green sagebrush. In summer, dark thunderstorms with sweeping curtains of rain moved ominously across the desert on jagged legs of lightning. And at any time of year, there were fiery sunsets where the sky blazed red, yellow, orange, and magenta.

As I said, I became a photographer in those days. Unfortunately, security regulations wouldn't allow me to carry a camera to the project. So I had to satisfy myself with taking *mental* photographs of those glorious scenes. And, in fact, taking those mental pictures turned out to be a good exercise in thinking about composing landscape photographs.

THE RIGHT PLACE AT THE RIGHT TIME

One key to landscape/scenic photography is *timing*. Anyone can barrel up to the rim of the Grand Canyon in the middle of a hot summer day, take a snapshot, and roar off in a cloud of dust. But a good landscape photographer takes the time to find the right place and the right time of day in which to capture the color and drama of this magnificent place. Sometimes it's a combination of serendipity and sweat. Galen Rowell tells of running for a mile (at 11,000 feet!) across the steppes of Tibet, chasing a storm, to make his famous photograph of the rainbow over the Lhasa Monastery. Sometimes it involves crucial timing. Ansel Adams had only moments in which to set up the camera, before the twilight faded, to make his famous *Moonrise over Hernandez, New Mexico*.

Timing means being there at the right time. To me, the essence of landscape/scenic photography is capturing some of the many moods of a place. And also capturing an element of drama. Most often, good landscape photographs are made by taking advantage of unusual lighting or changing weather: storms, clouds, fog, mist. Unfortunately, lighting and weather don't always cooperate. In her excellent book, *Capturing the Landscape with*

Your Camera, my friend Pat Caulfield sums it up well: "You can't force the sun to shine, the rain to fall, or a plant to bloom."

To someone who has never tried it in a serious way, landscape photography appears easy: You just point your camera and shoot. Only after taking many disappointing pictures do you realize how much work must go into a good landscape photograph.

Since many of us do our landscape photography on vacations, it's important to plan those trips well. As in the case of travel photography, a certain amount of time can be saved by researching the destination. Because weather often dictates mood and creates dramatic lighting for good photographs, research the weather and climate of the place you plan to visit.

For example, in many places in the Colorado Rocky Mountains, afternoon thunderstorms are common in the summer months, May through August. As these storms form, clouds build over the peaks, first as puffy white cumulus, then as dark, forbidding cumulonimbus. Soon, lightning crackles among the peaks. The sky is dark and forbidding. All of this makes for dramatic photography (*opposite*). The rain is brief but pounding. Veils of rain sweep downward from blue-black clouds. Later, as the storm passes, clouds begin to clear. Shafts of sunlight poke through ragged holes in the clouds, creating spectacular lighting. Hillsides full of trees are illuminated brightly by rays of sunlight, while other areas are dark and somber. The contrast between the light and dark, the bright colors and somber colors, makes for dramatic scenic photography. Finally, as most of the clouds clear away, the land is bathed in sunshine again, but this time everything gleams wetly, bright and shiny. More great photography. Sometimes the warming sun evaporates the water left by the rain, creating mist and rising vapors. More moody effects. And, since storms often clear in late afternoon, the remaining clouds are painted brilliant colors as the sun begins its descent below the horizon. The whole show could well have been staged by Canon or Nikon to sell cameras. On such days, you can shoot a great many wonderful pictures.

However—and this is where the timing and planning are so important—if you visit the same location in late August or early September, you may miss such dramatic scenes. The weather patterns at that time of year most often consist of day after day of boring blue sky, with few, if any, clouds or storms. (Of course, depending on the year, you also get into autumn foliage by mid-September.) So do your pre-trip research if you hope to be there for the drama.

GET TO KNOW A PLACE

When you plan your trip, be sure to allow enough time to get to know a place, whether it's near home or a distant journey. Don't try to take in too many places on a given trip. As I discussed in chapter 1, to capture the essence of a place, it's necessary to absorb it, feel its moods and qualities. You can't do that if you spend one day in Grand Teton National Park, another day in Yellowstone, and yet another in Glacier National Park. You would be better off concentrating your available time in only one place and visiting another the next year.

If I had slept in, I would have missed this moody shot of early morning mist at the Paws Up Ranch in Montana. Timing is everything in landscape photography.

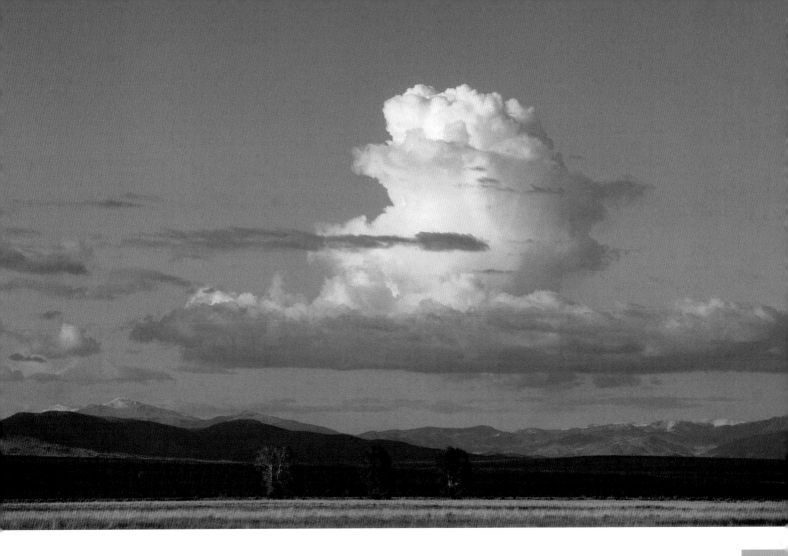

I find that so much of my own successful photography of a place hinges on how long I spend there. It has to do with the feeling I develop for a place and with experiencing many changing days and nights. This is an intangible element but an important one in landscape photography: The more you get to *know* a place, the better your photography of it will be.

The ease with which we can transport ourselves from one place to another, coupled with easy-to-use digital cameras, tends to make us try to cram too much in a given time. But just because we *can* shoot photographs quickly and move on doesn't mean we *have* to.

A LARGE-FORMAT MINDSET

Having decided to concentrate on a particular place, you need to consider the equipment to use. Traditionally, landscape photography is associated with large-format-view cameras,

typically taking film of 4×5 inches (10×13 cm) or larger. (The film frame in a standard film camera measures 24×36mm, and the sensor in a full-frame digital camera is the same size. Some medium-format digital cameras, such as the Hasselblad, have sensors even larger.) The larger film formats not only allowed for high-quality large prints to be made, but the view cameras themselves had features like tilting lenses and film back to allow great control over perspective and depth of field. Certainly many of the great contemporary landscape photographers used large-format: Ansel Adams, Eliot Porter, Edward Weston, Phil Hyde. But it's not absolutely essential.

Ask yourself how you intend to use your landscape photographs. Digital slideshows for your own personal pleasure and to share with friends? Prints, again for your own personal pleasure and perhaps home or office decor? Or do you have ambitions to exhibit and

Clouds and storms add drama to landscape photographs. This would have been a nothing shot with a plain, boring blue sky. But this incipient thundercloud over Colorado's San Luis Valley gave this picture impact.

possibly sell prints that are 16×20 inches (41×51 cm) or larger? The available digital cameras and lenses make it possible to get excellent results, and even some fairly large-sized prints that are sharp. But for the best results, you want to assume a large-format mindset, even as you forgo a large-format digital camera. This means spending extra time analyzing the image in the viewfinder.

I once discussed with the late Philip Hyde, a dedicated large-format film photographer, the pros and cons of 35mm-format versus large-format cameras. I joked with him about having to lug all that heavy stuff around, and he laughed, agreeing. But then he got philosophical. "You know," he said, "the nice thing about a large-format camera is that when you get everything set up and stick your head under that focusing cloth, the whole rest of the world goes away, and you're left with that big, beautiful image to concentrate on."

He's right. In some ways, modern digital cameras give us *too* much fluency. With that fluency comes a tendency to shoot too quickly and too much. In the days of shooting film,

large-format film cameras forced us to be more deliberate. In any case, with the cost of each large-format picture being up to ten times the cost of a 35mm film shot, you soon learned not to waste pictures.

When shooting landscape photography with digital, you should pay careful attention to what you see in the viewfinder. Often, landscape photographs are made up of many elements. It's necessary to concentrate carefully on the image in the viewfinder to be sure that you have a harmonious composition, with all those elements working together. So stop, think, and analyze before taking the picture. Sometimes, depending on ambient lighting conditions, it's helpful to review the picture on the LCD screen. You can zoom in on details, but check the overall scene for arrangements of patterns, lines, and shapes. It's especially important to look for clutter—elements that are too distracting. Extraneous tree branches at the edges of the picture, for example. Or just too many things going on in the picture.

Perhaps more than any other element, lighting is the key to landscape photography.

This thunderstorm over Serengeti makes for a dramatic landscape shot.

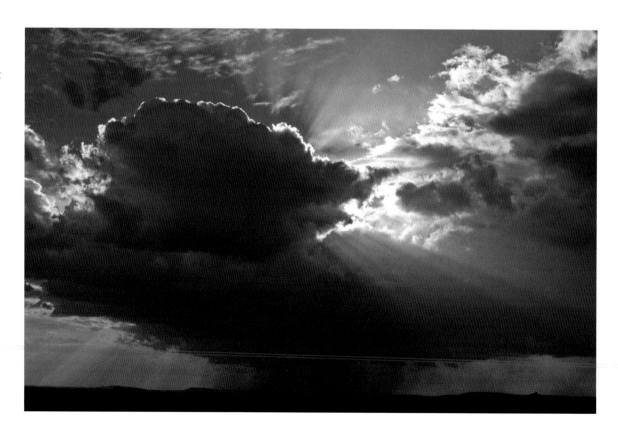

There isn't a pat formula for what lighting makes a great photograph. Again, it's more a matter of timing and recognizing when a scene has great lighting. And I don't mean just the color of sunrises and sunsets. Midday light tends to be flat and boring—unless there's something dramatic going on in the sky. I love skies. But cloudless, blue skies are boring. What I love are the ever-changing patterns of clouds and the drama of storms. Remember, part of your task in capturing the landscape is capturing the essence of this particular piece of land. Very often, no matter where you live, storms become a part of life there. And, if not storms, certainly clouds. Over the years, I have taken many photographs of just skies—skyscapes, I call them (*opposite*).

Of course, storm clouds generally don't apply to desert photography. There, storms are a rarity. Still, lighting is a key element in capturing the desert landscape. One of the things about deserts is the *texture* of objects in the landscape: the graininess of sand, the prickly look of vegetation, the sharp-edged clarity of rock. You want to capture the stark beauty of the desert land. To bring out texture, low-angle light or side lighting is best. Overhead sunlight washes out textural details, so early morning or late afternoon lighting is best. Contrast is often high in desert scenes, so be careful with exposure and check your histogram often.

EQUIPMENT CHOICES

As I mentioned in chapter 5, there's a mistaken belief that all good landscape photography is done with wide-angle lenses because they give a more panoramic view. In fact, wide-angle lenses can be disappointing unless they're used carefully, which usually means including some strong foreground elements to give a sense of space and perspective and drama. For mountain landscapes, more often than not, a medium telephoto lens gives a much stronger sense of grandeur. That's because telephotos amplify the height and

I wanted to create a sense of the vast, lonely spaces of the steppes of Siberia, so I used a medium wide-angle lens (my 18–55mm zoom set at 18mm, equivalent to a 28mm in 35mm format). I also shot at a low angle and placed the Buddhist monastery high in the picture but as a center of interest. And those dark clouds added some drama to the picture.

size of mountains in relation to foreground elements. In digital, my own favorite focal length for many landscapes is in the 60mm to 120mm range (90mm to 180mm with multiplier effect). This range of focal lengths comes closest to being the ideal perspective for many scenic photographs.

TIPS FOR SUCCESS

■ **Experiment with lens choices.** There are no hard and fast rules. Moreover, since we use zoom lenses nowadays, as opposed to fixed-focal-length lenses, it's simple to vary the zoom range until you find a suitable arrangement. Keep in mind, also, the angle from which you are shooting a landscape. Don't overlook the possibilities of using low-angle shots (i.e., close to the ground), especially when using wide- (*above*) or ultrawide-angle focal lengths. And by ultrawide I mean focal lengths in the range of 10mm to 14mm (15mm to 21mm with multiplier effect). Using a low angle and an ultrawide lens can make for some very dramatic effects. Keep in mind

that when using ultrawide lenses, background elements diminish in size. Those big, dramatic mountains will look less dramatic, and thus a dominant foreground element can save the picture.

■ **Create a sense of scale and perspective.** Often this is achieved by using the technique described above (a wide lens at a low angle with a prominent foreground element). But sometimes you can also create an unusual perspective by using a high angle, looking both downward and outward with a medium focal length of 35mm to 50mm (50mm to 80mm with multiplier effect).

■ **Create a strong center of interest.** Let's face it—landscape photographs can be very boring if not done well. Simply including a lot of pretty elements in a scene, from foreground to background, is not enough. It's most effective to have an element that draws the viewer's attention first. This can be done by juxtaposition of colors, shapes, lines, or patterns. In chapter 3, I discussed the dynamics of pictures and the need to analyze and isolate elements in a scene. Review that material with landscape shots in mind. Look for something that stands out in a scene—a colorful flower in the foreground of a sea of grass, for example. Or a lone tree in that same expanse of grassland.

MAKING LARGE PRINTS

Once upon a time, if you wanted to make very large, high-quality prints—say, 24×36 inches (61×91 cm)—you used a large-format or medium-format film camera. Are prints of this size possible with a digital camera? The answer is yes. There are several ways to accomplish in digital what large-format film can do:

■ **Buy a digital camera that has a full-frame sensor.** A full 35mm-frame sensor of 12 megapixels or larger can yield excellent-quality prints up to 20×30-inch (51×76-cm) size. If you have a digital camera with a sensor of 20 megapixels or larger, you are approaching the quality of images that are available using medium-format film cameras (2¼-inch [6-cm] sizes). With interpolation software (see below), you can upsize the image to make even larger prints.

■ **Use interpolation software.** Using a program like Genuine Fractals allows you to upsize images for making very large prints. See chapter 12 for more detailed information on this process.

■ **Create a stitched photo mosaic** using a moderate-sized-megapixel camera (10-megapixel, 12-megapixel, etc.). This is a fascinating process in which you create a number of small pictures of a large scene, overlap them from side to side and top to bottom, then stitch them together using a software program called PTGui (Panorama Tools graphical user interface; www.ptgui.com). The process is similar to that used in creating panoramas, but instead of a wide and narrow photo, you create a picture of normal proportions made up of these stitched images. Depending on how many images you use, you can create a final photograph equivalent to shooting, say, on a camera with a 500-megapixel sensor!

THE BENEFITS OF A TRIPOD

In the days of large-format film, you had to use a tripod. No way can you handhold a 4×5-view camera. With digital, however, it's possible to handhold and sometimes get acceptable results—especially with lenses that have image stabilization. But I would advise you to make a tripod a routine part of your landscape photography. First, it gives a stable enough platform to use slower shutter speeds that can't be used handheld, and you might want to use these slower shutter speeds because you need to use a smaller lens aperture for great depth of field. The one hallmark of good landscape photographs is supreme sharpness, giving great clarity to the land and sky and other elements of the picture. It is, in the tradition of landscape photographs, a way of giving the viewer a feeling of standing there and sensing how this land *feels*, and a tripod can help with that.

Another reason for using a tripod is that it makes you work more deliberately. Merely putting the camera on a tripod makes me think more carefully and analyze just what it is that I hope to accomplish in this picture. The tripod encourages me to adopt a large-format attitude about my picture-taking.

Left: Don't overlook the possibilities of black-and-white landscapes. When I saw this restored Old Believers church in Siberia, I thought of this as making a good black-and-white rendition, even though I shot in color. When I made the picture, I kept in mind how this might translate in tones of gray.

Below: Using the conversion technique outlined in chapter 10, I made this a black-and-white photo, which gives a nostalgic touch to the landscape.

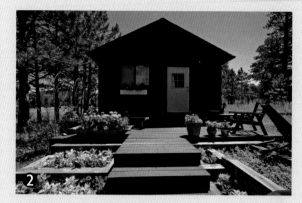

The original photograph.

A single shot adjusted in Camera Raw.

HIGH DYNAMIC RANGE

High dynamic range (HDR) is a technique that combines three or more images taken at different exposures to make a composite that retains highlight and shadow detail beyond the normal range of a single exposure. Here's an example.

This shot of my office (1) was made in bright, midday sunlight using my normal matrix metering for the camera. I was aiming to have my exposure compromise between holding some of the deep shadow detail and keeping some of the highlights from washing out. I wasn't very successful. Note that there are barely any details in the shadow areas, and the highlights, such as the gray-green leaves of the plants lower left, are washed out.

Just for comparison, I took the image and loaded it into Camera Raw. First I lowered the exposure using the Exposure slider, then I used the Recovery slider to try to add some detail to the blown highlights. Finally, I added some shadow detail by using the Fill Light slider. The result (2) improved the original somewhat.

But HDR is a better method. In order to use HDR technique, I made five separate exposures: the first illustrated here, then another at one f-stop underexposed and a third at two f-stops underexposed, a fourth at one f-stop overexposed and a fifth at two f-stops overexposed. All shots were made with the camera on a tripod.

Next, in Photoshop Bridge I selected the five images and loaded them into Photoshop HDR. (In Bridge, go to Tools>Photoshop>Merge to HDR.) On this screen (3), the default Bit Depth is 32/Channel; select 8 Bit/Channel. On the next screen (4), the default for Method is Exposure and Gamma; select Local Adaptation (5). On the Toning Curve and Histogram (6), I made adjustments; you can do a lot of experimentation here for better results. The final image (7) is an improvement over what I could do in Camera Raw.

Photoshop is the most popular software for HDR processing, which is why I go over it here. But the program Photomatix (www.hdrsoft.com) also does an amazing job and in less time. It is a very intuitive program. In a few mouse clicks, I came up with this final result (8).

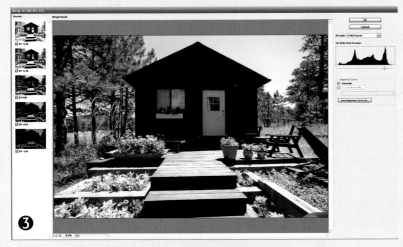

❸ Five shots loaded into Photoshop for HDR Conversion.

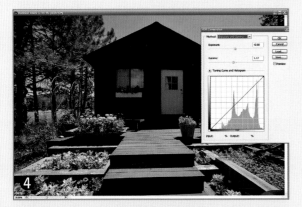

❹ The default Exposure and Gamma method.

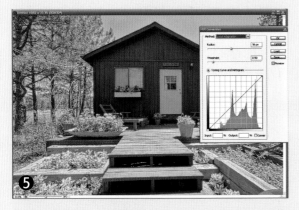

❺ The Local Adaptation method.

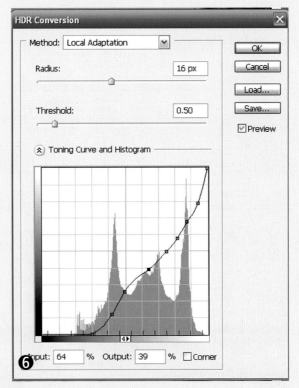

❻

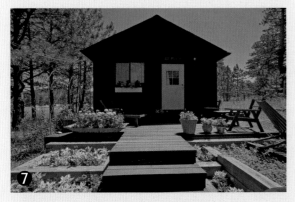

❼ The final photograph adjusted in Photoshop.

❽ The final photograph adjusted in Photomatix.

Although this shot is underexposed, I liked the moody sky, so I chose this image to work on.

EXPOSURE

As I mentioned earlier, lighting is a key element in landscape shots, and exposure, which is particularly important in digital work, goes hand in hand with lighting. In chapter 2, I mentioned the use of HDR, or high dynamic range, to expand the exposure capabilities, or dynamic range, of the sensor. The dynamic range of a photograph is what determines how much detail is visible in varying amounts of light. In an outdoor photograph HDR may capture detail in areas lit by bright sunlight and those in dark shadows. There are times, however, when HDR is not necessary—not only that, but it may be undesirable. Why? Sometimes a scene is more dramatic when the exposure range is compressed.

As an example, take a look at this shot of a flower-filled meadow taken early in the morning on an overcast day (*left*). If I had exposed for just the flowers and green grasses, the sky would be washed out. HDR might have worked here but for the fact that I was hand-holding and, in addition, some of the flowers and grasses were moving from a slight breeze. (To use HDR technique, exposures normally have to be made with a stationary camera and subject, though Photomatix will process hand-held images pretty well if you keep the camera reasonably steady.) So I based my exposure mostly to capture the detail and drama of those clouds, with the intention of later using Photoshop to pull out detail in those flowers and grasses.

There are a few ways to adjust the exposure in Photoshop. If you haven't realized it by now, Photoshop often has many ways to accomplish a single task—one of its great features, though it may take you a long while to find and learn them all:

- **The easy way.** The easiest way is to go to Image>Adjustments>Shadow/Highlight (*below*). The default values on that screen often make everything way too light (*opposite top*), but you can make some fine adjustments with those sliders. In this case, in the Shadows, I adjusted Amount to about 5, Tonal Width to 75, and Radius to 50. Then in Highlights I adjusted Amount to 10, Tonal Width to 36, and Radius to 52 (*opposite bottom*). This does a reasonable—and quick—job of adjusting.

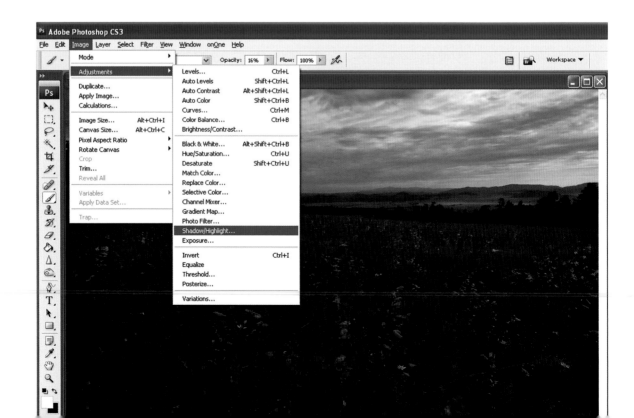

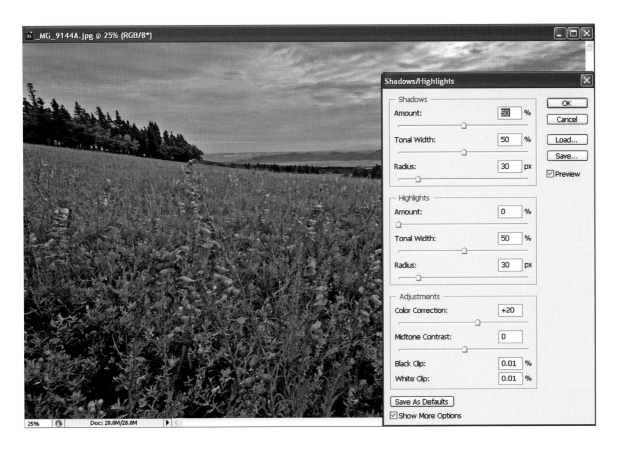

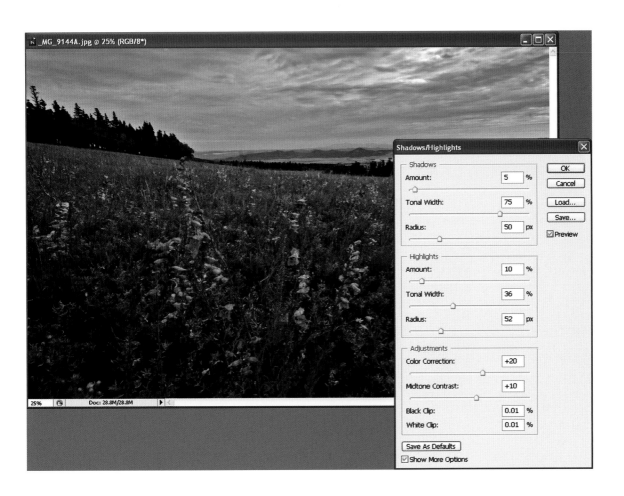

■ **Another easy way.** Another choice is to load the image into Camera Raw, a software plug-in that is available as part of Photoshop, and use its powerful controls. In particular, you can use the Fill Light slider to brighten the foreground grass and flowers, then keep the sky sufficiently darkened by using the Recovery slider.

■ **A more complex way.** Using layers is a great way to selectively lighten and darken areas in a picture non-destructively. This method allows you to create a layer with a 50 percent neutral density and lighten or darken parts of that layer without affecting the original pixels:

▶ On the bottom of the Layers palette, click on Create New Layer while holding down the Alt key. This brings up the New Layer dialogue.

▶ Click on Mode and select Soft Light.

▶ Next, check the box Fill with Soft-Light-neutral color (50% gray) and click OK. This creates a layer filled with 50 percent neutral gray. By default this layer is called Layer 1. You can change its name if you choose. For simple layer adjustments, I leave the layer names at default. However, if I am using lots of layers for complex adjustments, I give each layer a descriptive name to avoid confusion later.

▶ Now make sure that the new layer is selected. Use the Brush Tool to paint on Layer 1 with either black (to darken the image) or white (to lighten the image). I used a soft-edge brush with a Hardness setting about 15 and an Opacity of about 20%. Switching my Foreground color to white, I painted over portions of the image that I wanted lightened selectively. (Remember, if you goof, hit Ctrl-Z on a PC or Cmd-Z on a Mac to undo.) Basically, with a large-diameter brush, I lightened most of the foreground meadow, then with a smaller brush I lightened some of the flowers more selectively. Then I switched the Foreground color to black and darkened a bit more of the clouds in the sky. You can do a lot of experimenting to get just the effect that you like (*opposite*). I will cover more tips and techniques like this in chapter 10.

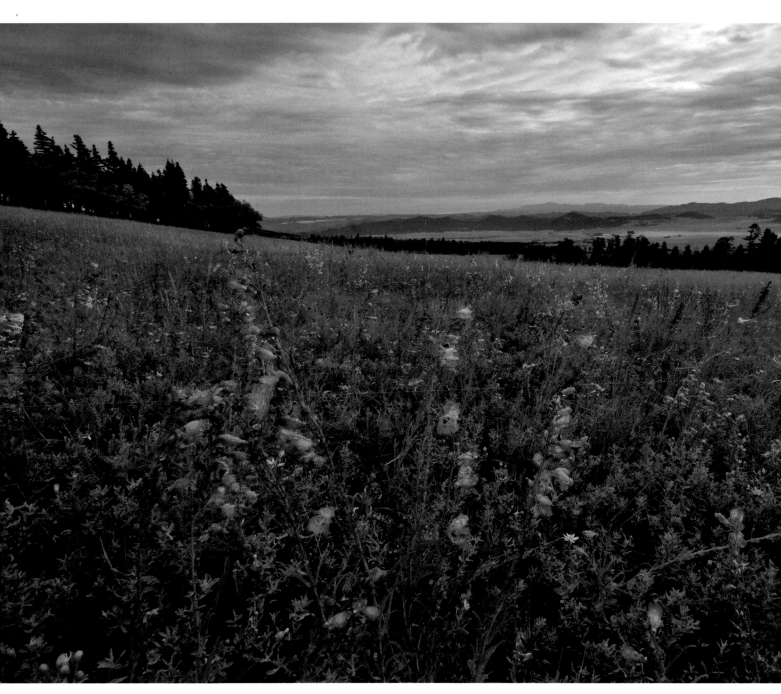

The final image.

PANORAMIC LANDSCAPES

It wasn't so long ago that you needed a special (film) camera to shoot a panorama photograph. There were a number of models available, at least one 35mm-format and a few medium- and large-format. These created a very wide image, spread across the length of the film. In fact, some of the earliest panorama cameras actually had lenses that rotated, sweeping the image across the wide span of film. In any event, the effect was impressive, giving a great, expansive view, not unlike our peripheral vision when we look out upon a landscape.

But there were limitations. First, the medium- and large-format versions were cumbersome and heavy to carry around. Even the 35mm version, though relatively light, was an extra piece of equipment you needed to carry. It hardly seemed worthwhile.

Today, digital photography makes panoramic photography so much easier. And you don't need special equipment: A DSLR (or any digital camera, for that matter) will

work just fine. See chapter 4, pages 72–73, for guidelines on how to shoot a series of photos that can later be stitched together side by side in Photoshop to make a single panoramic photograph.

A LANDSCAPE FRAME OF MIND

In the 1800s in the world of art, there emerged a group of landscape painters called the Hudson River school. Their paintings depicted a romanticized view of nature, portraying scenes of pristine loveliness, soft pastel colors, and peaceful ambience. The paintings of Thomas Cole, Frederic Church,

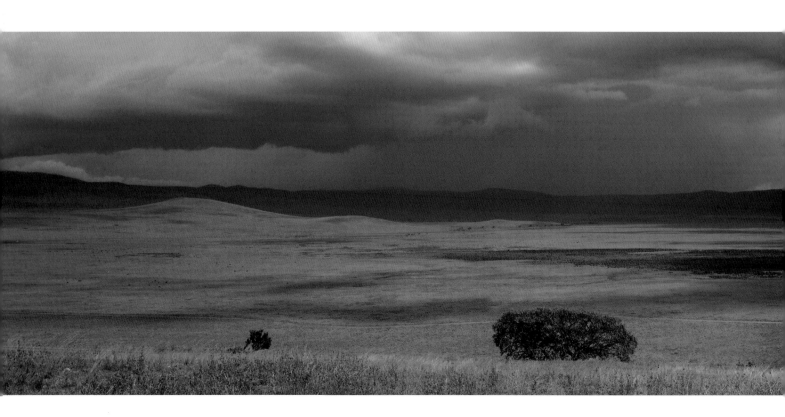

 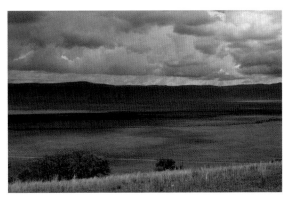

and others became enormously popular. The movement wasn't confined to the Hudson River Valley of New York, though. Painters like Albert Bierstadt and Thomas Moran used these techniques to render Western scenes—Yosemite Valley, Yellowstone—in the same way. Even today, who can look at a Bierstadt painting without marveling at the pristine grandeur of nature portrayed?

What's to be learned from this vision of nature? A lot. We do not have to emulate these painters, but by studying their control of light and composition and their rendition of drama in weather, we can learn a great deal.

What I seek in rendering a landscape as a photograph is the *essence* of a place. The starkness of a desert. The grandeur of a mountain range. The quiet of a forest. The rhythms and patterns of clouds and grasslands and waters. The drama of storms. In chapter 3, I talked about the impact of shape, form, lines, texture, color, and pattern. Think about the essence of your scene before shooting. Study it and look, really *look* and *see*. Perhaps we can all benefit from the words of one of today's great philosophers, Yogi Berra:

"You can observe a lot just by watching."

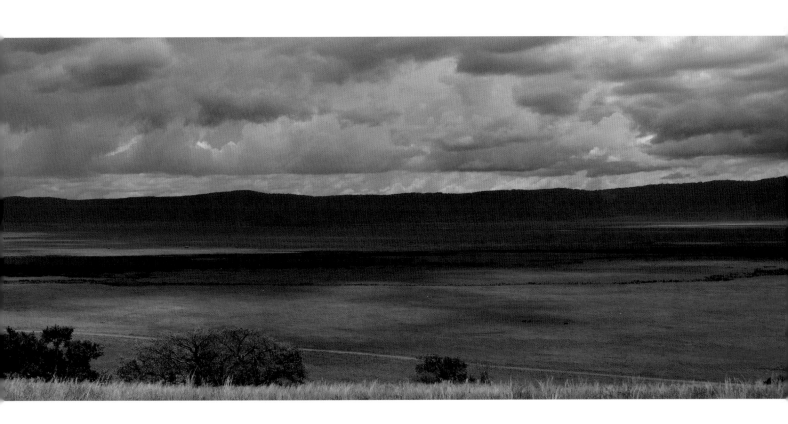

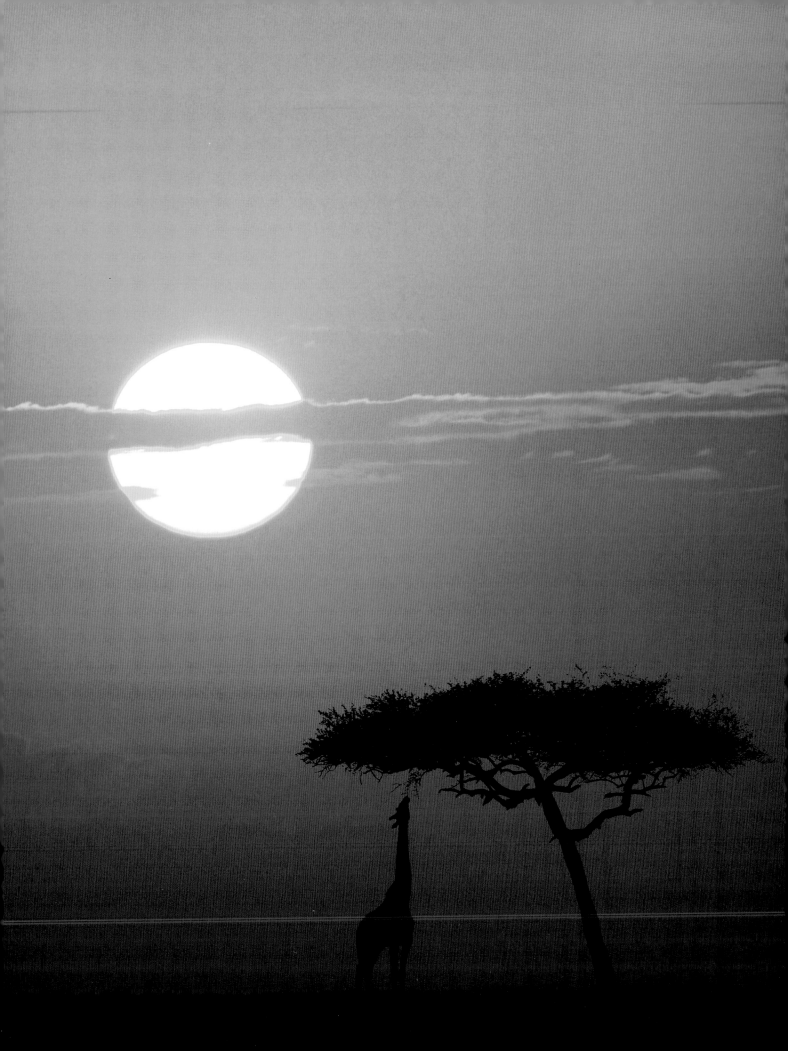

CHAPTER 9
AFTER THE SHOOT

Okay, you've returned from Timbuktu or Yellowstone or a place near home with marvelous pictures stored on your memory cards, laptop, or portable hard drive.

Now what?

After the pictures have been taken and stored, there is yet more work to do. (You didn't think you were going to get off that easily, did you?)

Back in the days of shooting film, if you were assiduous, you had work to do after getting the film processed into slides. There was the chore of editing and then filing the pictures in some logical way so that they could be retrieved later. I used to spend hours over a large lightbox sorting and editing slides, then filing them in slide sheets in appropriate folders in numerous filing cabinets. It was a lot of work. It still is, but now, instead of a lightbox, I spend my time in front of a computer screen. And it is somewhat easier.

This part of digital workflow is vital because, without careful methodology, chaos lies ahead—and perhaps loss of images. The first thing is to define your goals. Are you a serious shooter who plans to store tens of thousands (or hundreds of thousands) of images? Or are your goals a little less ambitious? If you are reading this, you are probably pretty serious, so let's deal with that.

Your images must be more or less permanently stored somewhere. If you use a laptop as your primary storage, you may have problems with storage space later, since most laptops have smaller hard drives than desktop computers. (This will change in the future as laptop hard drives get larger in capacity.) One good option for laptop users is to add an external hard drive via USB or FireWire ports. Many external drives are available up to 500GB, 750GB, 1TB (terrabyte, equal to 1,000 gigabytes), and 1.5TB. Undoubtedly, these capacities will grow in the future.

A giraffe grazes on an acacia tree in Serengeti National Park, Tanzania. Shot with a 100–400mm zoom lens.

COMPUTER

The platform, PC or Mac, really does not matter! That's right. There was a time years ago when Macs had an edge in graphics and imagery, but that's no longer true, so forget the silly statement that "Macs are better for photographers." Both systems are equally good. But you may want to get a reasonably new system for higher processing power and large storage capacity. Some photographers (I'm one of them) have a computer devoted to just image work and storage—not a bad idea. And get as much memory and hard drive storage capacity as you can afford.

A good choice would be to have a desktop computer with sufficient storage, both internal and external, devoted to your imaging work. How much storage? This will depend on your shooting habits, but consider that, after processing the RAW images of, say, a 10MP camera and saving them as TIFF files, these files, on average, may be about 25MB to 30MB in size for each image. (Keep in mind that the original RAW files will also average 8MB to 10MB apiece.) Doing the arithmetic, a 500GB hard drive (actual storage space will be about 450GB) will hold about eighteen thousand images at 25MB apiece. Sufficient? Only you can decide. On a desktop computer, you can add additional hard drives, both internal and external, to allow many more times that storage capacity.

STORAGE

For primary storage, there are a few strategies to consider. Hard drives are larger in capacity and cheaper than ever. But when hard drives fail (not *if* they fail but *when*) you should have a backup scheme in place (more about this in a moment).

Other storage options include optical media: CDs and DVDs. CDs are limited to about 650MB per disk, DVDs about 4.5GB per disk. (Yes, I know that CDs are often rated at 700MB capacity and DVDs 4.7GB, but realistically you should scale down those capacities to estimate storage.) From a practical standpoint, this means that if you are storing, say, image files as TIFFs and averaging about 20MB per file, you can store only 32 images on a CD and 225 on a DVD. Since RAW files are smaller than TIFFs, you can get more on a CD or DVD.

Nowadays, there are also double-layer DVDs (with 8.5GB capacity), Blu-ray disks (up to 25GB and higher in double layer versions), and others. As prices come down, they may become a viable storage media.

Using CDs and DVDs as primary storage presents certain problems—mainly access. You will need to keep switching disks to access all your images, and pulling image files off a CD or DVD takes longer than accessing them from a hard drive.

The longevity of these disks is also in question. The cheaper forms of optical media may not hold up for long periods of storage and use. There are now on the market so-called archival optical media disks, both CDs and DVDs. These disks use a gold metal reflective layer rather than aluminum or silver, and the makers claim that these CDs and DVDs store data up to one hundred years. They are also much more expensive. Regardless of longevity claims, the new technologies that are constantly emerging may make it necessary to re-store media from these disks to the newer storage devices.

From a truly practical standpoint, it makes sense to consider hard drives as your primary storage means, using CDs or DVDs as secondary or even tertiary backup. Today's hard drives can store an enormous amount of data. As mentioned, with a 500GB drive you can store about eighteen thousand images at an average of 25MB per image. Moreover, external hard drives of this capacity make it easy to add more and more storage space. These can plug into your computer's USB or FireWire port for fast access. Also, you can remove external hard drives and store them elsewhere for

security. When I'm gone for long periods of time, I store my external hard drives containing my image files in a safe deposit box.

Back in the days of film shooting, the first thing we did after getting the film processed was *edit*. And this meant being ruthless: tossing the marginal stuff, the not-quite-in-focus stuff, the poor exposures, compositions that didn't quite work out. I used to fill up wastebaskets full of tossed slides. Then the keepers went into a filing system using filing cabinets.

Today, using digital, your filing system is in your hard drive (nice, since it takes up far less space than those filing cabinets). However, just as in filing slides, your computer filing system must help you to find pictures later on—or else you will have serious problems. The sooner you start a good system, the better. There are a number of multipurpose software programs available—programs that not only help you store and find images but that process the RAW files and have some limited adjustment and enhancement features as well.

FILING, EDITING, AND PROCESSING DIGITAL IMAGES

Set up a filing system! To start you don't need anything other than the program that comes with your computer—in this case, Windows Explorer or the equivalent in Mac systems. You can do this in a number of ways. On your primary imaging hard drive, you can set up a master folder called Images or Pictures. Then you can create subfolders for various topics. In the film days, I recommended two basic filing schemes: by subject or by geographic area. In the computer, you have much more versatility. You may choose a chronological system or categorize pictures by shoots or assignments. Or combinations. When you were filing slides, chronological systems didn't make sense because they were not intuitive—that is, folders in the filing cabinets marked by dates didn't give a clue as to the pictures within. With preview folders on the computer hard drive,

you can scroll quickly through images, and if you use one of the image management programs, you may even search quickly using keywords or labels or tags. In my case, I still prefer to use a geographic filing system (as I did in filing slides) in the computer, with some modifications. So my primary imaging hard drive is structured by geography (*page 140*).

Note that my organizational system is not strictly geographic (some folders are of specific subjects). Also, notice that I've set up a hierarchy system. That is, subfolders contain certain subjects found in the area of the parent folder. In Serengeti, for example, I have numerous subfolders labeled by subject, such as Scenics, Lions, Giraffes, Leopards, etc. And, of course, the Serengeti folder is a subfolder of the Tanzania folder, which also contains other subfolders—Arusha, Selous, Ngorongoro, and others. The main idea is to *make it work for you*! You can always go in later and move things around to make it more suitable. (When dealing with slides, it was much more work to reorganize because you had to physically take out and move slides to another set of slide sheets in another folder.) This system is also expandable as needed. In other words, when my Lions file gets so full as to make it time-consuming to scroll through, I can create more subfolders: Lions sleeping, Lions hunting, Lions mating (does this one get an X rating?), Male lions, Female lions, and on and on.

Setting up such a system on your hard drive does not preclude using one of the many picture management software programs. In fact, organization is an aid in using these programs.

One other strategy I find useful is to create subfolders for RAW files. In the folder Tanzania\Serengeti\Lions, there is a subfolder labeled RAW. If I ever need to back up and store my RAW files on separate media, I can find them all in these subfolders. If the RAW files are mixed together with processed or scanned files, it becomes more of a chore to find and copy them.

Use Windows Explorer to set up an image filing system based mostly on geography with some specific folders for topical subjects.

The same rules that apply for editing slides apply for editing digital images—get tough! If anything, it's a little more difficult to edit digital images because there's a tendency, when dealing with a bad shot, to think, *Well, I can fix it in Photoshop.* That may or may not be true. It is true that some miraculous things can be done in the computer when it comes to repairing, altering, or enhancing digital images. But these things take time, and if you have thousands—or even just hundreds—of images needing such care, you may never get around to it. When I'm editing, I often ask myself three questions:

■ Will I publish this photo?
■ Will I make a print of this photo?
■ Will I share this photo with someone (as a print or via email)?

If you don't have any such criteria for your pictures, it won't take long to fill up a hard drive with junk. Use the delete button appropriately and often.

Aside from deciding on keepers, there is another aspect to editing. This involves processing RAW images—that is, taking the image file stored in the camera as raw data and turning it into a final product, usually a TIFF file, that is usable for a good print or for publishing.

PROCESSING RAW FILES

One of the first things you notice about RAW image files is that they tend to look a little flat, without much contrast or color saturation. This is not a fault of the camera; it's just the way RAW files are. They do vary from camera to camera. Keep in mind that these files contain a lot of picture information, and you have a great amount of control over how the final, processed image looks. This is one of the most powerful features of digital photography, not quite matched in film photography.

When you purchase your DSLR, it comes with software for processing RAW images and, in some cases, it includes an image browser for viewing whole files. In most cases, this software does a reasonably good job and is simple enough to use. Many people prefer to use the camera's software because of its simplicity. What you will discover is that these conversion programs use certain default settings for such features as saturation, contrast, and sharpening. In a great many cases, these default settings work for most images and save a lot of time. However, if you want the ultimate in control over your images, you may want to use a program like Photoshop, Bibble Pro, Capture One Pro, Canon Digital Photo Pro, or Adobe Lightroom. The resources appendix lists websites that offer more information on these programs. Since Photoshop is such a popular program, I'll use it as the example for the remaining part of this chapter. Other programs work in similar ways.

While some individual images may require special attention, most RAW files can be processed in batches. The usual method I use is to group images of a similar nature—shots made of the same or similar subjects under the same or similar lighting conditions and camera settings. I pick one of the images and do the fine-tuning and adjustments on it then select others for batch processing, using the settings that looked good for the first.

There are many ways to process your camera RAW files. Listed here are just a few.

- Adobe Camera RAW—part of Photoshop
- Lightroom from Adobe—a program separate from Photoshop
- Bibble—a popular program
- Capture One
- Aperture from Apple—for Mac users

In addition, most digital camera manufacturers supply their own programs for processing RAW files.

Another program for organizing your image files is iViewMediaPro. It processes RAW images, creates web pages, and more.

The RAW file loaded into Camera Raw.

WORKING IN CAMERA RAW

Here's a step-by-step example of processing a RAW file using an image shot in Serengeti National Park. First, in Adobe Bridge I selected the image, double-clicking on it to load it into Adobe Camera Raw. This shot of a giraffe in the open grasslands of Serengeti (*left*) was taken near midday, and the lighting was that flat and harsh kind you get at that time of day. Colors tend to be washed out, aside from the normal appearance of RAW files. Starting with the Basic controls to the right of the image, I worked my way down from the top:

- **White Balance.** My first step was to see if changing the White Balance setting would improve things a bit. The default setting here was As Shot, which gave a slightly cool rendition (a color temperature of 4650 kelvin). (In your camera's Menu, you can make a selection as to how the White Balance is set: Auto,

Daylight, Shade, Tungsten Lighting, Fluorescent, Flash, or Custom. Most times the Auto setting works well. The "As Shot" setting in Camera Raw above is just that—whatever choice you had selected for white balance when you shot.) I selected Daylight (*top*) and then Cloudy (*middle*) to experiment. As you can see, each selection was progressively warmer (higher color temperature). I also tried the Shade setting but decided it was far too warm. Ultimately, I decided Cloudy was also a bit much, so I chose Daylight as the White Balance setting.

White Balance set at Daylight.

Temperature. The Temperature setting, 5500 kelvin, was automatically picked as a result of using Daylight. Using the slider here, you can choose any temperature you wish to give a warmer or cooler rendition.

Tint. Tint I didn't mess with and rarely have need to, though you can experiment with this. This is most often useful if your image has an excessively magenta cast. Moving the slider toward the green part of the bar eliminates it.

Exposure. Next, I made an exposure adjustment, moving the Exposure slider to the left to a setting of -0.55 (*bottom*). This is helpful in toning down some of the excessive brightness of the midday scene.

Recovery. The next two controls, Recovery and Fill Light, weren't useful for this particular image, but they can be of great use in many others. Recovery refers to highlight recovery—that is, bringing back some detail to highlights that are washed out by bright light. Though this control does a good job, it's impossible to put back detail in images where highlights are totally blasted.

White Balance set at Cloudy.

Exposure darkened.

Blacks adjusted.

Clarity not adjusted.

Fill Light. I find that Fill Light is very useful for close-up images in which part of the subject has some deep shadows where you'd like to bring out more detail. It is, as the name implies, somewhat like using a fill flash. And, by the way, using Fill Light has little effect on lighter areas of the picture.

Blacks. The next control, Blacks, deepens the darker areas and has a similar effect as increasing contrast but without washing out lighter areas. By default, this is set at 5, and I chose a setting of 16 (*top*). Again, experiment with this to your own satisfaction.

Brightness/Contrast. The Brightness and Contrast controls are set by default at +50 and +25, respectively. I usually leave them as they are. In older versions of Photoshop, these controls were a bit tricky to use and best left alone, since increasing Brightness or Contrast would quickly wash out light areas. They have been improved, so you might experiment to determine if they can help an image.

Clarity. Clarity is a relatively new control in Photoshop. It can best be described as a way of increasing midtone contrast. For some pictures, it gives added "pop." (In fact, the Photoshop programmers who devised it wanted to call it "Punch.") It does help a great many images. The giraffe here is magnified to 100% without using Clarity (*middle*) and with Clarity set to 60 (*bottom*).

Clarity adjusted.

Vibrance. Vibrance is a great tool that boosts the vibrancy of your colors, which is essential when working with RAW files. The setting affects primary colors more than secondary colors or skin tones. For this shot, I chose a Vibrance level of 40 (*top*). Most often I find that a Vibrance setting of 35 to 40 works well.

Saturation. Saturation boosts the color saturation of *all* tones in the picture. Use it carefully! Results range from modest to garish. For this shot, I chose a Saturation level of 20 (*top*). When in doubt, use Vibrance instead; you can think of it as a more selective version of Saturation. The idea is to avoid that oversaturated look that appears in too many pictures these days.

Sharpening. The final control I used here is often overused—sometimes badly overused. On the Detail tab are the Sharpening control sliders. Keep in mind that in using your pictures later for publication, for websites, or for printing, you will have the opportunity to use sharpening in other parts of Photoshop. Too much sharpening in any of these steps can result in unsightly artifact halos at the edges of objects in the picture. So at this stage, in processing the RAW file, you may want to use only a modest amount of sharpening. Also, to best see the effect, I zoomed in to 200%. I experimented with setting the Amount to 113 (*middle*), leaving the other controls at default settings. It's a bit much, as you can see by the next screenshot where I set the Amount to 50 (*bottom*), my final setting before processing.

Vibrance and Saturation adjusted.

Sharpening overused. See the blockiness in the background and the halo artifacts.

Sharpening adjusted modestly.

The Save Options screen in Camera Raw.

Saving the Camera Raw processing setting for use on other images.

One thing to be certain of before processing the RAW file is that the original RAW file is saved. In other words, it gets processed but non-destructively. This is important because you may want to go back to that same file and, using the same or a different program, process it with different settings. That's the beauty of digital photography: the great number of options and the great control over the final image. When using Adobe Camera Raw, you click the Save Image button to complete the process. This brings up a dialogue screen (*above*). Here, you can select where to save the processed image (same folder, new folder, etc.) and how to save it (TIFF, JPEG, other formats). You can also create a new name or numbering system other than the naming convention used by the camera when it created the RAW image.

After you make your choices and click Save, you will be returned to the main Camera Raw screen. If you have been happy with the adjustments made to this RAW file, you may want to save those settings for future use on similar images. To do this, click on the right edge of the bar labeled Basic (*left, see arrow*), which will bring up a menu of options. Select Save Settings (*see arrow*). This brings up a dialogue box where you can check off which adjustments to save; all are checked by default. Leave them checked and click Save. This brings up yet another dialogue box where you can name the settings file (an xmp file). In this case, I named it SerengetiGiraffe.

Click Save, and you'll be back at the Camera Raw screen.

Now you have a few more choices: You can click the Open button, which opens the just-saved TIFF file in the main Photoshop window; you can click the Done button, which saves all the adjustments for the Raw file and returns you to Bridge; or you can click Cancel, which does not save the adjustments to the RAW file (but your settings have been saved and can be called up later) and returns you to Bridge. I usually click Cancel because I don't want the RAW file saved with the adjustments I made. I prefer to load the original RAW file later for any future adjustments. Let me note here that it doesn't matter, really, if you save the RAW file with the adjustments because if you reload that file in Camera Raw, you can select from the menu of options described above Camera Raw Defaults, and the image will return to original settings. Or you can use the saved, adjusted file as a starting point for a new set of adjustments.

As I mention earlier, you do not have to spend all this time on each and every image. You can easily batch-process any number of images. In Bridge, select those images that best match the shooting conditions for the first image you adjusted and processed (hold down Ctrl, or Cmd on Mac, while clicking on each image to select more than one). Right-click on any one of the selections, and choose Open in Camera Raw. When these files are opened in Camera Raw, you will have a vertical column of thumbnails of all the images selected to the left of the first image. Click on Select All at the top of the thumbnail column. Next, click at the right edge of the Basic heading to bring up the options menu. Select Apply Preset, and from the fly-out menu select the name of the preset you had saved above for your adjustments (*opposite*). This will then apply the previously saved adjustment settings to all the files selected. You can then save those as TIFF files using the same procedure described above.

Obviously those presets or adjustments settings you have saved for one particular set of images may not be applicable to all other images. When processing RAW images, I try to group and select them by the type of lighting conditions, type of subject, or any similarities that may apply. Just remember, if you save your original RAW files, you can always go back and reprocess one or more of them. Again, this is a great feature of digital imaging: You have complete control over processing those images.

Once you have gone through this procedure several times, it becomes easier and more routine. And, of course, that's the key: to make it a routine and part of your workflow. In time, you will make various adjustments better based on previous experience with images shot under a variety of lighting conditions.

METADATA

It is wise to add metadata when you process your digital images. I will discuss this also in the next chapter, but it is important to point out here that during your image processing, you should at least add some very basic metadata as a part of your routine.

What is metadata? It is information stored in the image file itself. In RAW files, your camera automatically adds EXIF (exchangeable image file format) data, such as date and time, camera settings, lens, and f-stop used. While this metadata is useful at times, what's also important is to add your own information—name, copyright, contact information—so that it is an integral part of the image file like the EXIF data.

You can apply preset settings to a batch of images using Apply Preset.

I generally do *not* add metadata to RAW files because the RAW files do not store certain metadata as securely as in TIFF or JPEG files. This means that, depending on how the RAW file is handled in certain programs, some or all metadata may be stripped out of the file during manipulation and processing. As part of my workflow, I add the metadata to the TIFF files after processing from RAW. This is done easily as follows:

First, load one of your TIFF images in Photoshop. Next, on the menu bar go to File>File Info. This brings up the dialogue box to add metadata to your file. (You do not have to do this with each and every file. What you do here will be saved as a metadata template, and later you can easily apply this to large numbers of files in batches.) Under Author, you fill in your name, and in Copyright Status select Copyrighted. In the Copyright Notice box, hold down the Alt key on your numeric keypad and enter 0169. This will enter a copyright symbol. Then add your name and any additional information. Next, click on IPTC

147

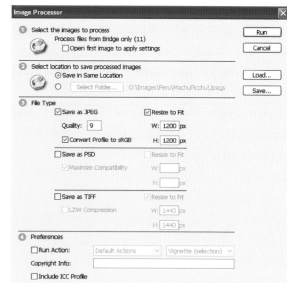

Contact in the menu box on the left (*above left*). IPTC stands for International Press Tele-communications Council and is standard for integrated metadata. On this screen, you should add all your contact information (the name is carried over from the first screen), such as address, phone numbers, and email. When done, click on the small arrow on the upper right, and this opens a drop-down menu. Select Save Metadata Template and give this file a name, e.g., Basic Copyright Data. Henceforth, you can select a whole batch of files in Adobe Bridge, go to Tools>Append Metadata and select the file you just saved. All your important information will then be embedded in those selected files.

CREATING JPEGS

In the processing of RAW files above, I described the method for converting to TIFF files. You could just as well select to convert those RAW images to JPEG, but by saving them first as TIFFs, you are saving them at the highest quality for making prints and publishing. It is very easy to create JPEGs from those TIFF files using Photoshop Image Processor. Again, this is done in batches, which speeds up the process.

First, in Adobe Bridge select the files you wish to convert, holding down the Ctrl or Cmd key to select multiples. Next, on the Bridge Menu bar, select Tools>Photoshop>Image Processor. This brings up the Image Processor dialogue box (*above right*), where you'll complete the following steps:

1. Here you'll note that in field 1, it shows the number of images selected in Bridge (in this case, 11).
2. In field 2, if you choose to Save in Same Location, it will automatically create a subfolder of JPEGs.
3. In field 3, you select the file type; in this case, it's JPEG. You can also enter a maximum width and height, which applies to either a horizontal or vertical image. The checkbox Convert Profile to sRGB is useful because it is usually recommended that the color space for web usage be in sRGB.
4. In field 4, you can select to run a Photoshop Action (more about this later) and include an ICC profile. For the latter, you should uncheck this if you use the JPEGs on a website.

Finally, click on Run, and the Image Processor will do its thing.

USING ACTIONS

This tool is one of the great timesavers in Photoshop. It's much like the old phrase, "Lights, camera, ACTION." Literally, it's like a movie. When invoked, the Action command will first record your actions, save them, and then—when you are ready—you can play them back by clicking a button. All that you did will work on another image or batch of images in the same way you did originally.

Here's an example. Let's say I want to resize an image or a group of images. First, load one of the images. So that you don't waste any time, preplan your moves—that is, go through the commands you will use to create the effect. Next, on the Action palette, click on the Create New Action button on the lower right. This brings up the New Action dialogue box. Give it a name; in this case I called it Resize (*below*). Then click Record. You'll notice that the Record button near the lower left of the Action palette turns red. Now you can start your procedure. You don't need to rush—this is recording only your actions, not movements or time. When you've finished, click on the Stop playing/recording button on the lower left of the Action palette You've now created a resizing Action that you can apply to a large batch of similar images.

BACKING UP

This is as important in your workflow as anything I've described so far. Backing up is vital. As I said earlier, the best way is to use external hard drives—preferably two of them. The cost these days for large-capacity drives is very favorable, so there isn't a good reason not to make this part of your routine.

How often you back up your images is up to you. It'll depend on how much you are willing to gamble on losing some images. I use two large external hard drives and alternate them. Obviously, if you are not uploading images from flash cards or scanning images from slides, there's no need to back up every day. I usually make a point of backing up after each upload or scanning session. What I end up with are image files on three hard drives: my main drive in the computer and two external drives. As I mentioned earlier, whenever I travel, I make sure one of those external drives goes to a safe deposit box. If you really want to be secure, you may also wish to select certain valuable images, copy them to archival CDs or DVDs, and put those in a safe place.

Whatever backup routine you work out is up to you. Just be sure to do it.

Creating a New Action in Photoshop, in this case, one that will resize images in batches.

The original photograph.

The Luminance screen.

The Saturation screen.

Vibrance, Saturation, and Luminance adjusted.

A CASE STUDY IN RAW PROCESSING

Here's a photo that benefits greatly from processing in Camera Raw. These woods near Littlehampton in West Sussex, England, were splashed with lovely blue spring flowers. I captured some of these in close-ups, using an ultrawide-angle lens low to the ground. But I wanted also to capture that subtle wash of blue across the green grasses of the forest floor. This medium-wide-shot RAW file doesn't quite do it (*top*).

After loading the image in Camera Raw, I added about 35 on the Vibrance slider and 4 on the Saturation. I then clicked on the HSL/Grayscale button, then on the Luminance tab. Here I increased the Luminance of the Yellows by a modest amount, increased the Blues by a large amount, and decreased the Greens by a large amount (*middle left*). Using this Luminance tab gives you great selective control over certain colors. Next, I clicked on the Saturation tab and boosted the saturation of Yellows (trees in the background) and Greens and Blues (*middle right*). As you can see, this improved things, but I still wasn't satisfied (*bottom*).

I then loaded Viveza software (a Photoshop plug-in from Nik Software), added a control point to selectively lighten certain areas, and used the brush tool to lighten areas of the blue flowers (*opposite top*). I also added a control point to darken some areas and used the brush tool to darken some of the grasses. The result was more satisfying (*opposite bottom*) and corresponded well with my vision of that scene as I experienced it.

Left: The image selectively lightened using the Viveza software plug-in.

Bottom: The final adjusted photograph.

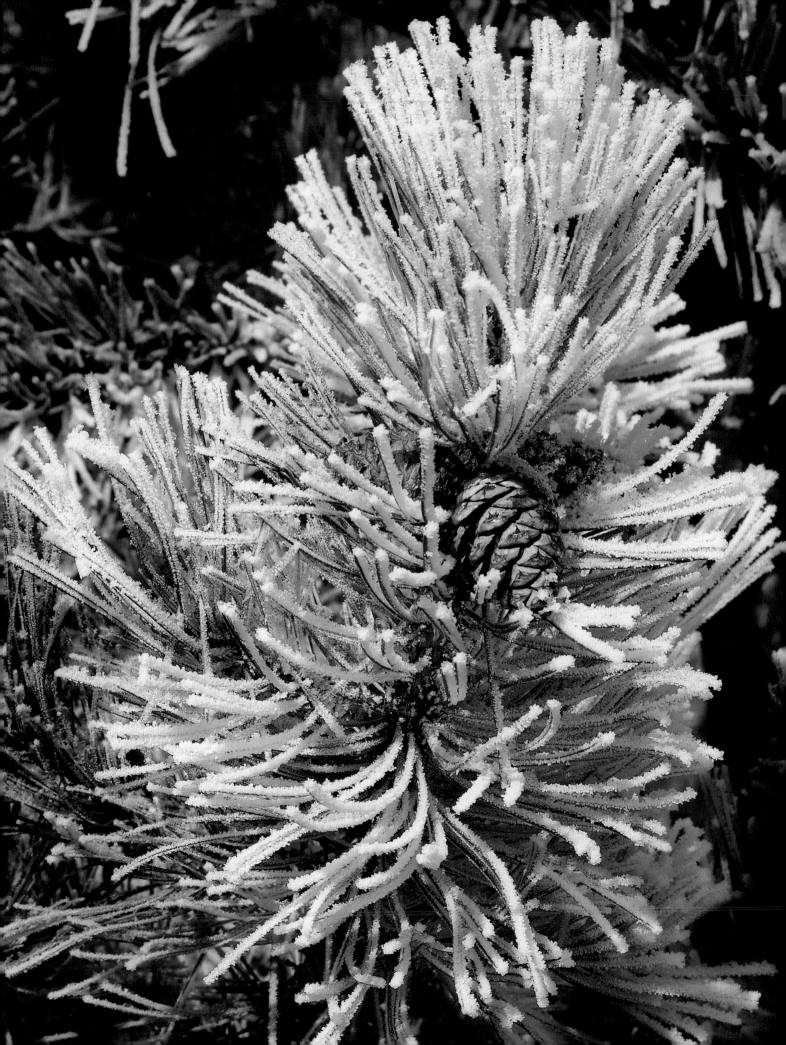

CHAPTER 10
HELPFUL TIPS AND TRICKS

Mention of the term "digital photography" conjures up visions of having to cope with Photoshop, the incredibly rich and complex program for image manipulation and processing. Even in its simpler form, Photoshop Elements, the program may seem daunting to master. As I mention in the introduction, this book is not intended to be a rigorous treatment of Photoshop. Many resources are available for learning this program, from hundreds of published books to online lessons and tutorial DVDs. I list some of these in the appendix. And I urge you to spend time with these resources learning more about Photoshop because it is such a powerful tool for improving the color balance, contrast, tonal range, saturation, and sharpness of your images for presentations, publications, and prints.

In other words, Photoshop can vastly improve your pictures.

I used to spend hours in the darkroom fine-tuning prints with laborious dodging and burning—and somehow never getting it exactly right. Nowadays, you can accomplish so much more using the computer. And I

don't mean radical manipulation of images—adding or taking away objects in scenes. You can do that, of course, if you've got nothing better to do on a long winter evening. (But be sure to be honest about labeling such pictures as manipulations.)

I don't consider myself a Photoshop guru. I'm still learning myself (and I think many experts will admit that they, too, are always finding new things in Photoshop). However, over years of using the program, I have discovered certain tips and techniques that might be helpful to you in improving your images. Keep in mind that what I suggest here is usually not the only way to accomplish something in Photoshop. Quite often you'll find, as I have, that there are an incredible number of ways to do certain things in the program, and some are more advantageous than others. Also, since I'm a lazy slob myself, I look for the easiest and quickest way, even though more complex methods might give slightly better results. Again, if the winter evenings are long and you have the time, go for the complex methods. Me, I'm usually in a hurry to get things done.

Frosted ponderosa pine needles and cones in my backyard, Evergreen, Colorado. Shot with a 100–400mm lens.

TIPS TO AVOID PROBLEMS LATER

■ **Before beginning work on any image, preserve your original.** When I have converted my RAW files to TIFFs, I make sure that the original RAW files are safely stored somewhere in case I ever want to go back and re-process with different parameters. (This is also important for another reason: Future improvements in image processing programs may give you better control over the quality of the processed image.) Moreover, when I go in to work on a TIFF image file, I make sure I save my original by doing a Save As with a different file name. I find it helpful to use a file name that reflects what I've done to the image. Here is a naming scheme that I use:

▶ **AdB:** adjusted brightness/highlight/shadow/contrast
▶ **AdSh:** adjusted sharpness
▶ **AdSat:** adjusted saturation
▶ **AdBSatSh:** adjusted brightness/highlight/shadow/contrast plus adjusted saturation and sharpened

The abbreviations are appended to the file name. So if the files are named by regional location (RW for Rwanda) and by number (0010 for the tenth photo taken there), then the final file name might look like this: RW0010AdBSatSh. If I make some of these adjustments at different times, I may save each but then later go back and delete some of the intermediate versions to save hard disk space. Later, I will also rename most of the files to conform to a reasonable naming scheme, e.g., NortonRW0010 (putting my name in the filename and the RW code for Rwanda).

■ **Work with layers.** Most adjustments made to an image *without* layers affect the original pixels and can be destructive. Using a layer is non-destructive. If things don't work out, you can always delete the layer, and nothing has happened to the original.

■ **Give layers appropriate, descriptive names.** By default, Photoshop names each layer Layer 1, Layer 2, or Curves 1, etc., depending on the type of layer you select. When working with numerous layers, it's useful to add descriptions to these names. For example, if I create a layer to selectively lighten or darken parts of an image, I'll rename the layer "Selective Lighten Darken." Or, using a Saturation layer, I may rename it "Saturation." Whatever works for you. Just as long as it allows you to come back later and recall what was done in each layer.

■ **If you want to adjust an image again later on, save it as a Photoshop document (PSD).** Saving the image as a PSD ensures that all layers and color channels are preserved. (Note: Saving as a JPEG results in flattening all the layers so that you aren't able to make further adjustments in those layers; saving as a TIFF or PSD keeps the layers.) Later, on opening the PSD file, you can make adjustments to those layers without having to re-create all the work you did earlier. If I'm making simple adjustments on a particular picture with, say, one layer, I may flatten the image and resave it as a TIFF to save hard disk space. (PSD files occupy much more disk space than TIFF files; depending on the complexity of the adjustments, this can be two to three times the file size of a TIFF.) However, for more complex image work with numerous layers, I always save as PSDs in case I want to make further layer adjustments.

■ **Keep notes.** This is especially useful for more complex adjustments. I usually keep a notebook handy and jot down adjustments made.

WORKING WITH LAYERS

The first time most of us use Photoshop, we get a bit confused over the idea of *layers*. It seems so complex. But quite simply, layers allow us to make an almost infinite number of adjustments to an image without degrading any of the pixels in the image.

Whenever you open an image in Photoshop, you'll notice a layer called "Background" in the Layers palette. Think of the Background layer as your original negative, to use a film analogy. When you make a print from your film negative in an enlarger, you can use filter packs or different types of paper for contrast control. You can also use dodging and burning techniques to lighten and darken areas. But the original negative isn't affected by these adjustments. When you use layers in Photoshop, the layers function in the same way. Any layers you stack on top will show changes or adjustments—e.g., contrast, saturation—but if you delete those layers, the original Background "negative" remains unchanged.

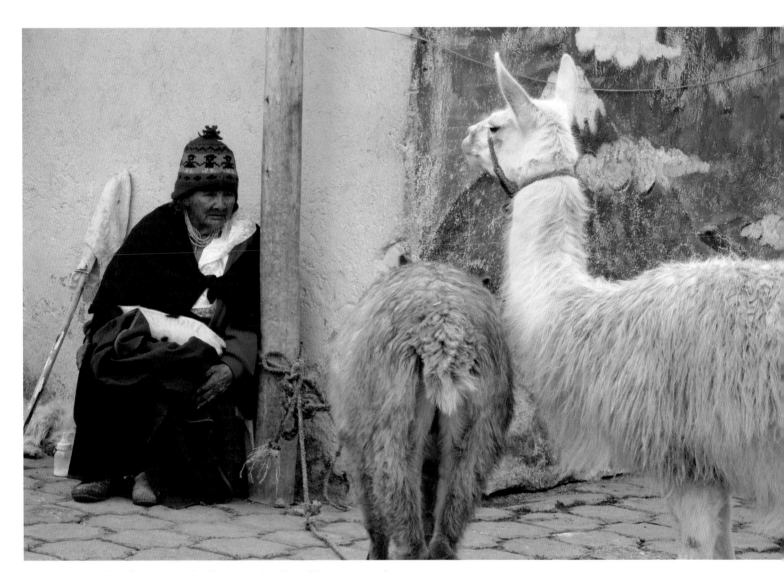

An old woman and her llamas, Otavallo village, Ecuador. Shot with a 28–135mm lens.

The original underexposed photograph of a bristlecone pine.

CORRECTING UNDEREXPOSURE

Here is an example of a picture in need of correction (*left*). This photo of a bristlecone pine at timberline in the Colorado Rockies was deliberately underexposed because I wanted that spot of sunlight to show up better against the dark foliage. The bright sky and spot of sunlight influenced the light meter with all that brightness, but I chose not to correct it at the time. Instead, I'll show you my process here.

First, I opened the image in Camera Raw. As you can see, no corrections had been applied (*below*).

Next, I started using the Camera Raw adjustments from the top down (*opposite*). No adjustments were made to White Balance, Temperature, or Tint. I dropped Exposure down to -0.85. I know, I know—it's already underexposed, but I wanted to be sure I wouldn't blow out too much of the lighter areas of sky with subsequent adjustments. Recovery adjustment helps to bring back areas of overexposure, in this case in the sky. I set Recovery at 66. And, by the way, using the sliders allows you to watch the changes taking place—so you just stop when it looks good. Fill Light is

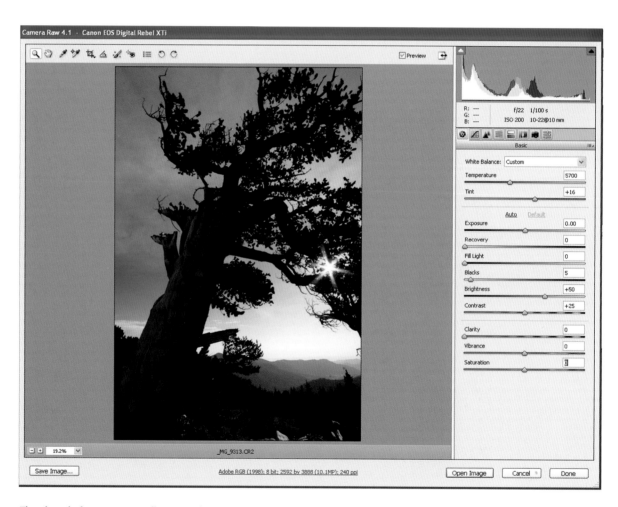

The photo before exposure adjustments in Camera Raw.

a great feature. It is like using a fill flash, which I might have done when taking this shot, except I didn't have one along. Again, adjust the slider until it looks good. Incidentally, Fill Light affects mostly the dark areas, but it does have a lesser effect on light areas as well. I adjusted Brightness and Contrast until it looked good, +100 and +77, respectively. The next three adjustments are very useful. Clarity gives a boost to midtone contrast, resulting in added "pop" to most images. I increased Clarity to 65. Vibrance boosts saturation for midtones without grossly oversaturating all the tonal ranges. I increased Vibrance to +40. I like this adjustment. As you'll note, I left Saturation at 0 because even a small amount seemed too much.

That's it. I clicked on Save Image and in the dialogue box saved the file as a TIFF to another folder for processed images.

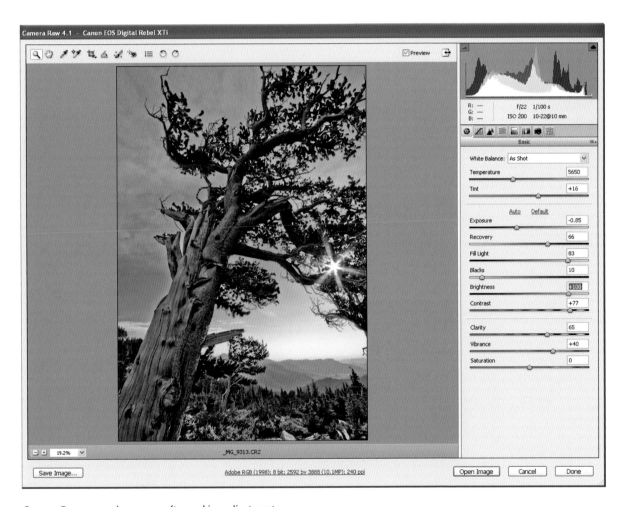

Camera Raw processing screen after making adjustments.

The original overexposed photograph of a dandelion seedball.

Right: The histogram shows blown highlights (the spike at the right edge of the graph).

CORRECTING OVEREXPOSURE

This dandelion shot is overexposed (*left*). Sometimes a dark background causes the meter to overexpose a light-colored subject, as it did with this shot. The histogram looks pretty bad (*right*). Note the spikes at the right edge indicating blown highlights. In the past, most of us would have given up on this one, but Camera Raw can do some miraculous things with RAW images.

First, in the Camera Raw processor, I dropped the Exposure down to -1.40 (*below*). (Again, using the sliders, you can follow the changes and stop when you've perceived enough change.) I set Recovery at 76. You can note the other settings; boosting the Contrast and Clarity really helped this shot (*opposite*).

Further improvements could be made using the selective lightening and darkening technique—"painting" parts of the background darker, for example. In addition, or instead of darkening, you could also blur that background more (*see "Adjusting the Depth of Field," page 174*).

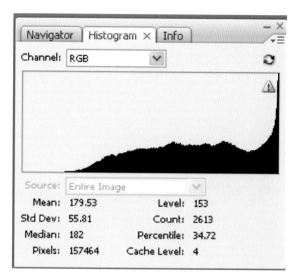

I decreased the Exposure setting and boosted the other settings using Camera Raw.

Opposite: The final photo has been adjusted for better exposure.

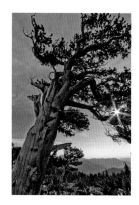

Even after the adjustments made on page 156, I still wanted to emphasize the subtle differences in the grain of the bristlecone pine.

SELECTIVE LIGHTENING AND DARKENING

Going back to my bristlecone pine image, although the image looks pretty good after adjusting for underexposure (*left*), I wanted to emphasize the grain of that weathered wood.

You can use the Dodge and Burn tools in Photoshop, but these are destructive to the image in the sense that you are working directly on the pixels. If you choose to use Dodge or Burn, create a new layer first so that you are working on the layer rather than on the Background image.

Here's another neat Photoshop trick that lets you "paint" a lighter or darker effect in a non-destructive way. First, you need to add a special layer that allows you to selectively lighten and darken with a paintbrush. On the Layers palette, go to the button on the lower right, Create a New Layer. Hold down the ALT key and click on that button. This brings up a New Layer dialogue box (*right top*). Click on Mode and select Soft Light (*right bottom*). Then check the box below Mode, which now reads Fill with Soft-Light-neutral color (50% gray). This creates a layer filled with a 50 percent gray neutral density.

This allows you to make certain areas lighter or darker by simply using a paintbrush with the Foreground color set as black (which darkens) or white (which lightens). In this instance, I chose the Paintbrush tool and made the brush narrow with an Opacity of about 15%. (You can play around with these adjustments.) I set the Foreground color to white. Then I began selectively "painting" down some of that wood grain to lighten it. I switched my Foreground color to black and painted some different areas, this time darkening some of that wood grain. I also darkened some of the background forest to make it less obtrusive.

Anytime you goof, you can always erase your last stroke by hitting Ctrl-Z, the Undo command (or Cmd-Z on a Mac). To undo further, go up to the Edit menu and select Step Backward. (You can also undo with the keyboard shortcut Ctrl-Alt-Z.)

When done (*opposite*), save the image as a PSD file so the layer is saved. Later, if you want to make further adjustments to the layer, you can always open the PSD file and "paint" some more lightness or darkness.

First, create a New Layer.

Select Soft Light.

Opposite: The final photo has been selectively lightened and darkened to emphasize the wood grain and the branches.

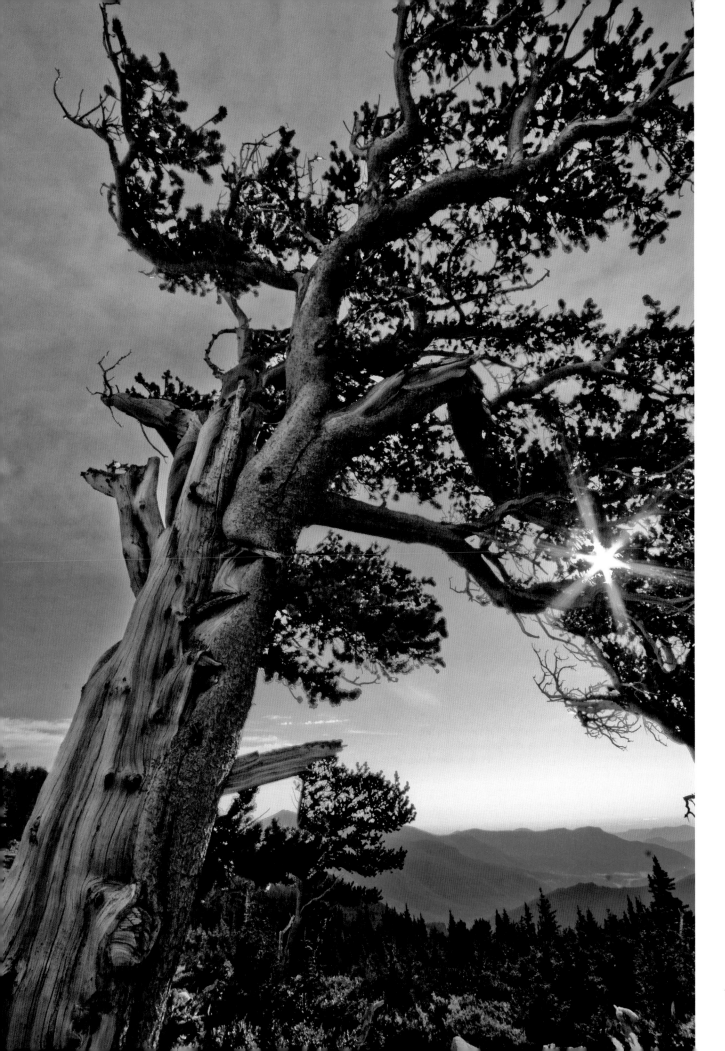

LAYER MASKS

Layer masks are part of the magic of Photoshop, and you would be well advised to spend some time learning how to use them. With layer masks, you can make selective corrections to exposure, color, and a great many other things. Here is a simple example of how layer masks work.

Top: The original photograph of a wooden carving.

Bottom: Here, the Opacity is lowered to create a fog effect.

This is a shot I made of a carving at a shaman site in Siberia (*top*). After loading the image in Photoshop, I went to Menu, Layer>New>Layer. You can also click on the Create a New Layer button at the bottom of the Layers palette. Next, I filled the layer with white by going to Menu, Edit>Fill and on the Fill dialogue selecting Background color (assuming the default black for foreground and white for background). This makes my image pure white.

To diverge for a moment, you can play around here making a fog effect by lowering the Opacity to about 40% (*lower left*).

However, leaving Opacity at 100%, I next added a layer mask by clicking on the Add mask button at the bottom of the Layers palette. Now, after making sure my foreground and background colors were default (press "d" on the keyboard) and also making sure the mask was selected by clicking on it, I then went to the Brush tool and—with an Opacity of 100%—"painted" back a part of the image. Note that when painted on the layer mask, the Foreground color black reveals the underlying image. Black reveals, white conceals. If you want to hide some of the image, make white the Foreground color and paint over the revealed parts. Note also that I used a soft-edged brush, which made the edges of the revealed image very soft (*opposite top*).

To achieve some other effects, I could now change the Opacity again to make some of the background more visible—but not as much as the center. In this case, I made the Background Opacity 60% while leaving the Fill Opacity at 100% (*opposite bottom*).

There are other ways to achieve similar effects. If you don't like the fog effect created by changing the Opacity, try instead using the Gaussian Blur tool. In this instance, I duplicated the Background layer and, with it selected, went to Menu, Filter>Gaussian Blur. As you can see, this blurred the image overall (*top of page 164*). Next, on this layer I created a layer mask and, with a soft-edged brush and black as my background color, "painted" away the blur in the center of the image to achieve a ghostly effect (*bottom of page 164*).

You can see by this one example some of the powerful features of layer masks.

Using a layer mask, "paint" back part of the image.

Use the Opacity setting to achieve a fog effect on your layer.

Try the Gaussian Blur Tool to blur the entire image.

Again, use a layer mask to "paint" back the blur in the center of the image.

EXPOSURE CORRECTION USING A LAYER MASK AND CAMERA RAW COMBINATION

The latest version of Camera Raw in Photoshop allows you to open TIFF and JPEG images so that you can use the program's great correction capabilities even if you don't shoot RAW images. Although the corrections available in Camera Raw work best on RAW images, you can do a lot with TIFFs or JPEGs, whether scanned from slides or negatives or converted from digital RAW files. (See chapter 11 for how to scan slides to convert to digital files.) Here I have a scanned slide that is badly underexposed (*right*). As you can see, the foreground trees and flowers are way too dark. Note, though, that the background sky has reasonable exposure. When I tried to lighten the entire image, it blew out the parts that were correctly exposed.

My solution was to combine the two images—the original underexposed one and the lightened one—and then use a layer mask to make some nice exposure corrections:

■ **Adjusting in Camera Raw.** First, I opened the original image in Camera Raw (in Bridge, select the image, right click, then select Open in Camera Raw). Note the settings I chose (*below*). You can make your own adjustments and observe the results until you are satisfied. Selecting an Exposure increase of +2.00 opened up those dark areas very well but in the process overexposed the sky and clouds in the background. I used the Recovery slider, but even that didn't help to recover the blown-out highlights. I also added 20 on the Fill Light. This is like using a fill flash, but I didn't want to overdo it. Brightness

The original underexposed photograph of a birch forest, scanned from a film slide.

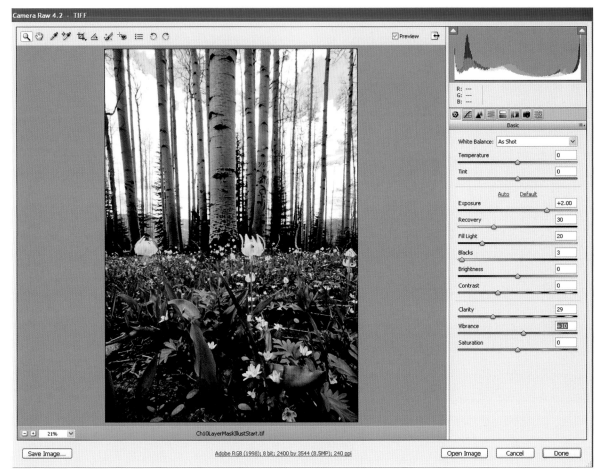

First, adjust the exposure in Camera Raw.

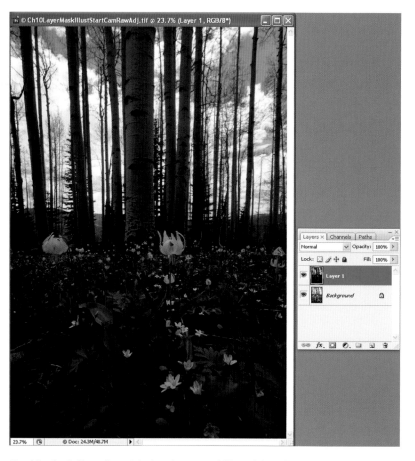

Combine both files—the original underexposed file and the adjusted file—in Photoshop.

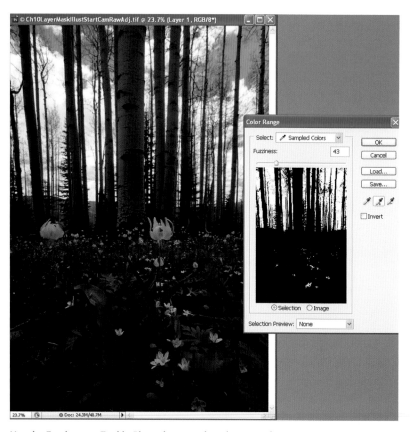

Use the Eyedropper Tool in Photoshop to select the properly exposed areas of the photo.

and Contrast I left at the default values. Clarity (which "pops" midtone contrast) I set at 29. I added a slight amount of Vibrance (a midtone saturation) because the colors were already pretty saturated (and thus I left Saturation at 0). I saved the image with a different name.

Combining the images in Photoshop. The next step was to load both files—the original underexposed image and the Camera Raw–adjusted lighter image—in Photoshop. With the original photo selected, I did a Ctrl-A (or go to Select>All on the Menu; Mac users hit Cmd-A) to select the whole image. Then, clicking on the lighter image, I hit Ctrl-V (or Edit>Paste on the menu bar) to paste the original image into the lighter one. Note that this automatically creates a layer (*left top*).

Using a layer mask in Photoshop. For the next step, I went to the Menu bar: Select>Color Range. This brings up the Color Range dialogue box. Selecting the Eyedropper Tool, I clicked on one of the areas of blue sky in the upper right. Then I selected +Eyedropper Tool (in the middle) to add to the selection by clicking on the white clouds and other areas of sky that weren't quite as blue. I also selected some of the white flowers (*left bottom*). When I was satisfied with the selections, I clicked OK. This gave me regions in the picture as selections; note the dotted lines in the image (*opposite top*). To use the selections, I created a layer mask (with the layer selected, click on the Add mask button at the bottom of the Layers palette). The new mask takes the selected areas and masks them in such a way as to lighten the dark areas, keeping the properly exposed areas the same (*opposite bottom*).

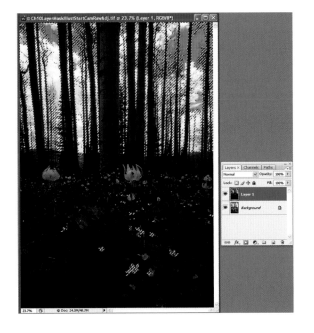

Left: Create a layer mask of the selected areas. This allows you to make adjustments to the overexposed areas while leaving the properly exposed areas as they are.

Below: The final photograph combines the two layers to achieve the best of both versions: the correctly exposed foreground and background.

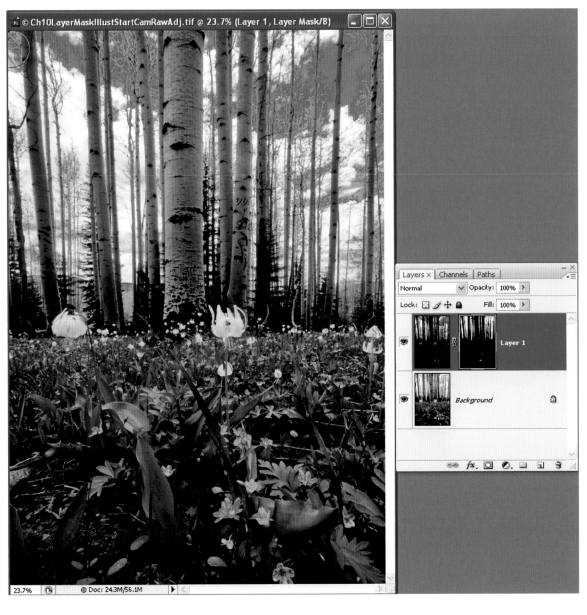

This is the shot of the bristlecone pine after processing from RAW (*page 157*) but before I did the selective lightening and darkening (*page 161*). It could still benefit from more contrast to help bring out subtle tonal differences in the wood grain.

Opposite: Here is the final image, combining the selective lightening and darkening from page 161 with the boost in contrast using the Curves graph.

CONTRAST CORRECTIONS

Some photos have too much contrast, some too little. Let's look at a shot that might benefit by a boost in contrast: my ancient bristlecone pine (*left*).

Now, first of all, there are many ways to control contrast. One method is simply to go to Image>Adjustments>Brightness/Contrast. In the older versions of Photoshop, this control was to be avoided because it really did not do a good job. In the latest version of Photoshop, however, it has been vastly improved and provides a quick and dirty way of adjusting contrast.

However, the method I prefer to use is an adjustment layer in Curves. First, load the image in Photoshop. In the Layers menu, select New Adjustment Layer, then Curves. This creates a new layer called Curves 1 (you can rename it anything you like), and it brings up a Curves graph (*below left*). Notice that there are two lines running from the upper right corner to the lower left. The straight, lightly shaded line represents the original contrast; the curved, darker line represents the adjusted contrast. In this case, I clicked on the curve to place a point on the lower part, then dragged it slightly downward and to the right. Farther up, I clicked another spot

and dragged it upward and to the left. The net effect was to make the middle portion of the curve slightly steeper—which increases the contrast. You can move these points to make further adjustments if you wish. The immediate effect is very noticeable, and it does help the image, especially the wood grain (*below right*). In comparison, the original seems flat.

If you're intimidated by using Curves for image adjustment, try doing the same thing by going to Image>Adjustments>Brightness/Contrast and adjusting the Contrast slider. Chances are, you will closely approximate what was done here.

Often a combination of adjustments is required to improve an image. Going back to my image of the bristlecone on which I used selective lightening and darkening (*page 161*), I also made, using an adjustment layer, a slight increase in contrast. Note how the wood grain really stands out (*opposite*).

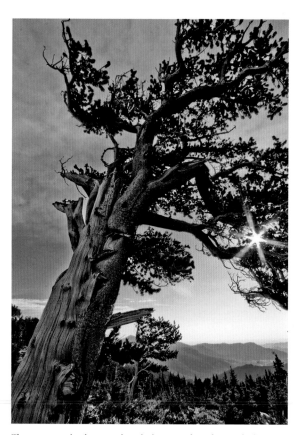

The Curves graph allows you to increase contrast on a layer.

The contrast in the wood grain is strongly enhanced after adjusting with the Curves graph.

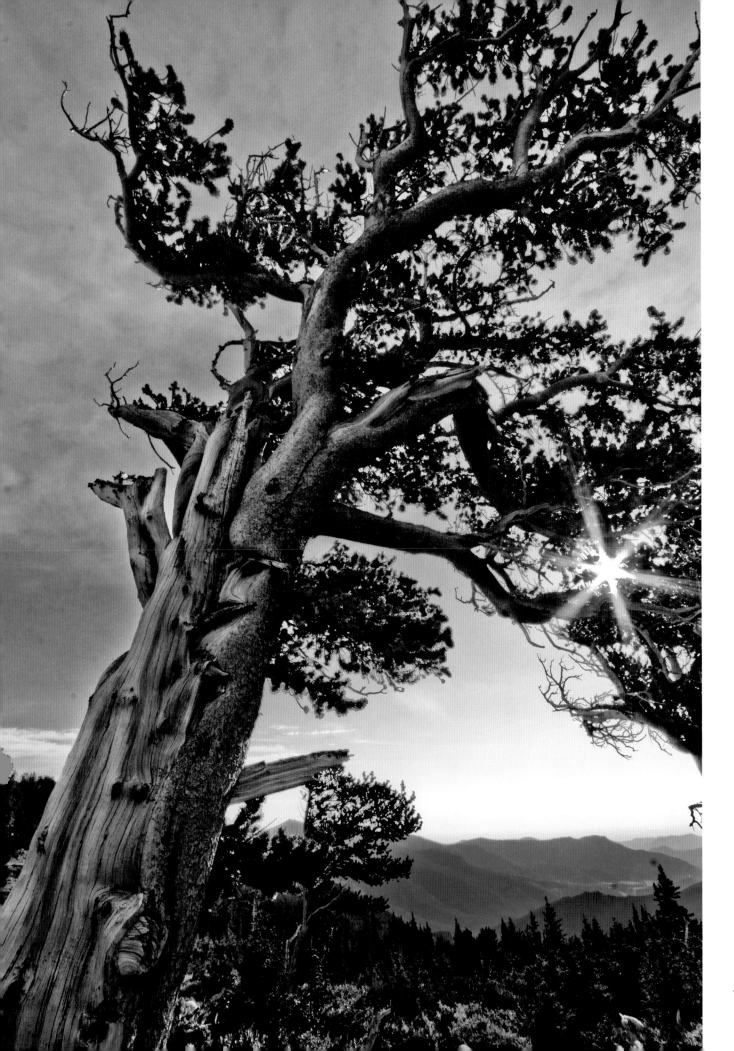

ADJUSTING CONTRAST: A CASE STUDY

The original flat image with little contrast.

Here is a dramatic example of improving contrast. My shot of this expanse of the eastern Serengeti Plains in Tanzania (*top*) was taken at midday, under flat lighting, on a day when there was some haziness, perhaps due to fine dust in the air. I like the clouds, but the overall picture is flat.

To improve it, I created an Adjustment Layer, Curves (go to Layer>New Adjustment Layer> Curves). Then, clicking a couple of adjustment points on the curve, I adjusted the upper part upward (lightening) and the lower part downward (darkening) and, in the process, steepened the middle slope to increase the contrast (*middle*). You can see the improvement in contrast in the final image (*bottom*).

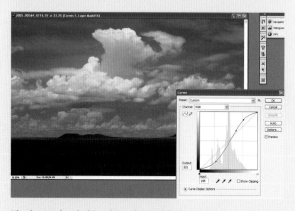

The image loaded in Photoshop with the contrast
adjusted using the Curves graph.

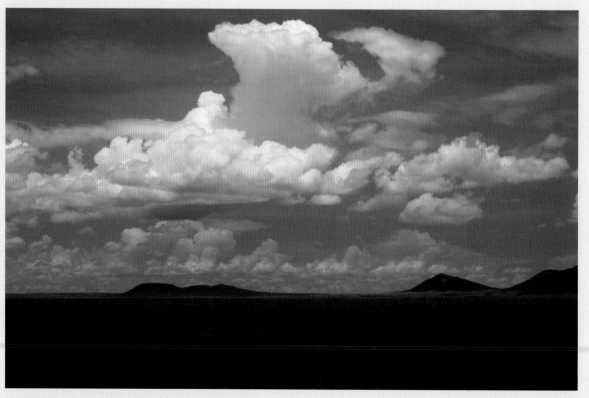

The final adjusted image with a strong boost in contrast.

STRAIGHTENING HORIZONS

Nothing is more aggravating than reviewing your pictures and discovering that, in your haste to get the shot, you didn't keep the horizon perfectly level. For me, this happens most often when I'm shooting at an awkward angle, for example low to the ground. It's especially difficult to observe that distant horizon line in the viewfinder with an ultrawide-angle lens. Fortunately, tilted horizons are easily corrected in Photoshop.

Here's a shot I made at Lake Baikal in Siberia (*top*). I was working quickly—too quickly, as it turns out—to get this shot of a lonely figure walking on the beach. I had the horizon line of the lake tilted a bit. Here's how to fix it:

On the Tools palette, click on the Eyedropper Tool and hold the left mouse button down. This brings a pullout menu (*middle*). Select the Ruler Tool. Next, place the crosshair of your mouse on the left edge of the lake horizon line and click and drag to place a line following the line of the lake's edge. Release the left mouse button and the line remains. Next, go to Image>Rotate Canvas>Arbitrary (*below*). This brings up a small dialogue box, Rotate Canvas, which has the angle already inserted. This is the angle of the line you drew with the Ruler Tool. Click OK and *voilà*—the horizon line is corrected by rotating the canvas to the proper angle. The only step left to do is to crop the image for the final product (*bottom*).

After selecting the horizon line with the Ruler Tool, use the Rotate Canvas function to determine exactly how much to rotate the picture.

The original tilted photograph of a beach scene.

Select the Ruler Tool in Photoshop.

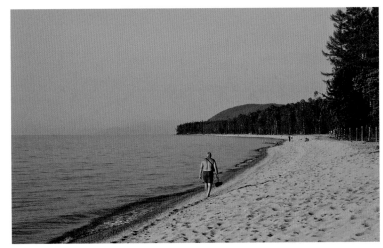

The final image has a perfectly straight horizon line.

reason I was attracted to the Hasselblad camera in particular was its interchangeable film backs. This was pretty exciting. Not only could I shoot color, but, in an instant, by changing the film back, I could shoot black-and-white of the same subject. Eventually, I moved away from black-and-white photography because it entailed too much time-consuming darkroom work. But now, with digital cameras and using some great new features in Photoshop, black-and-white photography is as exciting as ever—and without the smelly chemicals or long darkroom hours.

Let's go back to my hazy shot of the Serengeti Plains (*page 170*). Using the contrast-corrected version, I created an Adjustment Layer by going to Layer>New Adjustment Layer>Black and White. On the New Layer dialogue box, click OK. Now you have a black-and-white image with an adjustment dialogue box (*left*). However, the tones are flat.

If you have ever shot black-and-white film, you know that certain color filters create different tonal effects on the negative. For example, a red filter makes blue skies a darker tonal

Above: A photograph of the Serengeti Plains, corrected for contrast (*page 170*) and made black-and-white. Notice the flat tones.

Right: The final photo has been adjusted to improve the tonal effects.

BLACK-AND-WHITE CONVERSION

Back in the olden days of shooting film, and early on in my career, I used Hasselblad medium-format cameras for most of my work. Part of the reason was the larger image size, which gave a better quality on the printed pages of books and magazines. But part of the

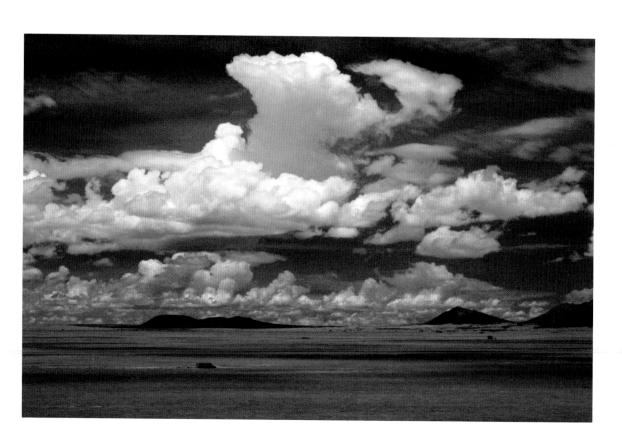

value. Blue filters lighten blues and darken reds. Yellow filters lighten yellows and greens, etc. But, you can never use more than one filter at a time.

Now, in Photoshop, you can! And the results are terrific. As you can see, by adjusting several of those color sliders for tonal effect, I created a dramatic black-and-white rendition of my Serengeti scene (*opposite bottom*).

Here is an example of another Serengeti scene: first the color version (*right*), then the black-and-white (*below*). So your color images can very effectively be converted to black-and-white and with all the benefits—and then some—of fine-tuning with color filters for best tonal ranges.

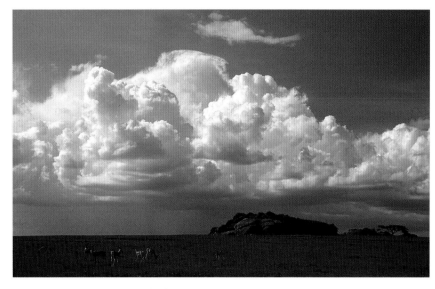

Above: The original photograph of another Serengeti scene.

Below: The final photo has been made black-and-white and adjusted for tonal effect.

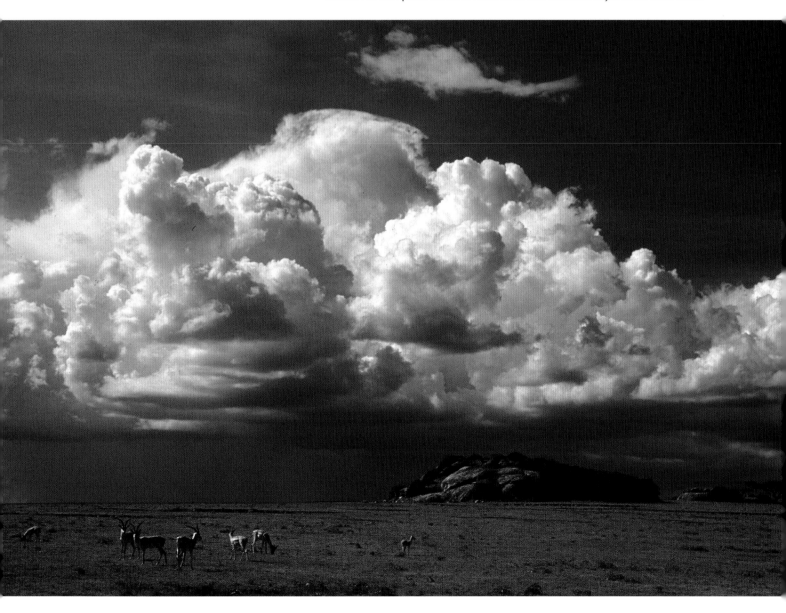

The original photograph of columbines and mountains in Colorado with a great depth of field.

ADJUSTING THE DEPTH OF FIELD

In chapter 5, I discussed controlling the depth of field for creative purposes while shooting. Here is an example of making changes *after* you've shot the picture, using some of the great controls in Photoshop.

In my shot here, taken near the Maroon Bells Wilderness Area in Colorado, I found this lovely patch of columbines growing at high elevation and overlooking distant peaks (*left*). I used an ultrawide-angle lens to achieve a

Use the Magic Wand to select the background area.

Use the Lens Blur tool to blur the background layer.

Adjust the settings until the background layer is blurred to the degree you want it.

great depth of field, and I moved in closely so that the flowers were prominent in the foreground. The lens used was a Canon 10–22mm zoom (equivalent to a 16–35mm in 35mm format) set at 10mm, the widest angle. Stopping down to f/16 gave me the great depth of field. If I had wanted to blur the mountains in the background to direct the viewer's attention exclusively to the foreground, I might have switched to a longer focal length and backed off. But I didn't at the time. Later, I wanted to see how the image would look with a shallow depth of field. So I used a technique in Photoshop to accomplish this.

First, I created a duplicate layer. Next, using the Magic Wand Tool, I selected the background area of mountain, sky, and forest. Be sure to choose the Add to Selection button and keep clicking in the background area to add to the selection. It takes a few minutes to get all of the background selected (*above*).

Next, I created a layer mask, then went to Filter>Blur>Lens Blur (*left top*). On the Lens Blur screen, I checked Invert (the mask as created had blurred the foreground and kept the background sharp), then increased Blur Focal Distance to 195 and increased Radius to 71 (*left bottom*). You can experiment by moving the sliders until you get the effect you want.

Finally, I saved it as a PSD file so that I had the option to come back later and fine-tune the blur control. In the final image (*opposite*), I like the effect of keeping the background blurred enough so that it doesn't distract from the delicacy and colors of the flowers.

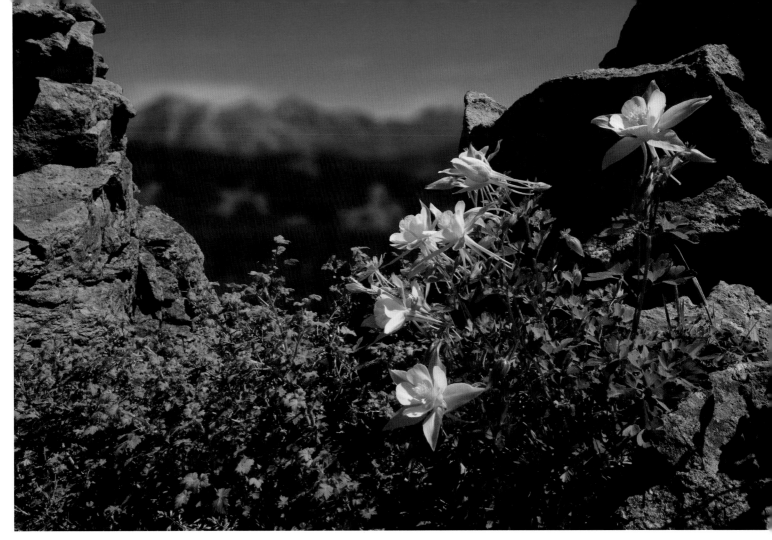

The final image has been adjusted for depth of field, creating a stronger focus on the foreground flowers.

A TOTAL BLUR

As usual in Photoshop, there is more than one way to adjust the depth of field. Another (more tedious) way is to create a duplicate layer, go to Filter>Blur>Lens Blur, and create a total blur over the whole image. Next, create a layer mask, and then with Foreground color selected as black, choose the Brush Tool and "paint" sharpness back on the image foreground. This image shows it partially completed. You

can then change the brush size and work on the edges of the rocks to carefully sharpen those and keep the background mountains and forest out of focus. You'll get some halo effect on those sharp edges (because they were blurred) and later have to touch up with the Clone Tool. This method takes longer and is not as precise as the other method, but it's worth trying out. As I've said, you need to use whatever works for you.

Create Metadata Template

Template Name: My metadata

Choose the metadata to include in this template:

Copyright Info URL	© Boyd Norton
IPTC Core	
✔ Creator	Boyd Norton
Creator: Job Title	
✔ Creator: Address	PO Box 2605
✔ Creator: City	Evergreen
✔ Creator: State/Province	CO
✔ Creator: Postal Code	80437
✔ Creator: Country	usa
✔ Creator: Phone(s)	
Creator: Email(s)	
✔ Creator: Website(s)	www.wildernessphotography.com
Headline	
Description	
Keywords	
IPTC Subject Code	
Description Writer	
Date Created	
Intellectual Genre	
IPTC Scene	
Location	
City	
State/Province	
Country	
ISO Country Code	
Title	
Job Identifier	
Instructions	
Provider	
Source	
✔ Copyright Notice	© Boyd Norton
Rights Usage Terms	
Audio	
Artist	
Album	

ⓘ Only checked properties will be added/changed to this template.

Properties selected: 11

Clear All Values Cancel Save

Metadata ensures that your copyright is on record. Using a metadata template allows you to tag your photos in batches instead of one by one.

The original photograph of St. Basil's Cathedral, photographed under a blah sky.

METADATA

Even if you're new to digital photography, you've probably heard the term *metadata*. What does it mean?

The prefix *meta* comes from the Greek and means "along with." In the photography world, metadata refers to picture information that is stored in the image file itself—in other words, *along with* the image. The most important aspect of metadata is that it allows you to tag your image files with such data as your name, copyright information, caption, and picture location.

All of this is of great value if you post your pictures on the web or submit them for publication. Pictures are usually submitted digitally these days, via email or other electronic transmission. In either case, you should be concerned about copyright protection. Including this information in your pictures' metadata is a way of ensuring that your copyright is on record. (Incidentally, if you enter such information in the metadata of the image, it does not show up visibly *on* the image, so many photographers also add a copyright symbol and their name in the corner of each image if it's posted on a website.)

Adding metadata should be routine when working on your digital images. It does not contribute much to the workflow if you do it right—meaning that you create a template to add metadata in batches.

First, in Adobe Bridge, go to Tools>Create Metadata Template (*top left*). Fill in whatever is appropriate, keeping in mind that this is generic information that goes in every picture file and should not have specific caption information. Give it a name and then click Save. Later, when working in Bridge, you can select batches of images, go to Tools>Append Metadata, and select from the dropdown menu the template with your information. Photoshop will then put that information in each file that has been selected.

FIXING THOSE BLAH SKIES

It has happened to all of us. You get to a special, faraway place and find that the lighting conditions are terrible. The situation is especially bad when you have limited time at that place. I remember certain magazine assignments I've had over the years when an editor sent me to some exotic location and I had only a day or two to get the job done—and the weather was lousy! Even the most understanding editors would grumble when I came back with pictures of those nice scenes featuring dull gray or washed-out skies.

Now those blah images can be fixed in Photoshop.

Here's an example from one of my last trips to Moscow, when I was photographing in Red Square. The famous St. Basil's Cathedral is on the right, the Spaskaya Tower of the Kremlin on the left (*opposite bottom*). But look at the blah sky. If I had been on assignment, my editor would have tossed this image. Time for a little Photoshop magic.

First, I selected the Magic Wand tool and set the Tolerance to 20. Tolerance determines the difference or similarity of the pixels selected; a low number means selecting pixels very similar, a high number means selecting those that may be different. Then I clicked on the Add to Selection button (*top*). Clicking in the sky area, I started selecting this part of the picture, moving the tool to different places and holding down the Shift key to get all areas of the sky selected. You can see here the "marching ants" indicating the area selected (*middle*). Next, I found in my Russia files a shot of sky and clouds I had photographed in Siberia several days later (*bottom*). Loading that image, I discovered that the light on the clouds was from a different direction than the lighting in the Red Square shot, so I flipped the image horizontally. Then I went to Select>All, and this selected the whole image. With all of it selected, I hit Ctrl-C (Cmd-C on a Mac) to copy this image. Back on the Red Square shot with the sky still

In Photoshop, select the Magic Wand tool.

Use the Magic Wand to select the sky.

Choose a digital photo with a different sky. This sky will be placed over the sky in the cathedral shot.

Paste the new sky into the original photo.

Activate the Layer Mask.

Use Gaussian Blur to soften the edges of the building so that they blend into the sky more realistically.

selected, I went to Edit>Paste Into. (If you just do a Paste command, it will place that sky image on top of the whole Red Square photo.) Here you can see the box with the pasted selection (*top*); you can move this around until you get just the right positioning. When it's positioned to your satisfaction, hit Enter to complete the placement.

Now we need to make the edges of those buildings blend into the scene so that it's not apparent that the sky is pasted in. This action softens those edges to make it more realistic. Click on the Layer Mask on the Layers palette to make it active (*middle*). Go to Filter>Blur>Gaussian Blur and select 1 Pixel; this ensures minimal blurring and softens the hard edges of the buildings only slightly. Then go to Filter>Other>Maximum and select 2 Pixels (*bottom*). This action gets rid of any halos around the edges of those buildings and trees, making everything blend together and look natural.

The remaining touchups I did included sharpening (Filter>Sharpen>Smart Sharpen) in order to add a little more "snap." I selected a 0.9 pixel radius and 100% for the amount (*opposite top*). Incidentally, in previous versions of Photoshop, I would have used Unsharp Mask, but in the latest versions Smart Sharpen does an excellent job and, in most cases, works as well as an Unsharp Mask.

The only other alterations that might be done in this image would be to fine-tune the sky background. If the sky seems too bright for the existing conditions, go the Layers palette, click on the thumbnail of Layer 1 (not the mask on the right), then go up to Opacity and click on the right-pointing arrow. This drops down a slider bar where you can reduce the opacity as much as you want. The more the opacity is reduced, the paler the sky becomes. Adjust it to what might seem more natural for the lighting conditions. I think the final image seems more natural (*opposite bottom*).

Use Smart Sharpen to add more "snap."

The final Photoshopped image has a new sky that looks natural.

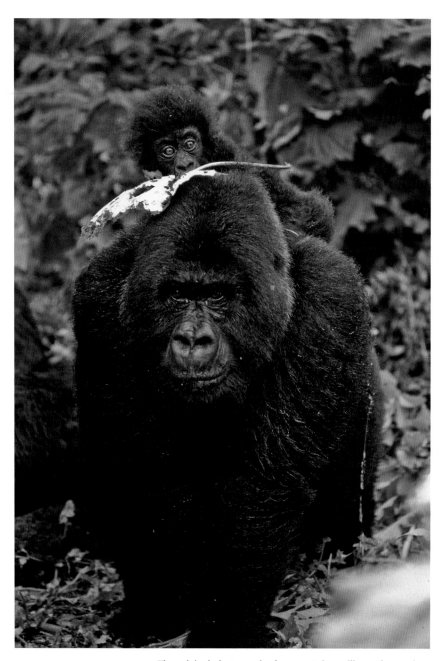

The original photograph of a mountain gorilla mother and her baby. Notice the brightness of the leaf in front of the baby and the out-of-focus foliage in the lower right.

PROBLEM IMAGES

While Camera Raw has the ability to make incredible adjustments to such things as blown-out highlights and deep shadow areas, there is only so much it can handle. Moreover, while RAW images allow for a lot of adjustments, scanned images from slides are less forgiving and tougher to deal with. Here's an example:

I made this shot of a female mountain gorilla with a youngster riding on her back (*left*) many years ago when I started working on my book *The Mountain Gorilla*. This shot was taken in what is now called the Democratic Republic of the Congo (back then it was Zaire). Although the picture has been published many times, editors have expressed dismay at the two obvious problems with the image: the brightness of the leaf in front of the youngster and the really hot, out-of-focus leaves in the lower right. Those leaves on the right can't very well be cropped out without ruining the image overall. And that leaf in front of the youngster—well, it is distracting because it is so light. What to do?

There are tools in Photoshop that can help:

■ **Clone out the hot, out-of-focus leaves.**
My solution was to use the Clone Tool to replace those leaves on the lower right with some of the smaller and darker foliage from the middle right edge of the picture. Use care with the Clone Tool. In this case, I chose an Opacity of 25% and a Brush Hardness of 12%. The brush hardness with a low value means the edges of the cloned part are very soft and thus blend in better. Also, that low opacity value meant that when I first clicked on a place for the clone, it came out very faint. I simply kept clicking until it built up sufficient density. In addition to the foliage near the right edge, I cloned some of the grasses and plants near the feet of the gorilla. You may need to experiment a great deal with this technique until you get the right blending.

Reduce the brightness of the leaf. For that leaf on the gorilla's head, I used the same selective darkening technique as in the Red Square photo (*pages 176–180*). Remember, click on Create New Layer while holding down the Alt key, select Soft Light from Blending Mode, and check the box Fill with Soft-Light-neutral color (50% gray). What I found was that there was just enough detail in the leaf to darken it a bit, but there was not quite enough to make it as dark as I wanted. Remember, this technique "paints" a denser neutral gray on the image layer, and when it reaches 100%, you won't get any more sharpening. So I just created another layer, as I did with the Red Square photo, and continued darkening it until I had the leaf where I felt it looked okay. (I didn't want it completely darkened, just to the point where its brightness wasn't so distracting.) The final result was reasonably good (*right*). As I've said before, there are often many other ways to improve images like this. One would involve copying and pasting and blending some foliage from another image. However, the method I chose took only a few minutes of work, and, as you know, I'm always looking for the lazy way!

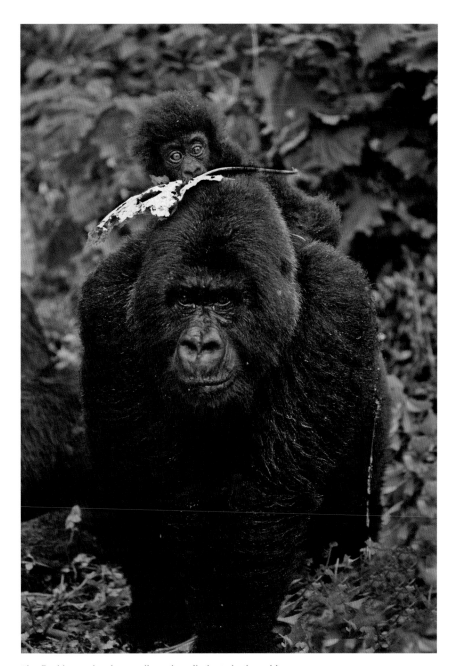

The final image has been adjusted to eliminate both problems.

SPOTTING AND CLEANUP OF IMAGES

Most digital images are relatively clean. Occasionally, the image sensor gets dust spots on it, although some of the newer cameras have self-cleaning sensors (don't ask me how, but they do seem to work fairly well). The biggest problem comes from scanned images. No matter how much compressed air you use or how much careful brushing you do, spots always show up on the scanned image.

Photoshop has great means for cleaning up images, though it can get very time consuming. Simply select the Spot Healing Brush Tool from the Tools palette. Be careful not to make the tool too large, especially when working near major edges—e.g., where sky meets hills or foliage. Otherwise, trying to remove a spot near that edge will result in a blemish. (Use Ctrl-Z or Cmd-Z to undo and make the brush smaller.)

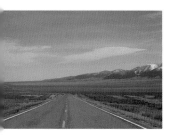

The original photograph of the Lemhi Valley under flat lighting.

NIK SOFTWARE PLUG-INS

As comprehensive as Photoshop is, there are some additional third-party plug-ins that expand the program's usefulness. I include them here because they have excellent features that are very helpful from time to time. The Nik Software selection of plug-ins is particularly useful. Its Professional Suite contains a number of tools: Color Efex Pro (which contains many useful filter effects and enhancements), Nik Foliage Filter (which enhances or changes the color of foliage), Nik Sharpener (which does a superb job of sharpening images prior

to making large prints), and Dfine (which is used to eliminate noise generated by high ISO settings or long exposures).

In Color Efex, I often use the Polarization filter, and, yes, it does work in very much the same way as a polarizer on a lens. Here's an example. This shot (*left*) was made on a long, lonely stretch of road in the Lemhi Valley of eastern Idaho. It was near midday, and the lighting was flat. I should have used a polarizer over the lens to eliminate some of that slight distant haze and to darken the blue sky. But I didn't. So I adjusted the image later using the Nik Polarization plug-in in Photoshop (*left*). I increased the strength above the default value to 190% because the picture was so flat. Notice, also, that it automatically creates a new layer with a layer mask. After clicking OK, I then had a choice of "painting" in the effect using the Brush tool or simply clicking on Fill in the Nik dialogue box. I clicked on Fill, and look what happened (*below*). The blues are richer, and the contrast is improved. Now, I could have achieved the same effect by working in Photoshop alone using various methods, but it would have taken much longer to accomplish what I was able to do in just a few clicks of the mouse.

Above: Use the Nik Polarization plug-in to polarize the light and increase the contrast.

Right: The final photo has been adjusted for richer colors and improved contrast.

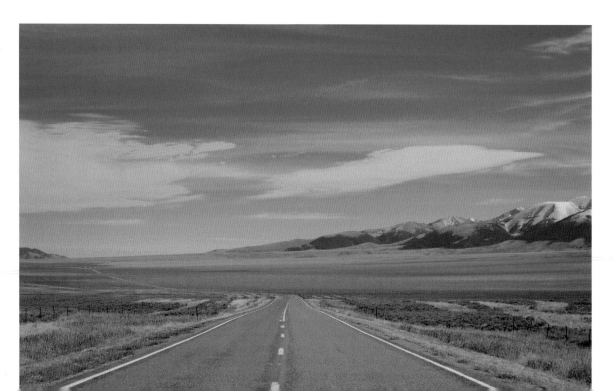

Here's another useful plug-in, the Nik Foliage Filter. Again, it's possible to do something similar on your own in Photoshop, but this plug-in is a great timesaver for selectively increasing saturation in parts of a picture. This shot is a scanned image made in Ontario's Lake Superior Provincial Park on a dull, slightly foggy morning (*left*). I liked the ambience but wondered how the picture would look with the lower yellow tree enhanced a bit (*right*). Now, in this case, I did not choose the Fill option in the Nik dialogue but rather "painted" the effect on just the lower tree using the Brush tool, and you can see the difference.

A final interesting application that is useful from time to time on dull, flat scenes is the Nik Sunshine filter in Color Efex, here applied to the Lake Superior Provincial Park scene (*bottom*).

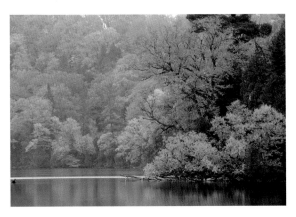

The original dull photo of an autumn scene on a foggy morning.

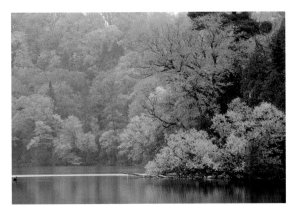

Here, the yellow tree in the foreground has been enhanced using the Nik Foliage Filter.

Below: Here, the whole scene has been boosted using the Nik Sunshine filter.

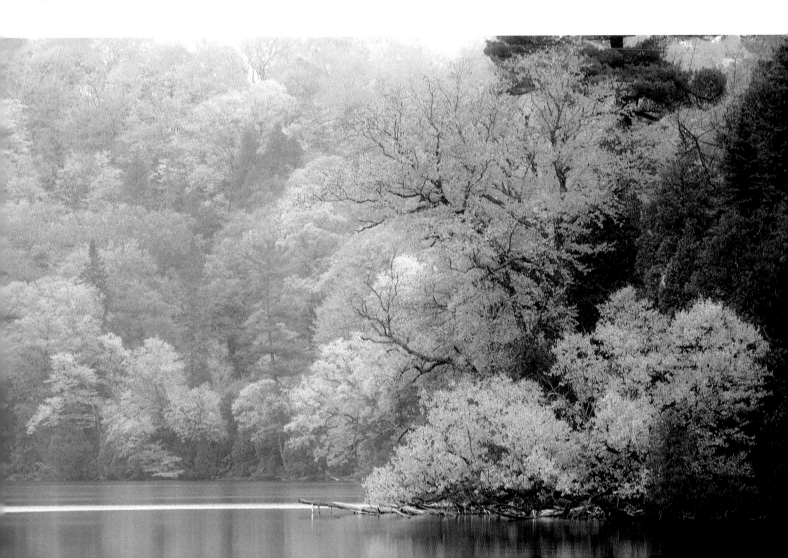

CHAPTER 11
DEALING WITH MIXED MEDIA

Perhaps this chapter should be sub-titled "What Do I Do with All Those Film Slides I Shot Over Many Years?" If you were born before 1980, chances are good that your first photography was done using film. Now you've made the transition to digital from conventional film photography—maybe somewhat reluctantly. How do you deal with all of your pictures: digital, film slides, and film negatives? You cannot effectively convert your digital images to slides (nor would you want to), but you *can* easily convert your slides to digital by scanning and then make beautiful prints from those images (more about printing in the next chapter).

First of all, I hope you set up a really good filing system for your slides or negatives. If you did, your older pictures are not only secure but accessible. You can keep them that way, but you really should consider scanning at least the best of them so that you have them in digital files.

Scanning is a pretty straightforward pro-cess. It involves a moving light source and a CCD sensor that captures the light in much the same way as a digital camera sensor. An in-ternal processor in the scanner then converts the analog image electrical impulses from the CCD to digital data.

WHAT KIND OF SCANNER SHOULD I USE?

There are many scanners on the market these days, and they range in price from very inex-pensive flatbeds to very costly high-end drum scanners. Flatbed scanners offer the conve-nience of scanning flat work, such as prints, artwork, and documents. With a notable ex-ception that I'll describe below, however, most flatbeds are not suitable for scanning your slides or negatives.

At the other end of the spectrum are drum scanners. These are used by printing houses and professional photo labs to produce high-resolution scans of publishing quality. On these, the slide or negative must be placed on a rotating drum after having been immersed in a liquid (which helps eliminate any surface blemishes like dust or scratches). The sensor on a drum scanner is usually a photomultiplier

A gnarled old oak tree near Littlehampton, England. Shot with a 28–135mm lens.

ADVANTAGES OF CONVERTING FILM TO DIGITAL

- You can take advantage of the great photo-quality inkjet printers available today to make superb enlarged prints.
- You can use the scanned images for display on the web.
- You can create great slideshows using various programs available—and even burn them to make self-running CDs and DVDs with music and narration to share with family and friends.
- You can actually improve and enhance many pictures using some of the great features in Photoshop.
- You can submit photos online for publication in magazines, books, websites, and more.
- You can scroll through digital files displayed on your monitor rather than digging through file folders in filing cabinets and holding multiple slide sheets over a light box. (It's even worse, of course, if you have to dig through many unorganized boxes of slides stashed away in a closet somewhere.)

This shot was taken many years ago on a climb of Wyoming's Grand Teton, using a Hasselblad. The 2¼-inch transparency was scanned on an Epson Perfection V750 Pro flatbed scanner.

tube (PMT) rather than a CCD device. The advantages of a PMT are its lower background noise level and greater sensitivity, giving better detail in shadow areas. A pinpoint laser beam then scans across the image to create a high-quality digital image. Drum scanners are very expensive, sometimes more than ten thousand dollars—enough so to make them impractical for most of us. For very special images, I use professional photo labs and have high-quality drum scans done. When done at highest resolution, the scans can be hundreds of megabytes in size.

In between these extremes are dedicated film scanners that do an excellent job at a reasonable cost. These devices scan individually mounted 35mm slides or strips of film (both unmounted slide film in strips and negative strips). A few models are multi-format, allowing you to scan either 35mm slides or larger 2¼-inch-format (5.7-cm) transparencies. If you have lots of slides to scan, I recommend getting a scanner that does at least four slides at

a time (*opposite*). Some of the Nikon scanners have an expensive attachment that allows you to scan a stack of fifty slides unattended. Others have built-in capability of scanning up to one hundred slides. If you have tens of thousands of slides to convert to digital, the time savings may be worth the extra cost, although there have been reports that large-batch scan attachments sometimes don't feed well.

SCANNER SPECS

Price aside, there are two primary factors in choosing a scanner: resolution, which is given in dpi (dots per inch), and D max, which turns out to be as important as resolution. There are some other considerations as well, including software and bit depth.

RESOLUTION

Resolution measures the amount of fine detail the scanner can capture. However, the specs of scanners are often confusing, particularly those given for flatbed scanners. What you need to look for (sometimes in the fine print) is the *optical* resolution. Too often scanners use *interpolation* to give what appears to be higher resolution. Interpolation is a mathematical process that adds pixels to parts of an image based on a sampling of adjacent pixels. What's added is not true image data—it's made up! While it's true that interpolation can do a good

job at times, for scanning purposes you should still consider only the optical resolution as a measure for getting the best out of your pictures.

Typically, you will want a scanner that will give you at least 2,800 dpi. Several are currently available that will go even higher—to 3,600 dpi, 4,800 dpi, and 5,400 dpi. For most uses, the range of 2,800 to 3,600 dpi is sufficient, particularly since the higher values give huge file sizes that quickly eat up disk space. As an example, my Minolta Dimage 5400 scanner (which is no longer available, unfortunately), when set at 5,400 dpi, creates a digital file in excess of 100MB. Rarely do I need files that large, so I usually set my scanner to 3,200 dpi, which gives a file averaging about 35MB—a much more reasonable size. (There are other reasons to keep your file sizes manageable. Depending on how much memory you have in your computer, working on a huge image file in programs like Photoshop can really slow things down.)

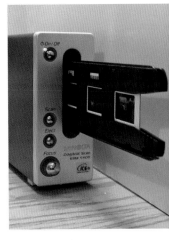

A dedicated film scanner, the Minolta Dimage Scan 5400 automatically scans four slides at a time at up to 5,400 dpi.

COMPARING SCANNERS

Type	Cost	Quality	Use
Flatbed scanner	Inexpensive	Low	Not appropriate for film scanning. Best for scanning documents or prints.
Flatbed scanner (Epson Perfection V750 Pro)	Mid-range	Good	Best option for scanning medium- or large-format transparencies at home.
Film scanner	Mid-range	Good	Best option for scanning 35mm slides and negatives at home.
Drum scanner	Expensive	High	Prohibitively expensive as a home scanner for most photographers. Use the drum scanner at a professional photo lab for special images.

This 35mm slide of a Siberian home (*above*) was scanned at 3,200 ppi on an Epson Perfection V750 Pro flatbed scanner. A blowup of a portion of the scan shows good detail (*right*). The same slide scanned on the Minolta Dimage 5400 dedicated film scanner, at the same 3,200 ppi, shows good detail as well, with slightly better shadow detail (*far right*).

D MAX

The second consideration is D max—a measure of the density of a piece of slide film. What's important here is the dynamic range, or D range, which is the difference between the D max and the D min (minimum, or the clearest area of film). Theoretically, the D max of the densest slide film is about 4.0. Of greatest importance is the ability of the scanner to pull details out of deep shadow areas, and thus the higher the D max number (or D range, if it's given), the more detail you'll get. Typically, you'll see dynamic range numbers of 3.2 or 3.9 or 4.2. That last, 4.2, may be a bit of an exaggeration on the part of the advertisers. I won't go into the technical detail here, but often these values are based on maximum theoretical dynamic range that, in turn, is dependent on the bit depth of the analog-to-digital processor in the scanner. In real life, these figures are deceptive—they assume a perfect, noise-free sensor and a perfect analog-to-digital converter, neither of which has been made yet. The main thing is to use the D max number as a rough guideline.

SOFTWARE

Look for a scanner that comes with software called Digital Image Correction and Enhancement (ICE). If you scan a lot of slides, this program will save you a huge amount of time later on by eliminating, or at least diminishing, dust and dirt on the slide. No matter how careful you are in cleaning those transparencies, you always seem to end up with dust spots. The only drawback to using Digital ICE is that it slows down the scanning time. But that is more than made up for when you consider how long it may take to eliminate those dust spots yourself in Photoshop.

BIT DEPTH

This is often given in the specs for scanners. Is it important? To some degree it is, but here, again, it's a numbers game. It would seem that 16-bit conversion per channel (there are three channels, remember: RGB—red, green, blue) for a total of 48-bit depth is desirable. Maybe, but in real life you will be hard pressed to see any difference in a slide scanned at a bit depth of 8 or 12 versus 14 or 16 bits per channel. Try it and satisfy yourself.

AN EXCEPTIONAL FLATBED SCANNER

Flatbed scanners, which do a decent job of scanning photographic prints, generally cannot produce the quality you need from slides or negatives. The exception is the Epson Perfection V750 Pro, a flatbed scanner that does an excellent job of scanning not only 35mm slides but medium- and large-format transparencies as well. The medium-format option is important to me because, in my early years of shooting, I used the medium-format Hasselblad camera and have many thousands of 2¼-inch transparencies in my files. There are only a few film scanners available that can handle medium-format, and these are often more expensive than the V750. The Epson also allows you to do fluid bed scanning, in which the transparency is immersed in a fluid, placed on a special holder, and scanned. The advantage is that it virtually eliminates all surface flaws, scratches, dirt, and dust. The disadvantage is that it is time consuming and messy. Most often, fluid scanning is more advantageous for medium- and large-format transparencies because of the larger surface area. For 35mm, I clean the slides carefully and use the Digital ICE option on a film scanner.

USING A SCANNER

Most, if not all, scanners give you a choice of image formats for saving your scanned pictures—JPEG, TIFF, or others. *Don't* save your scans as JPEGs. If you've invested good money in a quality scanner, it does not make sense to save the output to a less-than-ideal file format. As I mentioned earlier, the JPEG format compresses image file data by throwing out some information. Save your scans as TIFF files—a lossless format, meaning that each time the image is altered and saved, no data is lost. You can always make a JPEG copy from a TIFF file if you need a small version for web use or emailing. Yes, TIFF files do take up much more disk space, but believe me, it's worth it.

I usually set up a temporary file in which I save recently scanned images. This allows me to work on these images—cropping, dust removal, color corrections, etc. It is also possible

to open these TIFF images in Camera Raw, giving you great possibilities for fine-tuning and adjusting. Finally, when the scanned images are adjusted to my satisfaction, I rename them and move them into their permanent file folders organized by geographic area. Thus, my older film photos become integrated with my newer digital images and are more accessible for printing, submission for publication, and use on websites.

Once your older pictures have been scanned, I do not recommend discarding them. In my case, I would find it painful to throw out slides even though they have been integrated into my digital files. Furthermore, I may go back later and rescan certain images using different features on my scanner and software that may improve them even more. So the physical files serve as backup to my scanned images.

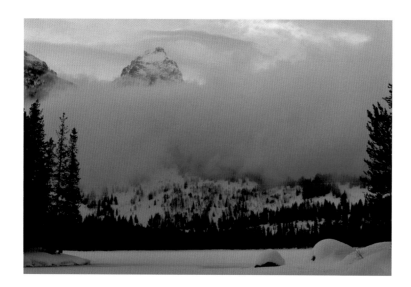

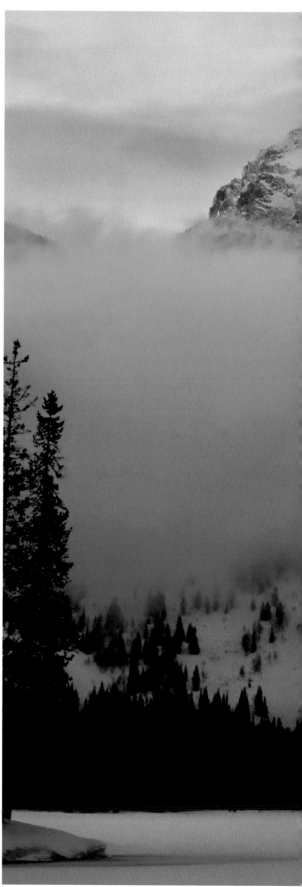

Above: Scanned on my Epson Perfection V750 Pro flatbed scanner, this cold winter scene in Grand Teton National Park was shot with a medium-format Hasselblad more than forty years ago.

Right: The same shot, enhanced in Photoshop to bring out faded and lost color.

ANOTHER OPTION

What about using your digital camera to copy slides? It is possible, using a good-quality macro lens, to shoot frame-filling pictures from a slide, much in the way we used to make duplicate slides on slide film. You could also use a slide-duplicating device, if you have one. While it is possible to do this, you'll find the quality just isn't there—trust me on this. This is especially true if you intend to make larger prints. You will be much better off investing in a slide scanner.

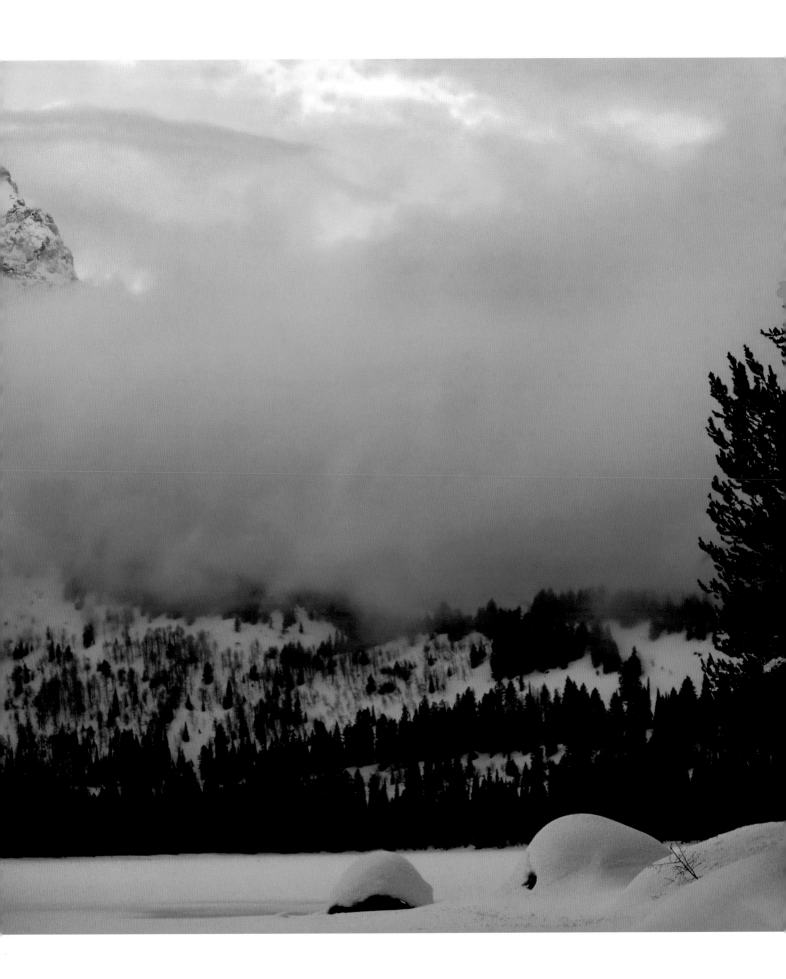

CHAPTER 12
THE FINAL IMAGE

mages, images, images. Eventually, we end up with thousands—maybe tens of thousands—of pictures stored on our hard drives. In the old days, we could put together slideshows to bore our friends. (Anyone remember the carousel projector?) Or sometimes we would go to the expense and time to make enlarged prints to hang on the wall. Some of us published our work in books or magazines. Regardless, as artists we all have the desire to share our photographic vision with others.

The digital revolution has made this easier to do.

Many years ago, I did my own color printing—Cibachrome, mostly. It was a time-consuming process. Because I wanted the best possible print, I sometimes would spend a whole day—and lots of paper and chemicals—fine-tuning until I got it just right. That meant tweaking exposure and color filtration in the enlarger, processing a test print, adjusting again, making another test print, processing that. Just for *one* picture. I spent hours in the darkroom with smelly chemicals. And my septic system may never be the same.

There has been an incredible revolution in color (and black-and-white) printing brought about by high-quality inkjet printers. It happened rapidly—and it's still going on. In addition to great printers, we can also use the internet to share our work with others—on websites or by email. And easy-to-use software makes it possible to burn CDs and DVDs with self-running picture shows that can be sent to family and friends. All of this technology has expanded greatly the potential for displaying our creative photography.

A doorway and flowers near Otavallo village, Ecuador. Shot with a 28–135mm lens.

COLOR SPACE

Let's begin with color space. To keep it simple, color space is a certain boundary of recording or display within a larger area of the visible spectrum of color. Our eyes are capable of seeing a broad range of the visible light spectrum, but our digital cameras, monitors, and printers do not necessarily record or display all of that range.

The simplest way I can explain it is to think of a baseball park. All that lies inside the boundaries of the outfield fences and the foul lines represents the spectrum of visible colors. However, cameras and printers do not record all within the fair territory in the ballpark. Instead, some color spaces represent only the area of, say, the infield. So anything that is outside the infield or that color space does not get recorded. That's not necessarily bad; it just means that there are limitations to what can be captured and displayed as compared to what the human eye sees.

The most common color spaces you'll encounter are sRGB, Adobe RGB, Color Match RGB, Apple RGB, and ProPhoto RGB. There is a smaller gamut of colors represented in sRGB, which is the color space used in monitors, web browsers, and certain software in Windows. You could liken sRGB to the space defined by just the infield. Adobe RGB is most commonly used for image editing and printing purposes; it has a wider gamut of colors than sRGB. It is more like a greatly expanded infield. That's why I suggested in chapter 1 that you set your camera to record images in Adobe RGB color space. This will allow you to capture a wider gamut of color than sRGB.

PRINTING

Most of us have printers hooked to our computers, and most often, these are inkjet printers capable of turning out very nice reproductions of our images. My first piece of advice for making prints is this: Run some tests with your printer (using default settings) to see whether or not the colors match what you see on your monitor *or* are satisfying to you. If the prints are good and match reasonably well what you see on your monitor, DON'T MESS WITH IT. And skip ahead to "Determining Maximum Print Size."

CALIBRATING THE MONITOR AND ICC PROFILES

If you are having problems with color matching, then you need to devote some time to calibrating your monitor and trying to match prints to what you see on the screen. This process is called color management, and volumes have been written about it. What it comes down to is this: When shooting slide film, we had a reference point for the color in our images. We could view the slides on a lightbox and—assuming that the film was properly processed and the light source was correct (5000 kelvin)—we had a good representation of color. Even taking into account the fact that some films, such as Fuji Velvia and Ektachrome 100VS, exaggerated colors, we still had a point of reference, and even those vivid colors could satisfy us. Red was red, green was green, and blue was blue. When I made a print or had one made by my lab, I had something to compare the colors and tonal range to—the original slide.

With digital, it's a whole different ballgame. The image first exists only as digital data, 0s

Calibrating a monitor using HueyPro.

and 1s, in some form of storage media. It is not really an image. It is just data. *It does not become a picture until we display it on a computer monitor.* And there are so many variations in how monitors display colors. How red is the red of that flower you photographed? Is it pinkish red, yellowish red, pastel red, or intense red? You can use the default or the factory setting for your monitor, but those might not create accurate color display. Also, the RAW file may look different from a JPEG created in your camera, and if you process the RAW file in Camera RAW or other programs, it will end up looking different too. When you spend time adjusting and manipulating the image in Photoshop on your monitor, how do you know that the final image will display accurately on someone else's monitor or, more importantly, when printed?

This is an important consideration because you may spend a lot of time (and ink and paper) trying to fine-tune a print. If you do this each time you want a good print, it gets costly. (If you haven't figured it out by now, printer manufacturers sell their printers quite cheaply—even the ones that make very large prints—because the ink and the paper sales are very profitable.)

Not to add to your confusion, I must point out that there are variations in printers as well. Different types of ink and different types of paper will give big variations in the final print.

In order to deal with all these variables, standards have been established dependent on what are known as ICC profiles. ICC stands for International Color Consortium, which promotes the standards for color management of different devices, including monitors, printers, cameras, and scanners. Probably of most importance to you is the setting of ICC profiles for your monitor and printer.

As a first step, you should consider calibrating your monitor and giving it an ICC profile. At times, our eyes can be very poor judges of color rendition. If you spend hours in front of your monitor, even a moderate color cast may not be apparent after a while. Also, ambient light in the room affects color perception. So it may not be surprising that when you send your image to a good-quality color printer, the resulting print may not match what you saw on the monitor. If it's a simple matter of lightness or darkness—that is, if the final print looks okay with regard to colors but it's either too light or too dark, you may be able to live with the current calibration of your monitor. You can simply increase the brightness of your images a slight amount to compensate when you print. (You don't have to save them with that brightness level unless you plan to make additional prints later; if you do save it, do a Save As and name it appropriately as a print-adjusted image.)

There are different methods for calibrating monitors. One involves visually tuning your monitor using Adobe Gamma, a software program that installs when you install Photoshop. You will find much discussion about Adobe Gamma online—some favorable, some not. The problem is, the program relies on visual adjustments, and it's difficult to trust our eyes to calibrate a monitor accurately. Since this is the cheapest option, my advice is to give it a try. If it works for you, don't mess with it further. Bear in mind that results may vary, depending on whether you use a CRT (cathode ray tube) monitor or an LCD (liquid crystal diode) monitor. Each type has different characteristics. Regardless of type, you should turn on the monitor well in advance of using Abode Gamma and let it warm up for at least half an hour.

Another visual calibration system is called EZcolor, supplied with my Epson Stylus Pro 3800 printer. This is the software only; an optical sensor is sold separately that gives more accurate adjustments. In addition to profiling your monitor, EZcolor can also do a profile for your printer and scanner.

The most accurate monitor calibration systems use hardware, optical sensors that

attach to your monitor's face and, in conjunction with supplied software, make the necessary adjustments before creating an ICC profile. These devices range from relatively inexpensive (under $100) to very expensive ($1,000 or more). One that I have found to work quite well is the HueyPro (slightly over $100).

Most of these monitor calibration systems recommend that you remove Adobe Gamma from your Startup menu because of possible conflict with your generated profile. To do this, go to Start>Startup and right-click on Adobe Gamma to delete it. On a Mac you don't need to do anything; a new profile will be stored and used properly.

CREATING AN ICC PROFILE FOR THE PRINTER

Once you have calibrated your monitor and generated an ICC profile for it, what next? It is often suggested that you create an ICC profile for your printer. However, it's not that simple. The printer is not the only thing involved here; the type of paper being used matters too. You have a couple of choices if you want to do a profile of your printer and papers:

- Use a hardware device designed to do such profiles.
- Send off test prints to services that will create a custom profile for you.

Regarding the first, printer/paper profiling devices tend to be much more expensive than similar devices for monitors. And for the second item, it could cost you hundreds of dollars to have a service profile a number of different papers. If you use a lot of different papers—e.g., fine art, canvas, glossy, luster, matte—this could entail a lot of work and expense because you do need a different profile for each. In addition, if you plan to use papers that are from manufacturers different from the printer's, these will require different profiles—which means more work and expense.

Remember, this book has the word *outdoor* in the title. If you are like me, you probably want to spend more time outdoors shooting and less time indoors calibrating printers and creating profiles. So, here's my no-nonsense recommendation: *Use your printer manufacturer's ICC profiles for the particular papers you use.* These generic profiles are generally quite good, especially for the newer-model professional printers. Check the website for the manufacturer of your printer to find ICC profiles or to check any updated versions. You may have to contact tech support for help in getting these profiles, but it will be worth your time. On my Epson Stylus Pro 3800, I have found these generic profiles to be excellent. (These profiles were installed automatically when I installed the software for the printer.) For third-party paper suppliers, check their websites for ICC profiles.

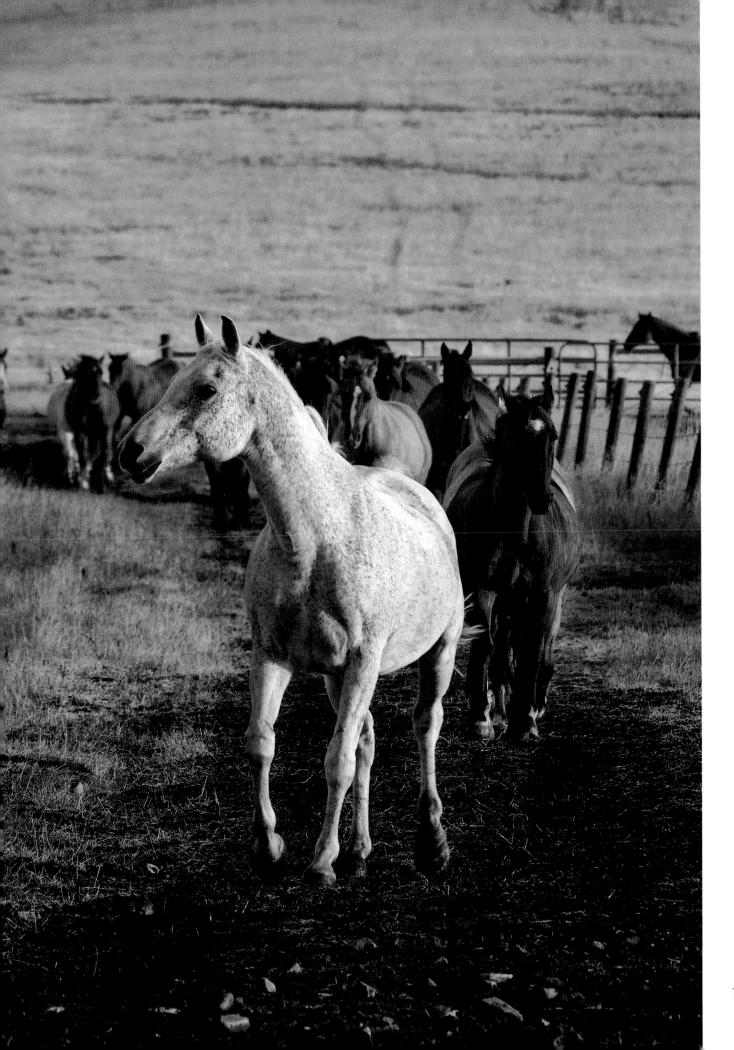

Right: A shot chosen to print at 17×22 inches (43×56 cm) on the Epson 3800.

Opposite left: The Properties screen allows you to select your paper type: glossy photo paper.

Opposite right: In the Advanced printer dialogue box, turn Printer Color Management to Off.

PRINTING STEP-BY-STEP

Here are some steps I follow when printing from Photoshop, using as an example a shot (*right*) from my workshop at Paws Up Ranch in Montana. Go to File>Print. This brings up the Print screen (*page 196*).

1. First of all, under Color Management, select Photoshop Manages Colors in the Color Handling box. (The other options are Printer Manages Color and No Color Management. Letting Photoshop manage the colors is the best option, and most printer manufacturers recommend this.)

2. Next, under Printer Profile (this is actually the printer model and paper type), select Pro38 PGPP. You may have to find out from the printer website what these codes mean. In this case, it means Epson Pro 3800 with the paper type as premium glossy photo paper. This is the ICC profile for that type of paper on that printer.

3. For Rendering Intent, choose Relative Colorimetric. (Experiment with other choices, but this is the best for most purposes.)

4. Leave the Black Point Compensation checked and Match Print Colors checked.

5. Next, click on Page Setup. You must make some selections here—first, under Media Type choose the same paper type, Premium Glossy Photo Paper (*opposite left*).

6. Under Mode, click on Custom. It is important here under Printer Color Management to select Off (No Color Adjustment) (*opposite right*). If you don't do this, you may get strange results because both Photoshop and the printer are trying to manage the color. You can experiment with other settings here, but you may not see much difference.

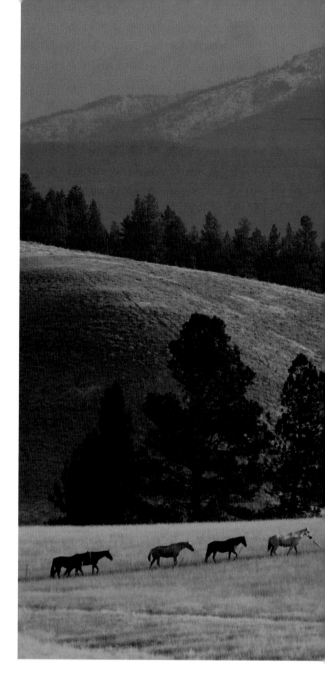

7. After clicking OK, you'll be back to the first Epson screen, and here you select the Paper Tab and choose Portrait (for vertical shots) or Landscape (for horizontal).

8. Then, after clicking OK, you'll be back at the Photoshop Print screen. Simply click Print and follow the rest of the directions.

As I said above, these directions are for my Epson 3800. Other printers will vary, so you'll need to follow directions for them carefully. The main point is that you can have the printer do the color management or, for best results, you can have Photoshop manage the color.

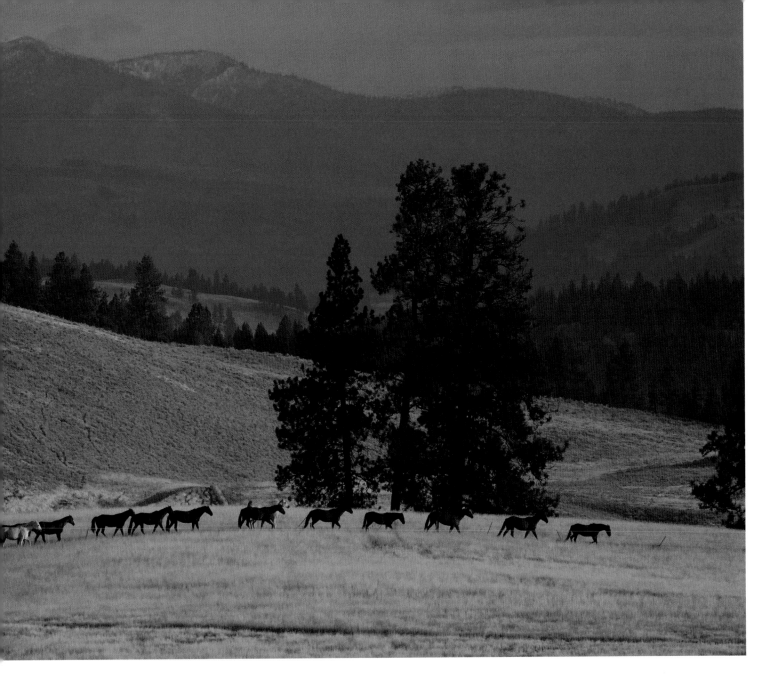

DPI VERSUS PPI

Dots per inch (dpi) are not the same as pixels per inch (ppi). The dpi is the number of dots of ink placed on the paper during printing. The ppi is the number of pixels in the stored image file in the computer. Standard print quality is 300 ppi, although you can get away with lower if the print is very large and viewed from a distance.

DETERMINING MAXIMUM PRINT SIZE

Even some of the least expensive point-and-shoot digital cameras allow you to make reasonably good prints up to 8½×11 inches (22×28 cm) in size. But if you've invested in the latest and greatest DSLR with a 10-, 12-, 15-megapixel or more sensor, how big can you go? The answer to that depends on several factors:

- The number of megapixels in your camera.
- The ppi (pixels per inch) setting for the image being sent to the printer.
- The viewing distance for the print.
- The method used for interpolation.

Let's look at these factors one at a time. First, size does matter—sensor resolution and size, that is. All other things being equal (and sometimes they're not), you can make larger prints from higher-megapixel cameras. You will find a huge number of online sites and forums with tables, charts, and lots of opinions on how megapixels affect print size. Some of the charts indicate that for, say, a 10-megapixel image file, you can only get a good-quality print up to about 9×13 inches (23×33 cm) when printed at a resolution of 300 ppi. A resolution of 300 ppi is considered the standard for print quality. Note that the 300 ppi refers to the image resolution in pixels per inch as displayed in Photoshop (go to Image>Image Size).

To determine your own situation, the math is very simple. In your camera specs, find the pixel resolution for your sensor and divide each dimension by 300. In my case, my Rebel xTi 10-megapixel camera has a pixel resolution of 3,888 by 2,592 pixels; dividing each by 300 gives me about 13×8.6 inches (33×22 cm) for the print size. Does this mean I can't print anything larger? No. In fact, you do not have to use 300 ppi. You can print at 250 or 200 ppi. Doing the math for 200 ppi gives a print dimension of 19×13 inches (23×33 cm). Will the print look good at that resolution? Only you can decide, but in general it will probably look very good. Remember that larger prints will be viewed from a greater distance. It's only when you move in very close and examine it that you may see some loss of sharpness.

INTERPOLATION

Interpolation makes for larger prints. However, there are some other considerations when discussing interpolation, as mentioned above. One of those is the so-called native resolution of your printer. In the case of my Epson 3800, it prints at 360 ppi. This means that if I send

an image at 300 ppi or 200 ppi to the printer, it will upsize it by interpolation to 360 ppi. To add to the confusion, the printer, depending on what settings you select, will either print at 1,440 *or* 2,880 dots per inch (dpi). The main point here is that the printer adjusts the image sent to it from Photoshop by interpolation.

What's interpolation?

This is a bit of mathematical magic, a complex calculation that allows you to increase the size of an image while maintaining reasonable quality. The process examines existing pixels and adds new pixels adjacent to them. (Yup, it makes them up.) The best programs for doing this are Photoshop, Genuine Fractals (GF), and Nik Sharpener Pro, and I recommend that you use one of these to upsize your image rather than having the printer do it. I find GF *slightly* better than Photoshop (*bottom*).

However, you do need to purchase GF separately, and Photoshop is the most commonly used photo software. If you use Photoshop, here are the settings. Note that Resample Image is checked and Bicubic

Smoother is selected (*below*); this giveS the best results for upsizing. Note also that there is a huge increase in file size. In this case it went from 28.8MB to 119.6MB!

Does interpolation result in good-quality enlargements? In my experience, yes. I get excellent prints at 17×22 inches (43×56 cm) on my Epson 3800. Even examining them close up shows outstanding resolution. But I suggest that you experiment and learn how to use your own printer in combination with Photoshop.

SLIDESHOWS

The Image Size screen allows you to change the settings for upsizing in Photoshop. Note that Bicubic Smoother is selected.

Here is a comparison of the image on pages 198–199 upsized using first Photoshop (*left*) and Genuine Fractals (*right*).

The interface of the MySlideShow Gold program showing the media bin (*upper right*) and vertical timeline (*lower right*).

When I used to give film slideshow presentations using my carousel projector, it entailed a lot of work. First, I had to go to the filing cabinets and select the slides to be used. The slides were laid out on a light table (a very large light table, I might add) and then arranged and rearranged into the order I wanted. When satisfied with the order of the presentation, I then loaded them into the carousel tray—often more than one tray—and I was ready for the show. But, if I wanted to make changes in the presentation, I had to remove all the slides from the tray, bring them back to the light table, add or change slides, rearrange the order, then put them back into the tray.

Digital slideshows are so much easier, and because of the ease of use, you can be much more creative in your presentation. For example, you can try out different ways of transitioning from picture to picture, such as fades and dissolves. Also, it's easier to add a musical background. I even include short video clips in some of my presentations. What's really great is how simple it is to modify the presentation. It's usually just a matter of deleting or rearranging the images in a timeline layout by dragging and dropping.

Depending on your intended use, you may want to create a slideshow to be exhibited on a computer screen or a slideshow for an multi-person audience presentation, similar to the carousel projector shows of old.

For computer- or web-based shows, a number of programs are available to help you create slide presentations for in-computer or website usage. Some, like Picasa, are free; some are part of other programs, such as Photoshop or Adobe Lightroom. Perhaps best known is PowerPoint (*opposite*), used most often for business and educational presentations. Most have similar features: a variety of transitions between pictures, a variation of the duration of the pictures on screen, and the capability to add music or voice narration. Some are designed to produce standalone or self-running programs, while others require manual control of the program (i.e., advancing to the next picture by mouse click).

For audience presentations, it gets a bit more complicated. The essentials for this are a laptop computer and, generally, an LCD projector. There are other types of projectors available: LCOS (liquid crystal on silicon) and DLP (digital light processing). The LCOS projectors are superior in sharpness but also very expensive. DLP projectors are not capable of giving rich, saturated colors like an LCD projector. All of these projectors take the information—in this case the images from the slide program in your laptop—and project it as large as you like on a screen.

SLIDESHOW DYNAMICS

Like a photo essay in a magazine, keep your slideshow short and dynamic. When I think of documentary photography, I think of early explorers who set sail on long journeys and returned with exciting stories of fabulous adventures, told and retold in courts and taverns or wherever people would listen in rapt fascination. Documentary photography is storytelling photography, and today we bring home tales of our adventures in memory cards

rather than a ship's diary. But the similarity with ancient yarn-spinners is very real, for, like all good storytellers, we need to think in terms of drama, detail, humor, and pacing. Most of all, there must be continuity. Like all good stories, there should be a beginning, a middle, and an end (and please, don't make the visual ending a cliché sunset).

If this begins to sound like Cinematography 101, you're right. Some of the traditional methods of filmmaking apply here, and our slideshows should embody those principles. For example, film sequences often open with an establishing shot—something that gives a sense of place—followed by a medium shot that brings us into a particular locale and begins to give us more detail about the place or people. And then there are detail or close shots that give us glimpses of action, people, or events of importance to the story. The remainder of a particular film sequence is often a mix of medium and close shots with a pacing that gives visual rhythm and also gives us a good sense of the story.

That last item, pace, is important. Nothing is more boring than a show with each and every slide lasting, say, five seconds on the screen. As in video or cinematography, visual pacing makes for a more dynamic presentation. For example, let's say that as part of your presentation of a trip you've taken, you have some interesting close-up shots of people's faces. This could be done with quick changes, say one second on screen, giving a quick montage of interesting people.

To add even more visual interest to your slide program, think about using techniques like panning or zooming on still photos. Some programs allow you to do this (which, by the way, is often referred to as the "Ken Burns technique" after the famous documentary filmmaker who has made extensive use of this.).

Something else to consider is the use of video-editing programs. No, you don't have to have video to use these programs. You can

The interface of a typical PowerPoint slide presentation timeline.

use digital images and take advantage of the great number of effects available—such as the panning or zooming as described above. Many of these programs are inexpensive, such as Adobe Premiere Elements and Sony Vegas Movie Studio. Most of these also make it easy to create standalone DVDs from your slideshow. The real advantage of these video programs lies in their extensive capability to pace your presentation accurately on the timeline, to add transitions (be careful, don't get too fancy; too much can be too much), and to supply great titling.

On that last, don't overlook Photoshop's great power in adding text to still photos. You can create some very nice title slides with drop-shadow text or embossed text and a whole lot more.

Digital photography will only continue to get better. Exciting things are happening. Now video is converging with still photography, and several cameras offer the capability to shoot high-definition video and high-quality still photos in the same camera body. Multimedia photography has arrived, giving us tremendous new capabilities for creative expression. But then, that's the subject of a whole new book.

RESOURCES

There are an almost infinite number of websites of great use and interest to photographers these days.
Listed here are links to resources that I have found to be useful.

CAMERAS

Canon: www.canon.com

Nikon: www.nikon.com

Olympus: www.olympusamerica.com

Pentax: www.pentaximaging.com

Sony: www.sonystyle.com

SOFTWARE

Adobe Photoshop and Lightroom: www.adobe.com

Bibble Pro: www.bibblelabs.com

Canon Digital Photo Pro: www.usa.canon.com

HDR Photomatix: www.hdrsoft.com

Helicon Focus Pro: www.heliconsoft.com

Microsoft Expression Media: www.microsoft.com

Nik: www.niksoftware.com

Phase One Capture One Pro: www.phaseone.com

Photo Mechanic: www.photomechanic.com

PTGui (Panorama Tools graphical user interface):
www.ptgui.com

ACCESSORIES

Epson: www.epson.com

ExpoAperture and Expodisc: www.expoimaging.net

Lowepro: www.lowepro.com

Pantone HueyPro: www.pantone.com

TRAVEL SERVICES

Mondo Verde Expeditions (adventure travel worldwide):
www.mondove.com

Strabo Photo Tours (adventure travel and photo
workshops worldwide): www.phototc.com

Unique Safaris (the best safari outfitter in East Africa):
www.uniquesafaris.com

WEBSITES OF INTEREST

Audubon magazine: www.audubonmagazine.org

Fine Print Imaging (the best printing service I've found):
www.fineprintimaging.com

Fulcrum Publishing: www.fulcrum-books.com

The Luminous Landscape (a wide variety of useful
information): www.luminous-landscape.com

TED (Technology, Entertainment, Design; very stimulating
creatively): www.ted.com

Voyageur Press: www.voyageurpress.com

PHOTOSHOP LEARNING AND TUTORIALS

Mark S. Johnson Photography (good Photoshop
tutorials here): www.msjphotography.com

Hongkiat (tips for tech users, including Photoshop
tutorials): www.hongkiat.com

ORGANIZATIONS YOU SHOULD KNOW ABOUT

International League of Conservation Photographers:
www.ilcp.com

National Wildlife Federation: www.nwf.org

North American Nature Photography Association:
www.nanpa.org

Sierra Club: www.sierraclub.org

The Wilderness Society: www.wilderness.org

The Wild Foundation: www.wild.org

ABOUT THE AUTHOR

Boyd Norton travels extensively in documenting the world's wild places and environmental issues, a specialty he has pursued as a photographer and writer for more than forty years. No stranger to hazardous assignments, he has had close encounters with poisonous snakes (he was bitten once), wild bush pilots, snorting Cape buffalo, charging grizzly bears, rhino and elephant poachers, whitewater rapids, Borneo headhunters, prowling leopards, mountain gorillas, and Moscow taxi drivers.

For most of his photographic and writing career, he has devoted a great amount of time to conservation issues and the preservation of wilderness and wildlife worldwide. He is a charter fellow of the International League of Conservation Photographers (www.ilcp.com) and a founder and fellow of the North American Nature Photography Association (www.nanpa.org). He has played a key role in the establishment of several wilderness areas in the Rocky Mountains and new national parks in Alaska, as well as in the designation of Siberia's Lake Baikal as a World Heritage Site. He is the recipient of an award from the Environmental Protection Agency, presented by Robert Redford, for his "important, exciting environmental photography and writing."

Norton's articles and photo essays have appeared in most major magazines, including such publications as *Time*, *National Geographic*, *Smithsonian*, *Audubon*, *Conde Nast's Traveler*, *Stern*, *Vogue*, *Geo*, *Money*, *Outdoor Photographer*, *Popular Photography*, *Reader's Digest*, *The New York Times*, *Travel Holiday*, *Travel & Leisure*, *The London Observer*, and many others worldwide. He is the author-photographer of sixteen books and is working on several new books. When he's not in the wilds of Borneo or Siberia or Africa, he calls Evergreen, Colorado, home. He lives with his wife, Barbara, and two Asian leopard cats named Chui and Kuching.